HANDMADE IN BRITAIN

BBC

Joanna Norman

V&A Publishing

for my parents

First published by V&A Publishing, 2012
Victoria and Albert Museum
South Kensington
London SW7 2RL
www.vandabooks.com

Distributed in North America by
Harry N. Abrams Inc., New York

By arrangement with the BBC
The BBC logo is a trade mark of the
British Broadcasting Company
and used under license.
BBC logo © BBC 1996

The moral right of the author has been asserted.

ISBN 978 1 85177 708 2

Library of Congress Control Number 2012936008

10 9 8 7 6 5 4 3 2 1
2016 2015 2014 2013 2012

A catalogue record for this book is available
from the British Library.

DESIGNER Philip Lewis
COPY-EDITOR Mandy Greenfield

New V&A Photography by
the V&A Photographic Studio

Printed in Great Britain by
Butler, Tanner & Dennis

V&A Publishing
Supporting the world's leading
museum of art and design,
the Victoria and Albert
Museum, London

BELOW 'My Heroes' by Grayson Perry (see pl.81)
PAGE 6 Mantua (detail of pl.116)
PAGES 8–9 Tray of jasper trials (detail of pl.101)
PAGES 28–9 Annunciation to the Shepherds
 (detail of pl.30)
PAGES 58–9 Fish Slice by Rod Kelly
 (detail of pl.77)
PAGES 94–5 'Kestrel' coffee set (see pl.108)
PAGES 130–1 The Syon Cope (detail of pl.113)
PAGES 162–3 Cravat by Grinling Gibbons
 (detail of pl.171)
PAGE 198 The Dolphin Basin (detail of pl.56)

Contents

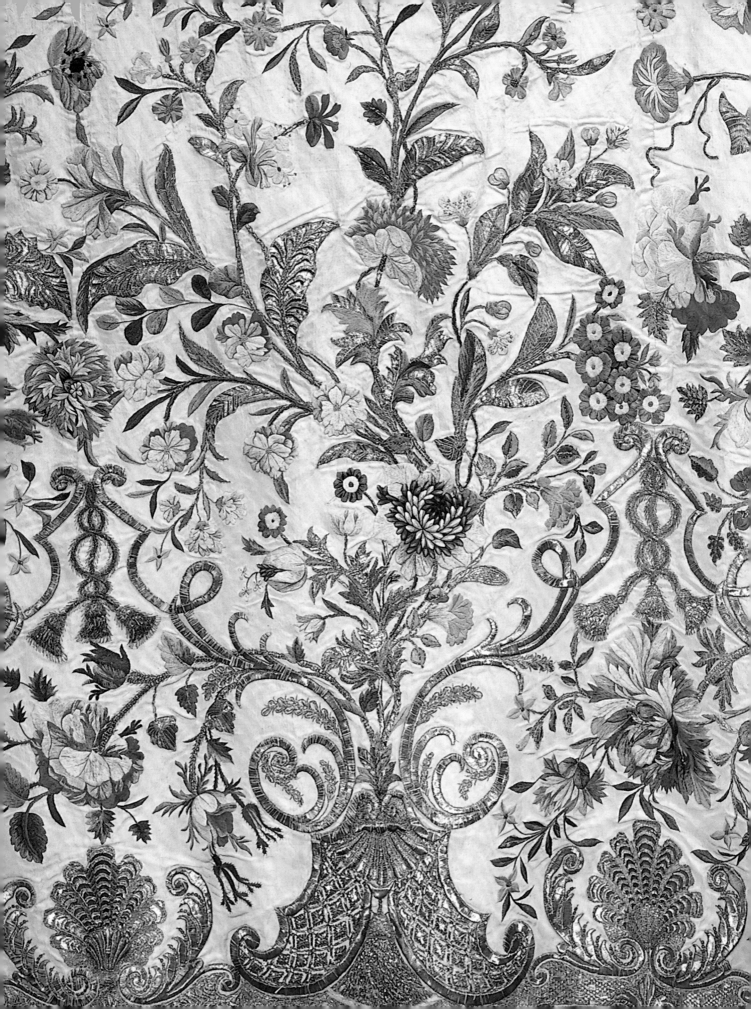

Foreword

This book accompanies *Handmade in Britain*, a year-long season of television programmes produced in partnership between the Victoria and Albert Museum and the BBC. From autumn 2011 *Handmade in Britain* has offered the most ambitious and wide-ranging exploration yet undertaken on British television of historical and contemporary craftsmanship. A programme of individual films and mini-series has focused in turn on introducing a different discipline to a television audience: stained glass, ceramics, metalwork, wood and fabric. In each case they have examined – to a large extent through objects in the V&A's collections, but also through those in other museums, churches and country houses – materials and techniques of manufacture, as well as the broader social and cultural contexts in, and for which, these objects were made.

This book takes a similar approach to that of the television programmes. Following an introduction, which ties together some of the threads common to the evolution of all disciplines, it focuses on each medium in turn. Each chapter broadly follows the narratives explored in the programmes, featuring many of the same objects that have intrigued and beguiled viewers with the stories they have to tell, and moving out from this focused examination of objects to look more broadly at the environments for which they were made.

Joanna Norman
November 2012

The richness and variety of the V&A collections make the Museum uniquely positioned to act as a partner to the BBC on *Handmade in Britain*. The partnership is revealed in the range of objects in every discipline featured in the programmes – and in this book – and in the focus on the relationship between historical and contemporary craftsmanship. From its original creation as the teaching collection of the School of Design in 1837 and its foundation as a public museum following the Great Exhibition of 1851, the V&A has always been motivated by the intention to educate, but also to inspire creativity. In line with this aim – and in keeping with the inclusion of contemporary practice in the *Handmade in Britain* programmes – we have here included contributions from contemporary practitioners in each discipline, offering their take on what inspires and motivates their own work.

In the twenty-first century the founding principles of the V&A remain no less relevant than they were more than 150 years ago. The aims of continuing to increase access to the collections through a variety of media, and of inspiring and promoting creativity, are fundamental to the Museum. In partnership with the BBC, *Handmade in Britain* offers a new medium to enable the Museum to engage with different audiences and to continue to inspire craftsmanship today.

Introduction

Across the ages and throughout the world, whether motivated by practical or economic necessity, by desire or inspiration, people have made things by hand. Traditionally, making is fundamental to community, a domestic as well as professional activity, in which makers express their technical expertise – but also their imagination. Consumers value the individuality of the handmade object, the care and skill required to make it, the technical virtuosity or design ability of its maker. Objects made by hand can reveal the desire of the craftsman not simply to fulfil function, but to produce an object that satisfies aesthetically as well as practically.

This book traces the history of making in Britain across some of the key disciplines in what are commonly known as the decorative or applied arts. Rather than the fine arts of painting and sculpture, it looks in turn at some of the 'useful' disciplines – ceramics, metalwork, textiles, woodwork and stained glass – that have played a role in our daily lives for centuries.

This usefulness, the 'need' for these objects to perform a specific function while also serving an aesthetic role, is what marks them out from the fine arts, and what has traditionally led to them being considered inferior. But with a blurring of categories, particularly from the twentieth century on, and the rise of conceptual art, such hierarchies no longer seem useful or relevant. For centuries the decorative arts have equally been a field for the display of artistic ability and imagination. Rather than being a reductive constraint, the structure imposed by the necessity to fulfil a particular function can enable designers' and craftsmen's imagination to work in innovative ways to create an interplay in their works between function, material and form (pl.1).

This book deals predominantly with high-status objects made by some of the most accomplished craftsmen and craftswomen of their day. Even where the names of these craftspeople are unknown, their objects reveal the skill and ingenuity that went into making them. Whether in their material composition or the techniques used to produce them, they also reveal the developments and innovations that have occurred in each discipline at various points in its history. The nature of many of these objects affects the broader story that they can represent, as they are largely those made for the upper and middling levels of society rather than across the complete social spectrum. Nonetheless, they can form a narrative that tells us much about the social, political and cultural history of Britain. While each individual chapter focuses on a specific craft discipline, it also explores the relationships that we have with objects and what they can tell us about changing habits of consumption and behaviour over the centuries. They reflect the ways in which making in Britain has been shaped by factors ranging from religion to geography and politics, in ways different from other European countries. Although its chronological scope is broad, this book concentrates above all on the years from 1500 to 1900 – a period that saw the complete transformation of Britain from a nation that imported almost all of its desirable goods, to the largest manufacturing and trading nation in the world. In the context of the twentieth-century decline in British manufacturing and today's post-colonial, post-industrial age, it also looks at contemporary practice in the arts, through the eyes of makers themselves.

Throughout Britain's history, its design and manufacture have developed in a distinct way, differently from

1
Teapot, made by the
Chelsea Porcelain Factory
White glazed soft-paste porcelain
England (London), 1745–9
V&A: C.46–1938

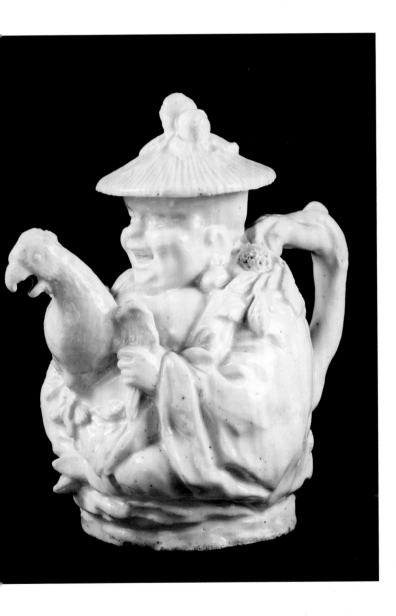

its European counterparts. Partly this has resulted from its geography: an island nation made up of four distinct countries on the periphery of the European landmass. By the beginning of the sixteenth century what we now know as Britain was not only geographically peripheral to Europe, but also politically marginal, riven by wars within its borders and constantly threatened by external forces. England, its largest power, had lost almost all the territories that it had previously held in France – and, with them, any serious influence on the continent. The key centres in Europe at this time for trade and artistic production were the Low Countries and the Mediterranean, which produced highly sophisticated goods, in stark contrast to England whose only export was woollen cloth. The British economy was primarily rural, with London, the capital city, only of moderate size in European terms, with a population of around 40,000. In terms of artistic production, most of Britain's population owned only fairly basic possessions and produced the majority of these themselves, while at the highest level of society elite consumers relied heavily on imports of luxury goods from abroad. Even the most notable medieval artistic achievements – such as the Gothic architecture of the cathedrals and great churches, stained-glass painting and *opus anglicanum* embroidery (pl.118) – remained particular to Britain rather than influencing developments on the continent.

These medieval achievements in the arts were primarily ecclesiastical in nature. As on the continent, during the Middle Ages the principal artistic and architectural patron was the Church. Ultimately ruled by the Pope from Rome, the Catholic Church was the spiritual authority to which earthly rulers were answerable.

The Church was the underpinning of medieval life, and the spiritual afterlife was the goal to which life on Earth was directed. With its ranks of ecclesiastical hierarchy and possession of land across the country, the Church was also an extremely rich and powerful social force (pl.2). Cathedral chapters, parish bodies, individual clerics and important lay patrons, both institutional and individual, commissioned buildings for worship that glorified God through their architecture and their fittings – stained glass, carved and painted woodwork, iron grilles, silver vessels and the lavishly embroidered vestments for which English embroiderers were renowned throughout Europe. Henry VIII's break with the Church in Rome, brought about to allow him to divorce Catherine of Aragon, and coinciding with the

broader movement of the Protestant Reformation, changed this for ever. The Dissolution of the Monasteries destroyed great swathes of ecclesiastical art and led to an economic shift in England, transferring huge amounts of wealth and land to the Crown, and established the monarch as the Supreme Head of the Church of England, answerable to nobody but God. Once this had begun, waves of iconoclasm continued for generations across the island – particularly violently in Scotland – changing the character of worship, removing its trappings and replacing them with a mistrust of imagery and an emphasis on the word of God, to be found in the new, printed, English-language bibles. With the Church now fragmented, stripped of its wealth and no longer the most important artistic patron, secular patronage became increasingly

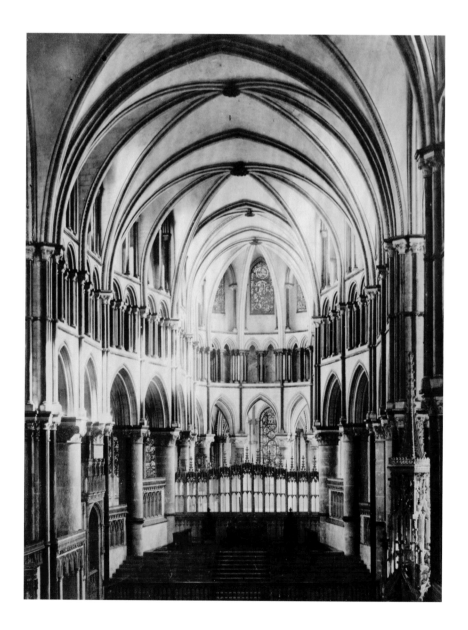

2
Choir of Canterbury Cathedral,
founded 597 CE
Photograph by Frances Bedford.
Given by David Lyndon Smith
V&A: E.280–2008

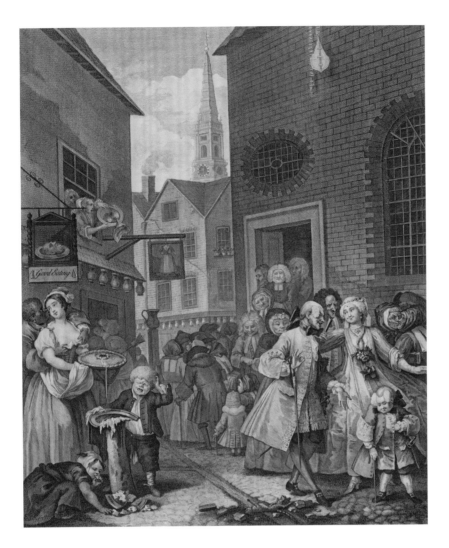

3
'Noon' from *The Four Times of Day*
by William Hogarth
Engraving
England (London), 1736–8
V & A: Dyce.2742

vital to the arts in Britain, and the Church only really recovered in a significant way – and, even then, only as one of multiple patrons – during a period of Victorian religious revival and the renewal of the Gothic style in the nineteenth century.

Nonetheless, religion played a major role in the development of the arts, particularly from outside. Diplomatic alliances were often forged according to religious sympathies, and led to the acquisition of new fashions under particular foreign influences. The divisive effects of the Reformation led to religious wars across Europe – and to waves of religious persecution. This proved beneficial to Britain, which welcomed refugees, including craftsmen, to its shores. For a country traditionally reliant on imports of luxury goods, replacing foreign imports with home-made goods was a particular aim, as it meant keeping money within the national economy. To this end, immigrant craftsmen were welcomed to the country, but were often obliged to train British craftsmen in their workshops in order to develop native skills and industries. Such was the case with the Protestant Delftware potters who arrived from Antwerp in the sixteenth century, and again with the Huguenot goldsmiths, silversmiths and silk weavers who arrived from France following the Revocation of the Edict of Nantes of 1685 (pl.3).

These craftsmen brought with them technical skills and training, as well as knowledge of the latest continental styles. The Huguenots are a prime example: in disciplines ranging from silk-weaving to blacksmithing to gold- and silversmithing, their success was due not only to their cheaper prices, but also to their ability to introduce the latest designs to the British market through their contacts in that country and – above all – the superior craftsmanship they had acquired as a result of the rigorous standards imposed by the state-sponsored guilds in France. Their abilities and entrepreneurship extended beyond their own trades: the development of domestic glass manufacturing in Britain arose in part thanks to the sixteenth-century Protestant refugee Jean

Carré from Antwerp, who established a glassworks at Crutched Friars in London and brought glass-workers to run it from Venice, the key centre for European glass. Two centuries later the Chelsea porcelain factory – one of the more successful early British porcelain enterprises – was managed by Nicholas Sprimont, a Liège-trained silversmith who was almost certainly a Huguenot refugee.

Immigration was not of course restricted to religious refugees, or to a particular period, rarely being halted by the frequent wars that characterized much of European history. Bede writes of the glaziers brought to England from France in the seventh century to work on the monastery of Monkwearmouth, and we know from surviving documents of the foreign glaziers who worked in the later Middle Ages on major royal commissions such as King's College Chapel, Cambridge. Henry VIII, the first English monarch to compete artistically on a European level – acquiring the largest ever collection of tapestries, as well as silver, gold and jewellery, and staging magnificent masques and tournaments – was also responsible for importing foreign craftsmen to Britain to introduce continental fashions and to work at court. The Royal Almain Armoury, which Henry founded in Greenwich in 1515, took its name from the German (*allemand* in French) and Dutch craftsmen whom he brought to England, and even in its later years under Elizabeth I it was still the 'Almains' who ran it (pl.4). Foreign artists and craftsmen were employed by later monarchs, including James I, who commissioned Peter Paul Rubens to paint the ceiling of the Banqueting House in Whitehall; by Charles I, who brought weavers from Flanders to set up a tapestry works at Mortlake, as well as individuals such as Christian van Vianen from the renowned Utrecht family of goldsmiths; and by William III and Mary II, who employed makers such as Jean Tijou, as well as the celebrated designer Daniel Marot. Other craftsmen arrived in Britain of their own volition, seeking a new market in which they might make their name. This was possibly the case with Grinling Gibbons, who may have seen London – rapidly expanding and rebuilding after the Great Fire of 1666 – as a site full of opportunity for a woodcarver with superior continental training and design knowledge (pl.5).

This influx of foreigners, often more highly skilled than their British counterparts, could create fraught relationships between foreign and native craftsmen, and particularly with the guilds that controlled the operation and regulated the quality of output of each particular trade. Accounts reveal complaints by native craftsmen to their guilds when 'aliens' were perceived to be taking their work away from them, and even riots in particularly serious circumstances, such as in Spitalfields in 1769. However, the immigrants were often able to circumvent guild controls and restrictions by working for the court, or by settling outside the boundaries of the City of London – which in both instances put them outside the

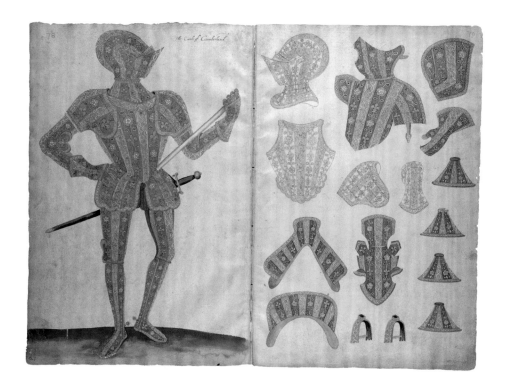

4
Design for armour for George Clifford, third Earl of Cumberland, from the *Almain Armourer's Album*, designed by Jacob Halder
Pen, ink and watercolour on paper
England (Greenwich, London), 1586–90
V&A: D.605&A–1894

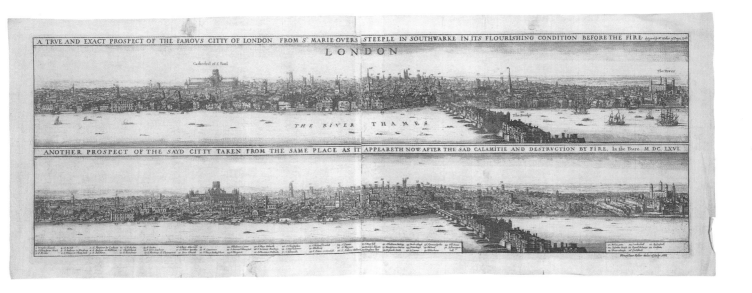

A TRVE AND EXACT PROSPECT OF THE FAMOVS CITTY OF LONDON FROM S⸳ MARIE-OVERS STEEPLE IN SOUTHWARKE IN ITS FLOURISHING CONDITION BEFORE THE FIRE

LONDON

THE RIVER THAMES

ANOTHER PROSPECT OF THE SAYD CITTY TAKEN FROM THE SAME PLACE AS IT APPEARETH NOW AFTER THE SAD CALAMITIE AND DESTRVCTION BY FIRE, In the Yeare. M. DC. LXVI.

5
*View of London before and
after the Great Fire of 1666*
by Wenceslaus Hollar
Etching
England (London), 1666
V&A: E.1589–1960

6
Portrait of Edward Howard
by Pompeo Batoni
Oil on canvas
Italy (Rome), 1766
V&A: W.36–1949

jurisdiction of the guilds – establishing themselves on the basis of their skills and competitive prices, which ensured that they maintained their market.

This immigration of foreign craftsmen was part of a broader engagement with the continent that characterized the early modern period of creative development in Britain. Royal marriages with foreign dynasties brought in new customs and artistic objects, while monarchs themselves might bring back ideas from abroad. When Charles II and his brother, the future James II, returned to Britain at the Restoration in 1660, they and exiled royalists brought with them knowledge of contemporary fashions in France, Italy and the Low Countries, where they had spent their exile. In the same way, William III and Mary II brought with them the French-inspired Dutch baroque style of the late seventeenth century, which influenced disciplines ranging from architecture and garden planning to interior design.

Particularly in the eighteenth century the Grand Tour introduced a swathe of young aristocracy and landed gentry to the art and architecture – both ancient and modern – of the continent, especially France and Italy (pl.6). The acquisitions they made abroad, brought back to Britain and displayed in their town and country houses,

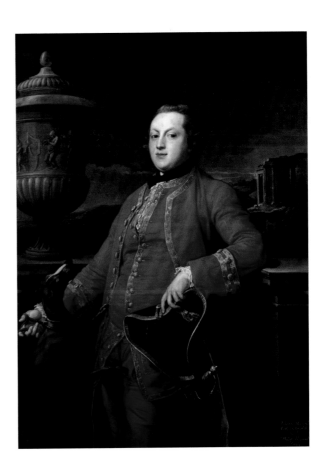

led to a greater awareness of continental design, which artists reinforced through their own travels and studies abroad. Trade outside Europe, promoted by the East India Company, introduced new objects, ranging from Persian carpets to Chinese and Japanese porcelain, Indian chintz and Japanese lacquer, which often inspired British imitations – such as soft-paste porcelain or japanning (pl.7) – and encouraged the development of chinoiserie style. Trade also introduced new and exotic raw materials, such as cotton and ivory, as well as commodities such as tea, coffee, chocolate and tobacco, which required novel objects in order to consume them. Styles and designs also increasingly travelled to Britain

through prints, with British designers and craftsmen realizing the potential of this means of disseminating knowledge of their works and exploiting it in their own way. Publications such as Tijou's *New Booke of Drawings*, Robert Adam's *Works in Architecture* and, above all, Thomas Chippendale's enormously successful *Gentleman and Cabinet-Maker's Director* (pl.8) served both as sourcebooks for designers and as pattern books for future customers. Manufacturers' catalogues were seen as a way of appealing to the eighteenth-century taste for shopping, while illustrated periodicals such as Rudolph Ackermann's *Repository of Arts* could prove influential in directing trends in taste and fashions.

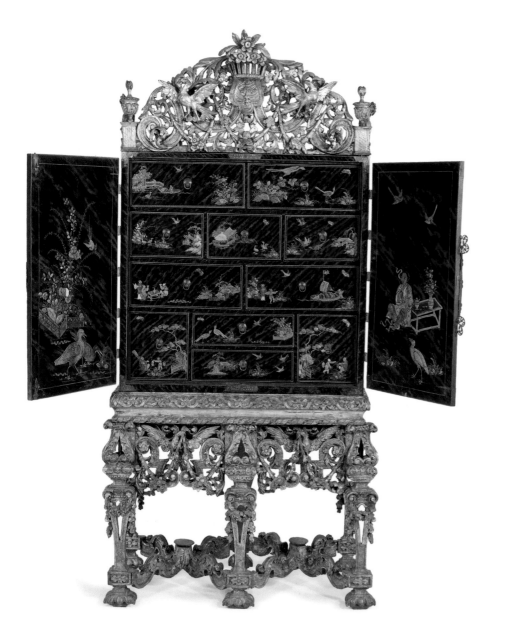

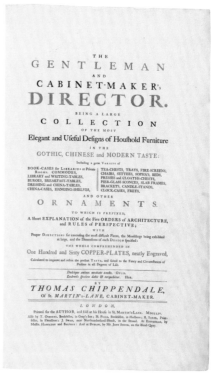

7
Cabinet-on-stand
Japanned on an oak carcase, with softwood dustboards and oak drawer linings; the stand and cresting of carved and silvered softwood and lime
England, 1690–1700
V&A: W.20–1959

8
Frontispiece of
The Gentleman and Cabinet-Maker's Director
by Thomas Chippendale
(London, 1754)
V&A: L.4674–1978

9
St Paul's Cathedral,
designed by Sir Christopher Wren,
built 1675–1710
Photograph by George Scamell, *c.*1860
V&A: E.280–2000

During much of the early modern period European taste was led by France. Paris was the centre of production for the most sought-after luxury goods and remained so, despite long-running Francophobia in England. However, partly due to ongoing mistrust – and even fear – of the pernicious influence of Catholicism, style movements that originated in Catholic countries such as France often evolved in a distinct way in Britain. Baroque, closely associated with the revived Catholic Church and the power of absolutist regimes, was adopted in Britain, but only to a limited extent, and was usually tempered by a restrained classicism, as can be seen in Wren's city churches and St Paul's Cathedral (pl.9), or in the ironwork of the followers of Jean Tijou. The more frivolous rococo style was introduced largely by the

Huguenots, but developed a spikier nature in Britain in crafts such as woodcarving, as well as a more developed interest in accurate botanical motifs, as seen in the silk designs of Anna Maria Garthwaite. A plurality of styles coexisted in Britain: the Georgian period saw rococo, chinoiserie and neo-Gothic styles appear, alongside the dominant current of classicism. However, the notion of a national style began to emerge in the late eighteenth century, as the works of architects and designers such as Robert Adam – whose architectural and interior schemes confirmed neoclassicism as the leading fashionable style – introduced a new approach of total design, which coordinated all elements of an interior.

Political governance compounded the effects of the movement of artists and the transmission of design ideas on practices of making in Britain. The power of the British Parliament as a force to limit the power of the sovereign was highly significant, and was in stark contrast to the systems of absolutist monarchy operated by various continental countries, particularly Britain's chief rival, France. Although far from being a truly

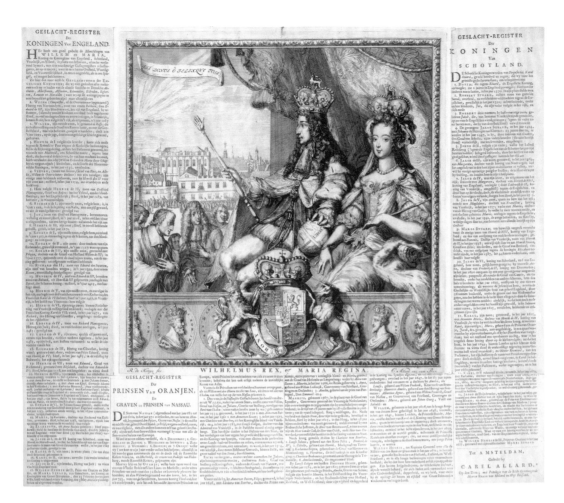

10

The Coronation of William III and Mary II
by Romeyn de Hooghe
Etching and letterpress
The Netherlands
(Amsterdam), 1689
V&A: E.2939–1995

democratic system, as it represented only a tiny elite of the population, parliamentary sovereignty prevented the possibility of an absolutist monarchy arising in Britain. The Civil War subjected any future monarch to the control of Parliament – a principle that became legally enshrined with the Glorious Revolution of 1688 and the coronation of William III and Mary II (pl.10). With the Glorious Revolution, Parliament demonstrated its power to effectively choose the line of succession to ensure the continuation of a Protestant monarchy, and did so again at the death of Queen Anne in 1714 and the accession of the Protestant Hanoverian George I.

The effect on the arts of this peculiarly British relationship between the monarchy and Parliament was twofold. First, there was a wider patronage base and a more pluralistic approach to design than in other European countries. In France the manufacturing arts were state-sponsored concerns, most notably the royal Gobelins workshops, which specialized in the production of luxury goods ranging from furniture to tapestries. The absolutist regime of Louis XIV not only ensured this state subsidy, but also promoted a particular style

through these products, at least at an elite level. In Britain this was not the case. Particularly from the eighteenth century on, British manufactures were predominantly commercial concerns, funded not by the aristocracy, but by entrepreneurs. This brought with it a considerable degree of instability, especially when, as in the case of the porcelain factories, there was no guarantee of success. But it also allowed a certain freedom of approach – there was no single arbiter of taste in Britain as there was in France – and a wider, more economically driven market.

Second, without a guaranteed market such as the court for their goods, British entrepreneurs and manufacturers were forced to compete fiercely to attract customers, operating in an environment of secrecy that was rife with industrial espionage. Such circumstances fostered a climate of scientific and technological experimentation and innovation, motivated primarily by the desire for financial success, which was particularly marked in Britain. It is notable that two of the great eighteenth-century British manufacturers, Josiah Wedgwood and Matthew Boulton, were particularly successful because they targeted different levels of

society: the elite, who would guarantee the quality and desirability of their products, and the middling classes, who offered a far larger market. Particularly during the eighteenth and early nineteenth centuries these 'middling classes', composed of lesser gentry, merchants, bankers and industrialists, were the fastest-growing and most significant part of the British market for desirable goods, aspiring as they did to imitate their superiors and demonstrate their politeness and gentility through their acquisition and use of the 'right' objects in their homes.

Notions of politeness and gentility underpin an understanding of the rise of making in the luxury trades from the late seventeenth century onwards. In addition to the practical motivations for acquiring particular kinds of objects – tapestries to provide insulation, silver for sterility and monetary value, leather wall hangings to exclude odours, iron for strength – increasingly a further factor came into play: a greater formalization and ritualization of daily life at the upper levels of society, which gradually filtered some way down the social scale. Like many fashions, this originated at the French court of Louis XIV, whose entire day was ritualized, from the

levée (the official rising of the king in the morning) to the *couchée* (the official going to bed) and including everything in between. This ritualization was reflected in the architecture and layout of palaces and noble houses, with sequences of state rooms arranged and furnished with display furniture for particular functions; and in the development of new objects to suit these novel domestic, yet public rituals, such as toilet services, ever-expanding ranges of dining utensils and tea and coffee services. Even when this extreme level of formality relaxed in the eighteenth century, the notion remained that objects were not merely static, but active tools in ritualized codes of behaviour. The performance of the preparation and serving of tea was one such: performed by the lady of the house, this elaborate ritual demonstrated her gentility, her possession of all the necessary utensils and her knowledge of how to use them in front of her female guests, even if it was often portrayed in print as something rather more akin to a coven of gossips (pl.11). When the actor David Garrick and his wife purchased an apartment in the fashionable Adelphi development, designed by Robert Adam, they made sure to furnish it

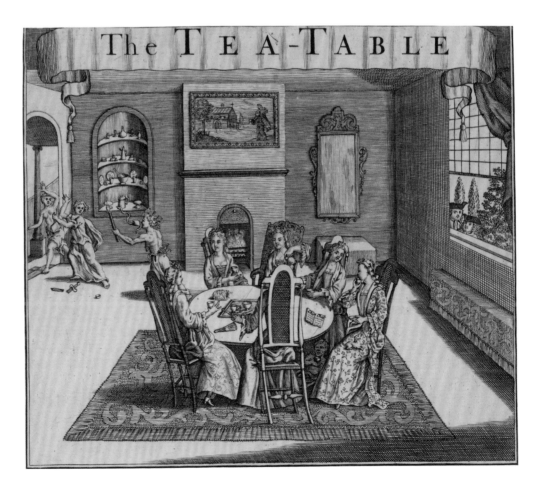

11
The Tea-Table, published by John Bowles
Etching and engraving
England (London), *c.*1710
The British Museum

19

THE GRINDING MILL.

THE SLIP KILNS.

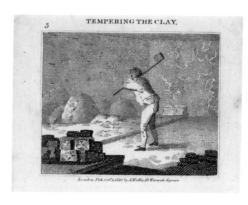

TEMPERING THE CLAY.

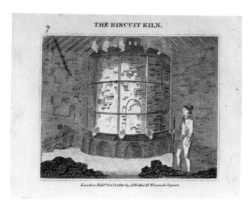

THE BISCUIT KILN.

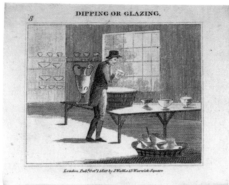

DIPPING OR GLAZING.

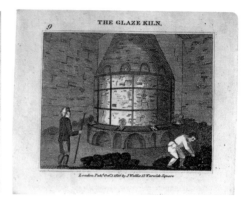

THE GLAZE KILN.

with the necessary equipment, including a silver tea and coffee service and furniture supplied by Chippendale. The performance in which these objects played their part was embellished by fashionable dress, often designed in such a way that it required a certain degree of skilled performance to be able to move in it (pl.116) with grace and elegance.

The eighteenth and nineteenth centuries saw a growing participation in this code of manners, from a widening of the sectors of society that were able to afford the luxury goods they necessitated, principally the ever-expanding market of the middling classes. From the mid-eighteenth century into the early nineteenth century it was this group that grew most rapidly, trebling the number of British consumers.[1] Britain had long been, and continued to be, a constantly expanding population, but was also an increasingly urban one: by 1650 London had expanded to become the largest city in western Europe with a population of 400,000, and would continue to grow considerably in subsequent centuries. Other towns and cities followed suit: in 1700 only 20 per cent of the British population lived in towns, but by 1901 75 per cent lived in urban areas. This huge swing was largely a result of Britain's rise as a manufacturing and trading power:

the industrial cities and ports were among the most rapidly growing urban centres. Gentrification also played its part, with new leisure towns such as Bath and Brighton developing during the Georgian era. All these were aided by improvements to transport networks by road, water and – from the early nineteenth century – rail.

By the time of Queen Victoria's accession in 1837 Britain was the leading world power, its European and international status having completely transformed over the course of several centuries. Victory in the Napoleonic Wars ensured the emergence of Britain as the leading political and economic European and global power, finally ending the hegemony of the French in Europe. It was greatly assisted by the shifting of the trade centre of Europe from the Mediterranean to the Atlantic, which had enabled Britain to build up its colonial possessions and trading posts in the Americas and Asia (despite the losses during the American War of Independence) and thus supersede the Dutch as the leading global trading nation. Britain's colonies benefited British manufacturing in two ways: they brought in new raw materials such as mahogany and cotton, and provided a ready market for British-made products, although not without negative impact on the colony's populations, who were subjected

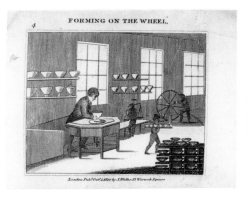

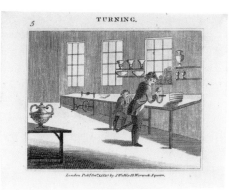

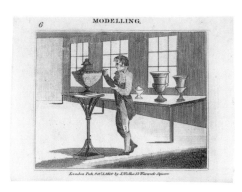

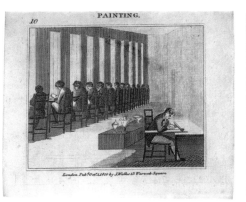

12
Set of plates showing the division of labour in the manufacture of porcelain, from *The process of making China. Illustrated with twelve engravings, descriptive of the works of the Royal China Manufactory, Worcester* (London, 1813)
V&A: 60.S.145

to exploitation and slavery. The previous century had seen Britain's position as a producer, rather than a consumer, of luxury goods transform. From the 1760s the Industrial Revolution had built on earlier technological innovations, such as the use of coke for smelting iron on a large scale, to advance manufacturing processes, introducing steam power and new machines for use particularly in the production of cotton textiles. The perception of British-made goods had also changed. In a wave of 'Anglomania', all things British became desirable across Europe from the second half of the eighteenth century. British male fashions – influenced by riding and sporting wear – were seen as a sober and preferable alternative to the fussiness of French court dress.[2] British ceramics, such as Wedgwood's creamwares, were admired by patrons as illustrious as Catherine the Great, Empress of Russia, while model factories such as Wedgwood's Etruria and Matthew Boulton's Soho became tourist attractions, admired for their division of labour into specific processes and new technologies that increased the efficiency of production. Even in the manufacture of luxury goods, which were mostly still made by hand because of the degree of skill and precision required, improvements to hand-powered tools and

technological innovations – ranging from transfer- and block-printing to coke smelting – made certain processes more efficient (pl.12).[3]

During Queen Victoria's reign Britain became the richest country the world had ever known. However, such extraordinary financial success did not prevent a growing tide of discontent with manufacturing production. Criticisms of excessive luxury – as well as a Protestant unease with materialism and with a society founded primarily on wealth and commerce – had long been voiced in Britain, but were now related specifically to manufacturing, the ever-increasing use of machines being condemned as an inhuman soullessness at the heart of British production.[4] British design continued to be deemed inferior to that of France, and the connection

between designer, artisan and consumer seemed to have been lost in the continued division of labour. The process of making came to be seen as completely fragmented, and the motivations for making as excessively pecuniary. This critique was formalized with the Arts and Crafts movement in the second half of the nineteenth century, when thinkers such as John Ruskin and William Morris advocated a move away from industry and a return to traditional craft skills, in a new philosophy motivated by the desire to return to a world in which one person would follow the making process through from start to finish, from design to end-product.

This volte-face not only affected British production at the end of the nineteenth century, but has shaped much thinking and practice within the decorative arts ever since. Alongside large-scale manufacture and professional design, a studio crafts movement emerged in the early twentieth century that offered a different approach to design and making. Figures such as Bernard Leach consciously turned away from modernity and instead pursued the revival of traditional craft skills and vernacular styles. The effects of two world wars contributed to this. In the aftermath of the First World War the crafts were seen as potentially beneficial for returning wounded servicemen, as simple manual labour that could provide them with both therapy and occupation.[5] During the Second World War the crafts and making were linked directly to an idea of British nationhood that was broadcast abroad as part of a campaign to garner military and popular support, with a 1942 British Council-organized Exhibition of Modern British Crafts being staged in ten US and five Canadian locations.[6] The wars also resulted in a new influx of refugees, including such eminent figures as the ceramicists Lucie Rie and Hans Coper, but also encouraged a shift in art-school training, favouring the practical rather than the fine arts. Servicemen returning from the war, in need of professional opportunities, were offered grants and exempted from the usual qualification pre-requisites to study at art college, thus democratizing and commercializing work that might have been thought of as predominantly a pastime for the middle classes.

The revitalization of the crafts in Britain was celebrated both in individual events – such as the 1951 Festival of Britain, in which they played a leading role – and in particular commissions, perhaps most notably the rebuilt Coventry Cathedral, which brought together the work of some of the finest designers and craftsmen in different disciplines to create a environment that was intended to celebrate the revival of post-war Britain. Into the 1970s other external factors contributed to further developments: furniture design was influenced by the growing ecological movement, while silver benefited from a partial return to formal dining. The foundation of the Crafts Council in 1971 formalized the crafts movement,

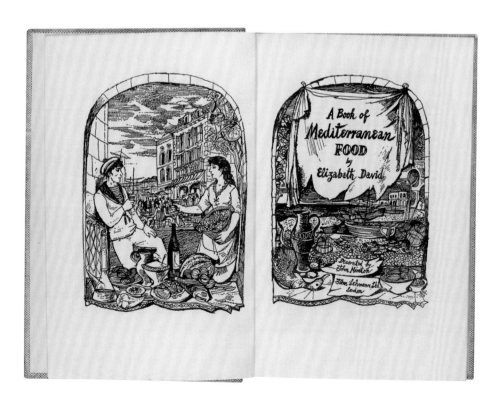

13
Frontispiece of *A Book of Mediterranean Food*
by Elizabeth David
(London, 1950)
V&A: G.29.W.54

14
HMP Wandsworth quilt
made by Fine Cell Work
Pieced, appliquéd and
embroidered cotton and linen
England (London), 2010
V&A: T.27–2010

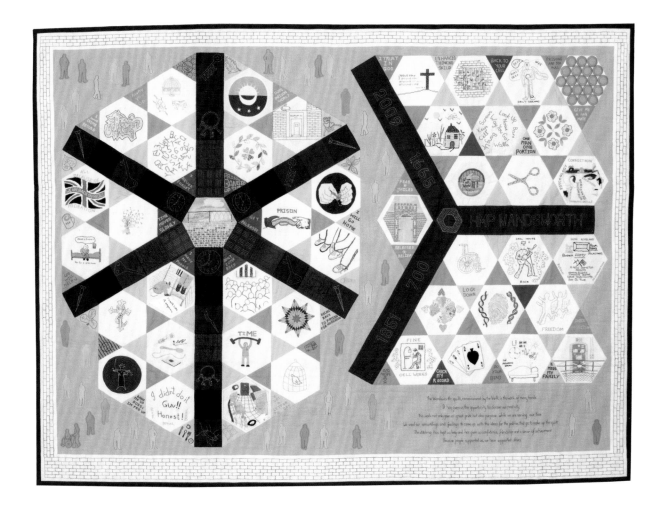

validating and promoting the status of contemporary crafts, and the increasing value accorded to handmade objects corresponded with a new interest in the homespun. These developments suited a post-war age of austerity and continued in later years, coming to reflect shifts in behaviour in areas such as cooking, with the popularity of new health-food stores and the recipes of Elizabeth David (pl.13).

The collapse of the majority of British manufacturing in the latter part of the twentieth century has made the state of making in Britain at the beginning of the twenty-first century a fraught subject. The paradox at the heart of the crafts movement is as clear as it was a century ago: while the skill and individuality needed to make handmade objects are to be celebrated and valued, they are also the factors that make handmade objects the preserve of the rich, who are the only consumers able to afford them. The number of people equipped with practical, technical skills is to a certain extent dependent on the value that society accords to 'applied' rather than 'pure' thinking, and on the training in such practices

created as a result, meaning that the number of people capable of highly skilled craftsmanship is relatively small. Yet it is clear from the artists, designers and craftsmen working in contemporary Britain that the impetus to produce highly crafted objects remains as strong as ever. The possibilities offered by new – especially digital – technologies open up different directions to practitioners (as new technologies always have), even if they bring with them a re-evaluation of the relationship between new and traditional processes.[7] Furthermore, in a new age of 'austerity Britain' it is clear that the popular appeal of the handmade object lies not only in its status as something to be acquired, but as something to be produced, as the growing popularity of quilting and knitting as individual or communal activities demonstrates (pl.14). The toil and care that making something by hand entails can seem to be at odds with a society so often criticized for its culture of instant gratification, but it is clear from professional and amateur practice that it remains something to be nurtured and celebrated.

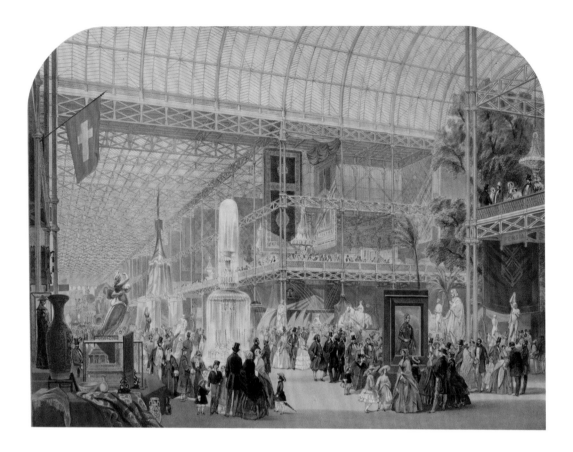

As the national museum of art and design, it is entirely appropriate that the V&A should provide the starting point for an exploration of handmaking in Britain. From metalwork to textiles, ceramics to furniture, the V&A houses one of the finest collections of decorative arts in the world, but its significance is embodied not just in the objects it contains. Unlike most comparable European institutions (such as the musée du Louvre or the Prado), the Museum did not evolve from the appropriation of a royal collection, but was instead founded as a governmental initiative for public good. With its origins in the 1837 establishment of a teaching collection for the Government School of Design (later the Royal College of Art), the Museum of Manufactures – as the V&A was initially known – came into being as a result of the success, and profits, of the 1851 Great Exhibition of the Works of Industry of All Nations (pl.15). The Museum was intended to be a repository for the finest examples of historical and contemporary design across the arts. However, it was prompted not simply by the desire to acquire, but also to inspire and educate. Its intentions were didactic: to educate the people of Britain through visual stimulation, and to grant contemporary manufacturers and designers the opportunity to see examples of 'good' design in order to provide inspiration for their own works.

The need for such an institution was linked directly to Britain's success as a leading manufacturing nation. By the mid-nineteenth century Britain may have been the greatest exporting nation in the world, but, as the Great Exhibition exposed, it was far from being a leader in design. The Great Exhibition was intended to demonstrate British prowess in manufacturing, but it was France that carried off most of the prizes in the applied arts.[8] The inferiority of British design had already been assessed by a Select Committee in 1836, which had expressed a concern about the lack of design training in Britain in the applied arts and had provided the impetus for the foundation of the Government School of Design. The concern was not merely about the quality of design per se, but was rooted in the fear of the negative impact this might have on British manufacturing, if French products were perceived to be superior. Through the collections and education programme of the South Kensington Museum (as it was soon renamed), it was intended that design for manufacturing would improve, with ensuing commercial benefit. It is no coincidence that the earliest acquisitions of the Museum included contemporary examples of good design by foreign designers and manufacturers bought from the Great Exhibition and

its subsequent imitations, but also concentrated on particular areas such as ceramics, which was appropriate given the importance of the ceramics industry to the British economy at this time.[9]

The intentions of the South Kensington Museum – which was renamed the Victoria and Albert Museum in 1899 – were reflected not only in the comprehensive scope of the collections, but in the ambition of the museum building as well. As a 'palace for the masses', it contained not only galleries to display its newly formed and ever-increasing collections, but also art studios, lecture rooms and the very first museum restaurant in the world. Just as the glasshouse of the Crystal Palace had complemented the 100,000 objects that it contained for the Great Exhibition in its astonishing demonstration of technology and craft, being constructed from prefabricated modules of hand-blown glass, cast iron and timber, so too the architectural fabric of the South Kensington Museum complemented its collections and expressed its purpose in the techniques that it employed. The exterior façade of the building, which was composed of brick, terracotta and mosaic, bore the images of the key figures behind the museum (including Henry Cole, its first director, and the architect Francis Fowke), as well as a central pediment bearing an image of Queen Victoria presenting medals at the Great Exhibition (pl.16).

17
Tiles from the Grill Room, V&A,
designed by Edward Poynter,
begun 1866

18
'At the End of the Day'
by Natasha Kerr
Transfer-printed, silkscreen-printed,
hand-painted, hand-stitched linen
England (London), 2007
V&A: T.43–2008

Similarly, the interior showcased contemporary design and technology. It was the first museum to be equipped with artificial lighting to enable evening visiting, a factor intended to appeal to the working population. The three Refreshment Rooms that made up the museum restaurant each displayed a different design approach representative of their time: the Gamble Room (the original restaurant) was paved in encaustic tiles, its walls and columns clad in new 'majolica' glazed tiles, produced by Minton & Co.; the Grill Room, designed by Edward Poynter, was equipped with a contemporary cast-iron stove and tile panels painted by a ladies' tile-painting class at the School of Design (pl.17); while the medieval-inspired Green Dining Room was the first major commission carried out by the new company of Morris, Marshall, Faulkner & Co. Cast iron was put to structural and decorative use in the arches of the South Court, the balconies and railings of the Lecture Room, and interior and exterior fittings of the building, displaying the contemporary popularity of the material for combined architectural and aesthetic purposes.

This desire to inspire creativity, as well as to collect it, still lies at the very heart of the V&A's purpose today. Its concerns about the quality of British design and manufacture are just as valid as they have always been, although its scope is more international. The V&A continues to work closely with the creative industries in order to promote contemporary design, as well as commissioning and collecting contemporary craft for the Museum (pl.18). The collecting and study of making in different materials are embedded in the organization of the Museum's collections, and in galleries devoted to materials and techniques, as well as those dedicated to particular periods and places. By keeping its original intentions at its heart, the V&A continues to act as a sourcebook for contemporary designers and practitioners, and as a source of wonder and inspiration to the public. As the essays and objects featured in this book show, the story of handmaking in Britain is the story of periods of rise and fall, but one that is still very much alive today.

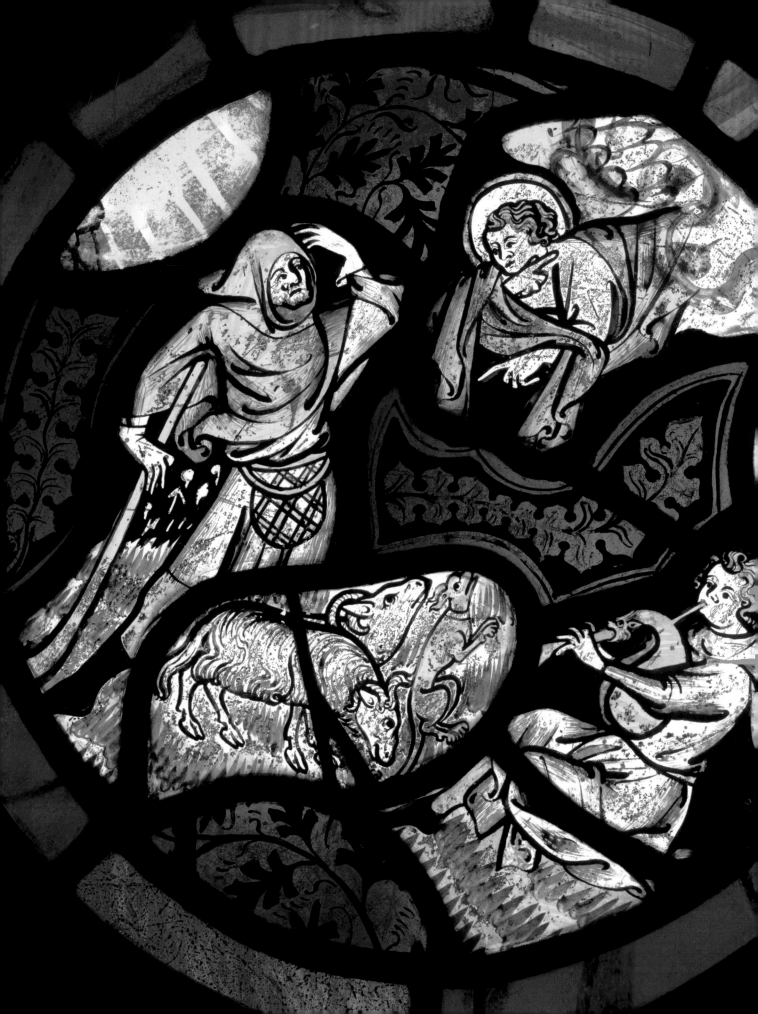

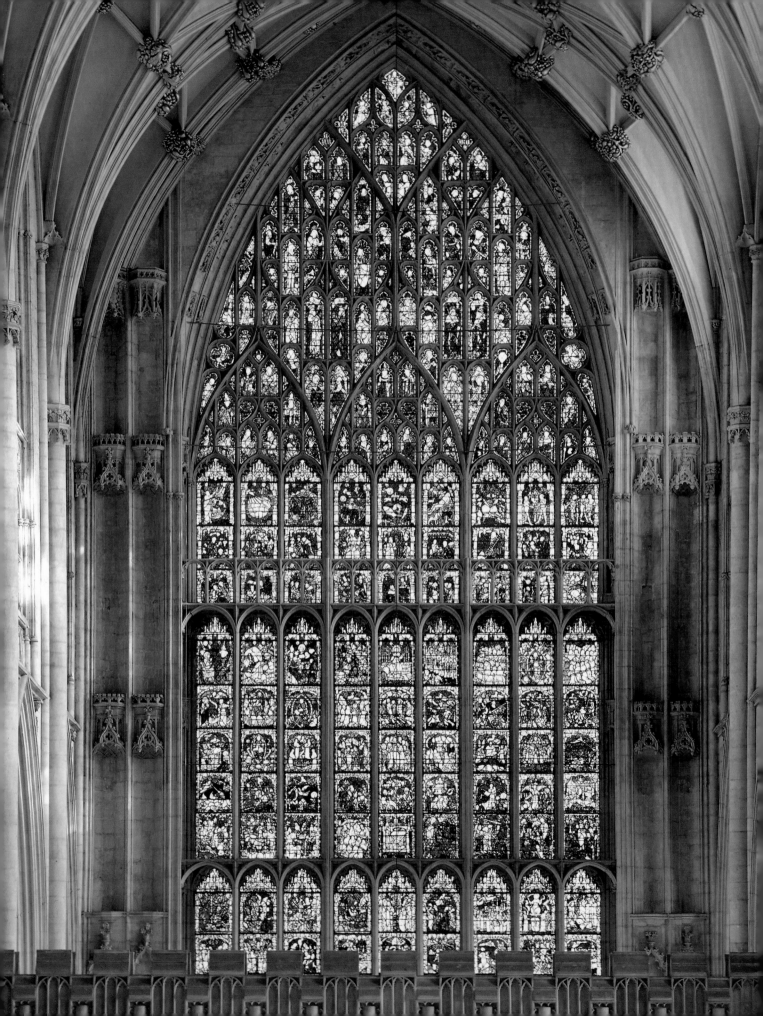

19
**The Great East Window of
York Minster** by John Thornton
Stained and painted glass
England, 1405–8

20
**God the Almighty, from
the Great East Window of
York Minster** by John Thornton
Stained and painted glass
England, 1405–8

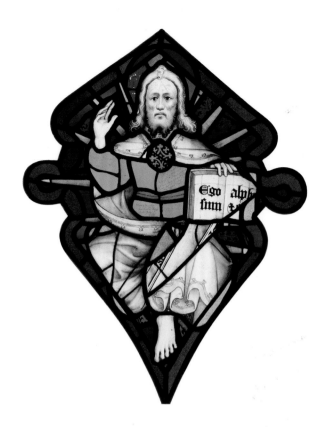

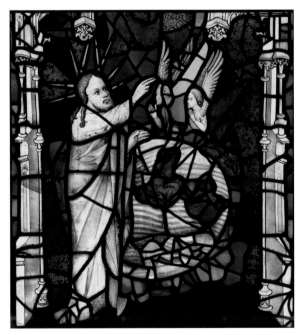

At the east end of York Minster stands the largest single expanse of medieval stained glass in Britain (pl.19). The Great East Window, executed by the glazier John Thornton of Coventry in just three years from 1405 to 1408, is a staggering feat of craftsmanship, made all the more extraordinary by the ambition of its subject matter. In 108 scenes the window describes the history of the Christian world, from the Creation to the Apocalypse. Taken from the first and last books of the Bible, these narrative episodes are surmounted in the window tracery above by the figures of saints, prophets, angels and, at the very apex of the window, God the Almighty, enthroned in majesty and holding a book bearing the words *Ego sum Alph[a] et[Ω]* (pl.20). These words, taken from the Book of Revelation, encapsulate the entire story of the window: *I am the beginning and the end.* But beneath the attendant ranks of heavenly hierarchy the first narrative scene of the Creation sequence reinforces the window's second message. Taken from the Bible's book of Genesis (1:3), it depicts the first day of Creation: God separating the light from the darkness with the words *Let there be light* (pl.21). This provides the key to the whole purpose of stained glass in sacred buildings: it illuminates, both physically and symbolically, the church of God's creation.[1]

While the Great East Window may be the largest surviving medieval stained-glass window in Britain and its unusual iconographic complexity is undeniable, it is far from unique for this period. Until the Dissolution of the Monasteries under Henry VIII (generally dated to about 1536–41) and subsequent phases of Protestant destruction of churches and their fittings, stained glass adorned many of the cathedrals and great churches of the country, casting light and colour onto their interiors. In the medieval church, stained glass served a didactic as well as aesthetic purpose, as one of the chief forms of narrative art. For a largely illiterate population, church

21
**The Separation of the Light
from the Darkness, from
the Great East Window of
York Minster** by John Thornton
Stained and painted glass
England, 1405–8

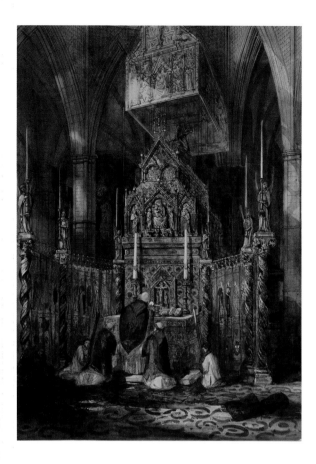

22
Reconstruction of the medieval appearance and setting of the Confessor's shrine at Westminster Abbey
by William Burges
Watercolour on paper
England, 1852
RIBA

imagery illustrated the Bible stories they could not read, but which taught them how they should live their lives and, most importantly, prepare for the eternal afterlife. The sixth-century pope Gregory the Great famously promoted this use of images in church, describing them as 'the Bible of the unlettered', thereby countering accusations of idolatry with the defence of didacticism.[2] But with the arrival of the Reformation, this defence was no longer tolerated. Although initially much stained glass was left unharmed, in contrast to the wanton destruction of other church furnishings, this was partly because it was functional rather than solely decorative; the clear glass needed to fill empty windows would have been extremely expensive. However, during later waves of iconoclasm reaching into the seventeenth century – particularly under the reign of Edward VI – much stained glass was eventually removed, meaning that what remains is only a fraction of what once existed.

This fragmentary survival makes looking at medieval stained glass today a very different experience from what it would have been at the time. While we often see it as an added flash of colour and narrative within otherwise quite plain church interiors, it would originally have been just one element of a decorated environment full of colour and imagery. Polychrome (painted) sculptures of saints, carved and painted rood screens, silver altar vessels and embroidered priests' vestments would, together with the glass, have created rich and vibrant interiors, further enhanced as a sensory experience by the use of music and incense and mobilized by the ritual movement of the clergy through the physical space of the church (pl.22).

Today, with the loss of many of these elements, we have only a partial picture of what the medieval British church would have looked like. To complicate matters further, the fragility of stained glass, which is permanently exposed to the elements, means that over the centuries much has decayed, been considerably restored or replaced with copies. Similarly, the expense of stained glass, combined with the need to repair it and the desire to refurbish church buildings in the latest style, led to the common practice of reusing old stained-glass panels, moving them to less prominent locations in the church when they were deemed old-fashioned and replacing them with more up-to-date panels. So what we see today is often a confusing – even misleading – signal of the original intent, even in those churches that retain a significant quantity of stained glass.

In England stained glass has been used to decorate church windows from at least the seventh century. The

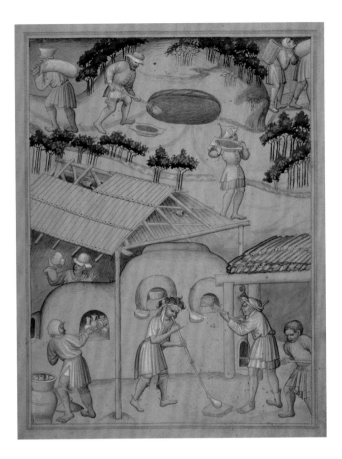

23
Miniature showing a forest glass-house, from *The Foreign Travels of Sir John Mandeville*
Ink and pigments on vellum
Possibly Bohemia, Germany or The Netherlands, 1420–50
British Library

first significant reference comes from Bede, the Northumbrian monk and theologian whose *Historia ecclesiastica gentis Anglorum* (completed in 731) relates the history of English Christianity up to that date. Bede writes that in 674 Benedict Biscop, Abbot of Monkwearmouth in Tyne and Wear, built a new monastery there, dedicated to St Peter. The earliest documented stone church in the North, it was built by masons from Gaul who were chosen for their superior skills and craftsmanship. In 675, according to Bede, the abbot sent messengers to Gaul once more, this time for *vitrifactores, artifices* – glass-makers, artists – required to glaze the windows of his new church, because there were none in England. This reference, together with glass fragments uncovered from archaeological excavations at the site of Monkwearmouth and at its twin monastery of St Paul in Jarrow (built in 682), provides evidence of the first use of window glass in Britain since the Roman period.[3]

The actual craft of stained glass has changed little over hundreds of years, as we know both from the evidence of surviving windows and from medieval art treatises, such as the early twelfth-century *De diversis artibus*, written by the pseudonymous monk Theophilus, and *Il libro dell'arte* by the Italian artist Cennino Cennini (*c*.1390). Both of these works were intended as practical handbooks for craftsmen working in a range of artistic disciplines, including glass-painting and (in Theophilus's work) glass-making. In the Middle Ages these would have been two separate practices: while glass-making was a technical, scientific process, requiring a kiln and specific natural resources, glass-painting was primarily an artistic endeavour. The glass-maker was responsible for making the glass and supplying it to the glass-painter, who was responsible for turning it into a finished window.

The glass itself was made by heating together in a furnace two key raw ingredients: sand and ash (either from wood or plants). At a sufficiently high temperature the sand and ash fuse to form liquid glass. As this slowly cools, it can be spun into large discs (a technique known as the 'crown' method), or blown into long bottle-like cylinders, which can then be split open and flattened into sheets (pl.23). This technique, described by Theophilus and known as the 'muff' or 'sleeve' method, can also be used to create domestic vessels by blowing and manipulating the glass into a range of forms, and is still used by traditional glass-blowers today. The basic glass was white, but it could be coloured by adding metal oxides such as cobalt (to make the glass blue) or iron (for green-yellow), becoming known as 'pot-metal' glass because the colour was added to the glass in a clay pot while in the

24
Vidimus for a stained-glass
window depicting the
Crucifixion and Resurrection
Pen and brown ink with watercolour
washes on paper
Probably England, *c*.1525–30
National Galleries of Scotland

kiln. Ruby (red) glass was created using a technique called 'flashing'. Because the copper oxide used to colour the glass red was very heavy, it made the glass too opaque to be of use in a window, which needed to retain its translucency. To avoid this, white glass was coated red on one side only, which not only enabled light to pass through, but also allowed for greater decorative possibilities, as the coating could be partially abraded to reveal the white beneath, creating two-colour patterns.

It is clear from archaeological finds that there were glass-houses working in this way on various sites in medieval England, such as at Blunden's Wood in Hambledon, Surrey. However, it is unclear how much of the glass found in medieval windows was actually made in England. No traces of coloured window glass have been found at any English glass kiln sites, and the textual evidence associated with particular commissions suggests that most (if not all) coloured glass, and even much white glass, was imported from Europe. Because of its high potash content, English glass easily corroded, and surviving contracts for stained-glass commissions sometimes directly specify that foreign glass should be used. In 1447 the King's Glazier, John Prudde, was instructed by Richard Beauchamp, Earl of Warwick, to supply the windows for a private memorial chapel in St Mary's Church, Warwick, in which Beauchamp's tomb would be placed. The contract stated categorically that the windows should be made from 'Glasse beyond the Seas, and with no Glasse of England'.[4] At two shillings per square foot (930 square centimetres), this was the most expensive commission known for any glazing scheme in fifteenth-century England, owing in part to the expense of the high-quality imported glass.[5]

Once the glass sheets were delivered to the glazier, the work of turning them into a window panel began. The process was not as simple as cutting and painting different pieces of coloured glass and joining them with lead; nor was it carried out by a single craftsman. Before the thirteenth century it is difficult to distinguish glass-makers from glass-painters, as both were referred to using the same name – *vitrearius* – but from then on the evidence suggests that most glazing workshops were small enterprises, consisting of a master glazier and one or two assistants, including an apprentice. In many cases the master was not personally responsible for painting the glass, but had control over the overall process, executing the cartoons (full-size working drawings) for the scheme and supervising the painters in his workshop. The contract to John Thornton for the Great East Window in York stipulated that he should 'portraiture[*sic*] the s[ai]d window with Historical Images & other painted work in the best manner & form that he possibly could', but this seems to have applied to the preparation of cartoons rather than the actual glass-painting, which Thornton certainly could not have executed single-handed during the three years in which he was to complete the commission.[6]

In order to prepare the cartoons an overall design for the whole window was made, known as a *vidimus*. This showed the chosen subject matter, artistic composition, colour scheme and the relationship of the windows to their architectural surroundings. This visual document was not only crucial for the painters in setting out the designs, but also often served as part of the legal contract between commissioner and glazier. Although often executed by professional draughtsmen, on occasion a *vidimus* might be made by the patron himself, to avoid any confusion about his intentions. Some *vidimuses* survive, including one in the National Galleries of Scotland in Edinburgh and a related album of 24 in the Musées royaux des Beaux-Arts in Brussels, all of which are thought to relate to projects commissioned by Cardinal Wolsey and dating from *c*.1525–30 (pl.24). In each of them watercolour washes show the intended

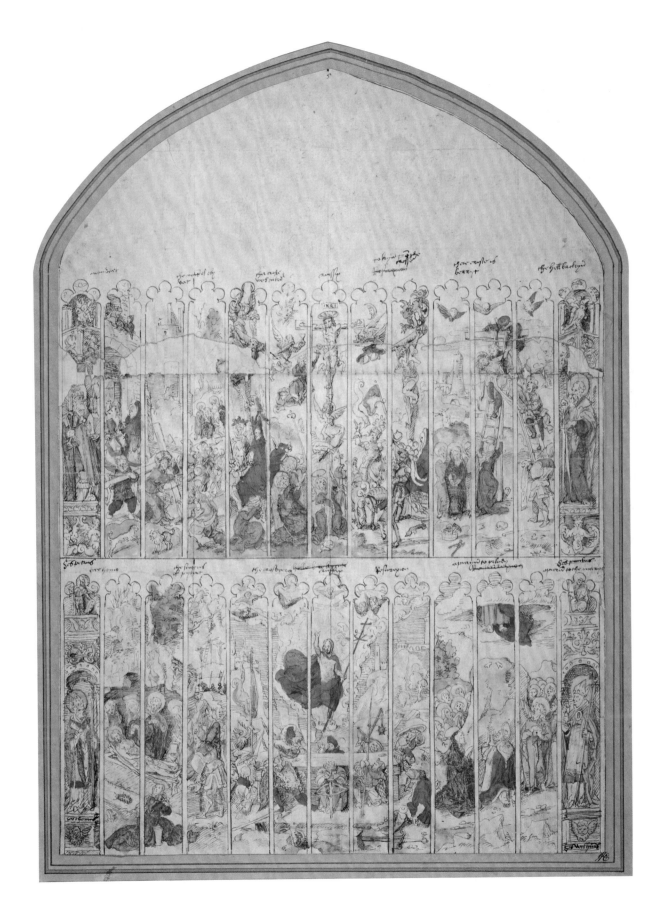

colours, pen-and-ink lines indicate the architectural masonry framework of the window, and textual annotations may denote changes made by the patron.

Once the *vidimus* was agreed and the cartoons (including leading lines) made, the glazier would follow them to cut the glass sheets into individual pieces of different colours, using a hot iron and trimming the edges of each piece with a grozing iron. He would then paint details of the design onto the interior surface of the glass pieces, using a pigment containing gum arabic that would bind with the glass when fired. Often the painting was carried out in stages: the outlines first, followed by varying degrees of detail. From the twelfth century onwards shading was sometimes added to the exterior surface of the glass to give a more three-dimensional effect. Once fired to secure the paint to the surface of the glass, the pieces were fixed in place with strips of lead, secured with nails and soldered together, creating a panel that could be inserted into a window.

Although today we tend to use the term 'stained glass' to refer to all coloured decorative glass, what we actually mean is both pot-metal and painted glass. Of the many glass fragments excavated at Monkwearmouth and Jarrow – more than a thousand – none show any traces of paint. Instead they comprise pieces of clear and coloured glass, with a spectrum ranging from different shades of blue through to red. From their shapes it seems that these individual pieces were originally set (as some have now been reset) into a colourful, purely decorative mosaic pattern in the church's small round windows (pl.25).

Although only a single fragment of painted glass survives from the early to mid-tenth century, and more from the eleventh to twelfth centuries, the earliest

surviving complete windows of stained and painted glass in England date from the twelfth century and are in Canterbury Cathedral in Kent. As the See of the most senior bishop in England, Canterbury was the most important church in the country. The glazing of the cathedral choir, consecrated in 1130, befitted its status: a contemporary, William of Malmesbury, marvelled at the choir windows, writing, 'no such thing is to be seen in the light of glass windows in England'.[7] Although a fire destroyed the choir in 1174, a second glazing campaign towards the end of the century resulted in a more significant and comprehensive iconographic programme. It consisted of a series of windows representing the Ancestors of Christ (more than 80 figures, beginning with Adam, of which 35 survive), two sequences of panels representing the Old Law and New Law, a series of Old and New Testament types and antitypes, a Last Judgement and a sequence of saints, in windows above the altars dedicated to them, culminating in the Trinity Chapel, which from 1220 housed the relics of St Thomas à Becket – the most valued possession of the Cathedral, which turned it into one of the most important pilgrimage sites in western Christendom. Extremely complex and yet coherent as a whole, the Canterbury windows are the most important early cycle in English stained-glass painting, setting the standard for subsequent schemes.

Several fragments of glass from the Canterbury windows are now in the V&A, having been removed in the nineteenth century and replaced with copies, as was common practice at the time. A panel from the series of the Ancestors of Christ represents the head of the Patriarch Semei (pl.26), and although it is not in its original state – existing only as a fragment set at a later

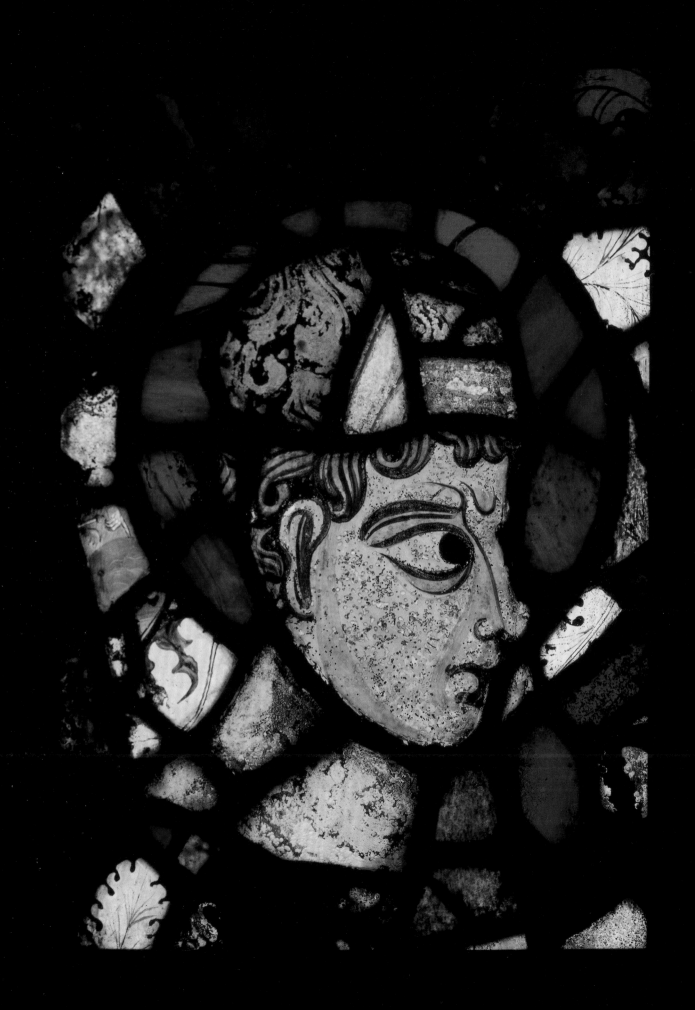

date into a composite panel of other fragments – it nonetheless reveals, like other figurative panels from the Cathedral, the clear flowing lines used to portray the patriarch's features, stylistically not dissimilar to wall or manuscript painting of the same period in Canterbury and Winchester.[8] Similarly, three fragments of ornamental border panels highlight the dominant stylistic influences from northern France at this time: one closely follows the design of a panel (also in the V&A) from the Abbey Church of Saint-Denis near Paris (pls 27 and 28). There are also certain chromatic similarities between the Canterbury windows and a set of panels originally from the Sainte-Chapelle in Paris, dating from the mid-thirteenth century (pl.29): both sets are characterized by their use of brilliant, jewel-like colours, predominantly deep blues and reds. They use only a limited amount of white glass, leading to an overall richness, with the narrative scenes seeming to emerge from a sea of blue.

However, the use of such rich colours in church windows caused certain problems. Although they beautified the church and added a means to present a narrative, they were very expensive and time-consuming to make, and did not allow a great deal of light into the church. One way of overcoming this was first explored in the Chapter House at York Minster at the end of the thirteenth century. Here, horizontal bands of coloured figurative panels alternate with bands of light-coloured decorative grisaille (painted in grey monochrome) panels – enabling the windows still to be used for narrative painting, but also permitting a greater amount of light through them. In addition the grisaille bands were cheaper and quicker to manufacture, as they involved simply painting onto

27
Border panels from Canterbury Cathedral
Stained and painted glass
England, c.1200–20
V&A: C.7 and 8–1959

28
Border panel from the Abbey Church of Saint-Denis, Paris
Stained and painted glass
France, c.1140–44
V&A: 5814–1858

l with four scenes, from
ainte-Chapelle, Paris
ed and painted glass
e, 1243–8
1222–1864

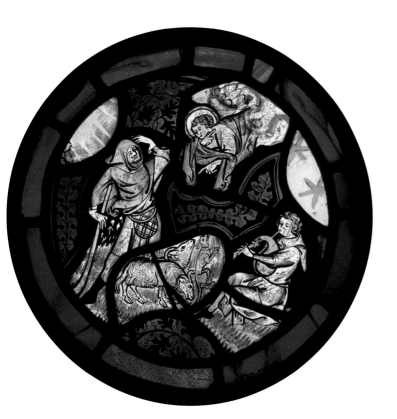

30
Annunciation to the Shepherds
Stained and painted glass
England, *c*.1340
V&A: 2270–1900

white glass, rather than cutting and leading discrete pieces of different colours. These 'band windows' were used as a common solution until a key technical innovation at the beginning of the fourteenth century: the adoption of yellow stain, which revolutionized stained-glass-painting. Known in Islamic Egypt since the tenth century, this technique made its way to western Europe at the end of the thirteenth century via Spain, and appears in surviving English windows from around 1307–12, the first dated example being in York Minster.

The yellow stain results from a silver-sulphide solution applied to glass before firing. This brought two key advantages: it increased the chromatic range available to glaziers, as they could create new colours with the yellow stain that did not previously exist; and the process had practical, stylistic and economic benefits – a single piece of glass could be partially stained and thus used for two colours. This was particularly useful when painting the faces and hair of figures, which could now be done on a single piece of glass, rather than two separate pieces (one white and one yellow), so the yellow stain saved time, lead and money. A roundel in the V&A depicting the scene of the Annunciation to the Shepherds (pl.30), and dating from the mid-fourteenth century, displays this clearly: yellow stain is exploited fully in the figures of the shepherds, angel, sheep and dog, all of which use both yellow and white on the same piece of glass.

Even more significantly, the yellow stain contributed to a shift in the way that stained-glass windows were conceived. Instead of the rich, jewelled tonalities of panels such as those at Canterbury and the Sainte-Chapelle, a greater use of white and lightly coloured glass led to more translucency and brighter interiors. This was probably partly due to economic considerations, as white glass was considerably cheaper than coloured pot-metal glass, but was also linked to developments in Gothic architecture and their impact on windows as part of the church building. This can perhaps be seen most spectacularly in the east window of Gloucester Cathedral (pl.31), dating from *c*.1350 and the largest window in the world at the time of its construction. The masonry structure has been reduced to the barest and thinnest of ribs, increasing the proportion of glass to stone and creating the effect of a translucent screen: a wall made of glass.[9]

These new architectural and translucent glass styles can be seen in three panels depicting the standing figures of St John the Evangelist, the Prophet Ezekiel and St James the Less made for the chapel of Winchester College in the 1390s (pl.32). Just as at Gloucester, the predominant 'colour' here is white; while blues and reds are still used, they are complemented by more subtle colours, such as earthy brown and olive-green, and appear in far smaller quantities than the white or

yellow stain that makes up the flesh tones and robes of the figures and the architectural surrounds.

Originally these figures were placed on the north and south walls at the east end of the chapel, as part of a scheme that comprised figures of the 12 prophets placed above those of the 12 apostles.[10] The main east window depicted the genealogy of Christ through the Tree of Jesse, so the choice of prophets and apostles – the foretellers and first followers of Christ – was suitable for the windows that flanked it. The panels (removed and replaced with copies in the nineteenth century) not only demonstrate the marked shift in tonality that arose as a result of the introduction of yellow stain, but also

31
East Window of Gloucester Cathedral
Stained and painted glass
England, c.1350

32
St John the Evangelist, the Prophet Ezekiel and St James the Less, from Winchester College Chapel,
probably by Thomas Glazier of Oxford
Stained and painted glass
England, c.1393
V&A: 4237–1855

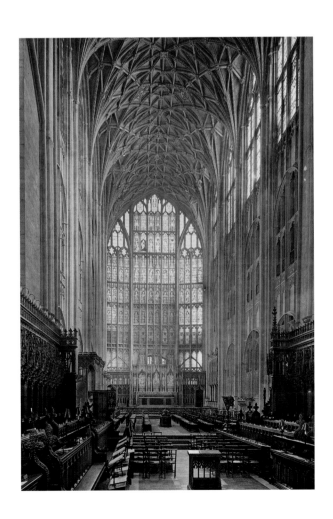

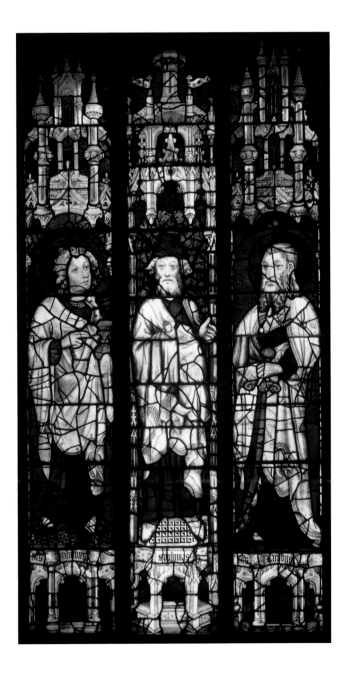

St Thomas à Becket, in the
Beauchamp Chapel at the collegiate
church of St Mary, Warwick,
by John Prudde
Stained and painted glass
England, 1447–9

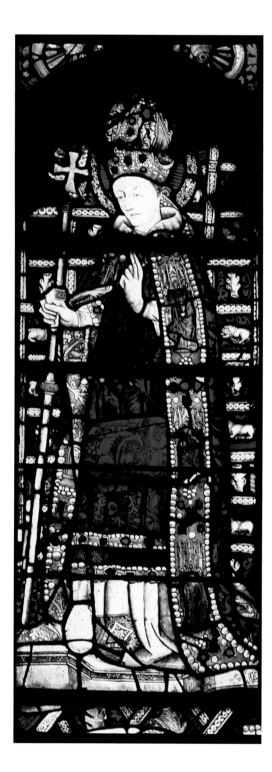

highlight the growing levels of sophistication in the art of glass-painting. Thought to have been made by one of the foremost stained-glass artists of his time, Thomas Glazier of Oxford, the panels were commissioned by William of Wykeham, Bishop of Winchester and Chancellor of England to Edward III and Richard II. One of the richest and most powerful men in England at certain periods in his life, Wykeham was responsible for the foundation of two important educational institutions: Winchester College and New College, Oxford, for which Thomas Glazier also supplied the windows.

The Winchester panels display considerable artistic sophistication: both the figures and the architectural niches in which they stand are convincingly three-dimensional, in a way not previously seen in English stained-glass-painting. The use of architectural canopied settings, usually containing single standing figures, seems to have appeared in stained glass around the end of the twelfth century – in the Chapter House at York Minster, for example – although in their earlier manifestations they showed little sense of depth. Here, in line with contemporary developments in the other pictorial arts, there is clearly an attempt to create a sense of perspective and different planes. Surmounted by pinnacled canopies, each slightly different, the architectural surrounds are not merely decorative framing mechanisms for the figures, but also give the impression of three-dimensional spaces, out of which the figures seem to step. Similarly, the figures themselves have a far greater bodily presence than was seen in earlier windows. Their facial features appear more realistic and their draperies more dynamic, thanks to the use of careful and subtle shading and stippling, which give them a convincing physicality.

The Winchester scheme, with its use of perspective and more realistic modelling of the figures, represents a turning point in stained-glass-painting in England and paved the way for later works, including those of John

Thornton at York Minster. It also highlights the growing tendency for an ever-greater proportion of clear to coloured glass in church windows, which would last until the Reformation and can be seen in some of the most impressive and extensive surviving glazing schemes, such as those at Great Malvern Priory and the chapel of King's College, Cambridge.

Exceptions to this shift can be found, however, most notably in the Beauchamp Chapel in St Mary's, Warwick, where the extraordinary expense of the commission is reflected in the lavish quantity of coloured glass. White glass is used almost exclusively for the flesh tones; everywhere else is colour, whether ruby, blue or yellow. The impression of richness is further compounded by technical virtuosity, as the haloes and robes of the figures depicted in the windows, such as St Thomas à Becket, are decorated with 'jewelled' inserts that imitate the use of glass or paste jewels on contemporary clothing (pl.33). 'Jewelling' was an extremely demanding process, as it required the glazier to drill a hole through one piece of glass in order to insert a smaller piece, in a contrasting colour, and then secure it with leading.[11] Although it can be seen in other windows of the time, it was used in the Beauchamp Chapel windows to an unprecedented degree, reinforcing the expense and status of the commission.

Commissions such as this provide us with an insight into the motivations of the patrons and donors of stained-glass windows, who included the monarch, the ecclesiastical hierarchy, the nobility and, increasingly towards the end of the Middle Ages, the gentry and merchant classes. In some cases one patron might pay for the glazing of an entire church or chapel, as Richard Beauchamp did. It was more common, though, for churches to contain a host of windows donated by different patrons at different times – the size, complexity and location of the windows often mirroring the status of their donors. On an institutional level, guilds and lay religious confraternities frequently commissioned stained glass to represent their companies, as in the Church of the Friars Minor in the City of London, to which the Fishmongers', Vintners' and Drapers' Companies are all known to have given windows.[12] During the course of the Middle Ages the social diversity of stained-glass patrons increased. The church of Long Melford in Suffolk provides a prime example of this. Rebuilt in the second half of the fifteenth century and subsequently glazed, it was largely financed by a rich clothier named John Clopton, who died in 1494. His role reflects a gradual increase in commissions from rich merchants over the fourteenth and fifteenth centuries, largely due to the rise of the English export trade in woollen fabrics, which also resulted in increased economic prosperity in new regional urban centres, such as Colchester, Reading and Coventry.[13]

Ultimately many commissions had similar motivations, whoever the donor. Artistic patronage in all forms was regarded as an obligation of medieval kingship – and thus a model for citizenship – as a means of projecting an image of permanence and stability. It was particularly important within the church, where it was seen as a means of piously honouring God. Balanced with this was the desire of individuals for commemoration, and for the expression and display of personal or institutional status and wealth through art. Stained glass commissioned for this purpose was a very public statement, as the church was a key communal focal point for everyday life. Surviving windows reflect this desire for self-promotion in a public context, often including a portrait of the window's donor. In York Minster, Bishop Walter Skirlaw appears kneeling at the base of the Great East Window, which he commissioned; another window on the north aisle of the nave also depicts its donor – the wealthy goldsmith and bell-founder Richard Tunnoc, who served as a bailiff and mayor of York – presenting his window

to St William of York (pl.34).[14] The chapel of Merton College, Oxford, shows the donor Henry de Mamesfeld in each of the 12 chancel windows, not once, but twice.

Linked to the desire for commemoration, but of far more serious importance to the pre-Reformation mind, was the thought of Purgatory. In a period dominated by the ravages of the Black Death, mortality and the afterlife were the foremost concerns of medieval life. According to the doctrine of Purgatory, at the moment of death Christian souls could go in one of three directions. If they had led a sin-free life, they went straight to eternal Paradise. If they had committed mortal sins for which no forgiveness was possible, they went straight to everlasting Hell. If, however, like the majority of the population, their souls were neither perfect nor irredeemable, they would be subject to a certain period of time in Purgatory – a place or state of cleansing that would purify them and equip them for their subsequent passage to Paradise. However, this period of time was not set, as it was believed that a soul's stay in Purgatory could be eased through the prayers of the living, and for this purpose stained-glass windows were important, especially if they were located in parts of the church used by the laity, such as the nave. Here the heraldry or figure of the donor,

usually represented kneeling in prayer, would remind the congregation to pray for his soul and thus aid him on his path to salvation.

Aside from the representations of donors, specific motivations dictated the choice of subject matter for stained-glass windows. Certain subjects were particularly common. Individual figures of saints were often depicted, particularly as the tall, narrow windows of later Gothic architecture lent themselves to single standing figures in self-contained niches. The choice of saints frequently reflected the preferences of the donor, such as at St Mary's, Warwick, where Richard Beauchamp selected those saints associated particularly with the Lancastrian dynasty that he had loyally served during his lifetime.[15] The subjects of pilgrimage windows, such as those at Canterbury and York, were obviously dictated by the saint whose relics they honoured. In Canterbury the St Thomas à Becket cycle included just two episodes from the saint's life, but 10 scenes of miracles worked posthumously by him, demonstrating to pilgrims the potential benefits they might also enjoy. In York Minster a cycle commissioned by the wealthy Ros family of Helmsley (and probably executed by John Thornton) depicts the story of St William of York in 95 scenes, from

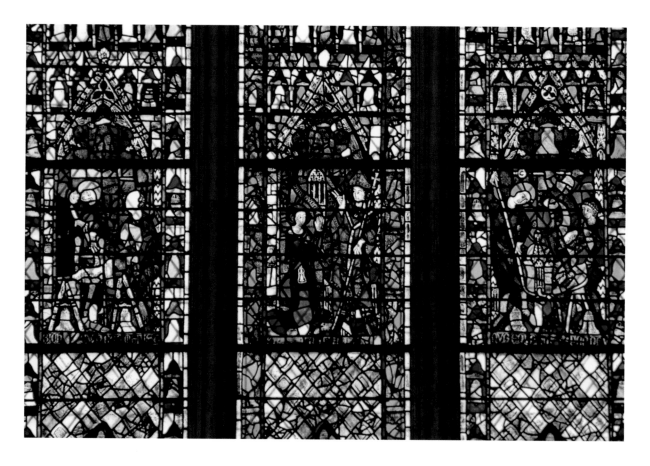

his birth to the occurrence of miracles at his shrine in the
Minster. Like the Becket cycle at Canterbury, this was
specifically intended to encourage the cult of St William
as a local saint (which previously York had lacked) and
to emphasize the physical as well as spiritual benefits
of visiting the Minster.[16]

Other subjects for self-contained cycles followed the
teachings of the catechism, such as the Seven Sacraments
or the Seven Acts of Mercy. Narrative scenes took their
inspiration from the Old or New Testaments, often
presented as a series of types and antitypes: Old Testament
events prefiguring those of the New Testament. Cycles
depicting the life and passion of Christ were popular, and
might be paired with a life of the Virgin. Frequently, as
at Canterbury, a whole scheme would be commissioned
comprising several different elements, to build up an
intricate iconographic programme. Nonetheless the level
of narrative and iconographic complexity seen in the
Great East Window in York is particularly unusual. As
well as the individual figures of the heavenly hierarchy
who appear in the tracery, and a series of enthroned
figures along the base representing the history of
the church in York, the window represents two major
narrative sequences: the Old Testament story of the
Creation, and the Apocalypse or Last Judgement. The
latter is noteworthy as a representation in stained glass
– it was far more common for the Last Judgement to
appear in the form of a wall painting, known as a 'Doom'
and painted above a church's chancel arch, as a reminder

of mortality and the need to prepare for death by living
a good life. The narrative choices made for the Great East
Window are perhaps particularly surprising given its
location – the east end of the Minster would have been
accessible solely to the clergy, so the laity would only
have seen it from afar, rendering its complex detail
difficult to decipher. It is noticeable that, in his visual
representation of the biblical scenes, Thornton seems
to have taken this into account, by placing particularly
important scenes in the central light of the window
whenever possible, or by reinterpreting Bible texts to
make them visually clearer.

Whatever input Thornton may have had into such
aspects of the design, it seems highly likely – given the
extremely short period in which the window was to be
completed – that his patron, Bishop Skirlaw, would have
given him a textual or visual source to use as a model.
Although we know of no direct model for the Great
East Window, the Apocalypse appears in numerous
illuminated manuscripts of the time. The relationship
between stained glass and such manuscripts has often
been remarked upon, and examples of particular panels
bear comparison. The Annunciation to the Shepherds
roundel in the V&A has similarities with images from
several illuminated manuscripts, including the De Lisle
psalter and the Queen Mary psalter, both dating from
c.1310–20 and now held in the British Library. Similarly,
the so-called 'monkey's funeral' border of the Pilgrimage
Window in York Minster from c.1325 (pl.35) recalls the

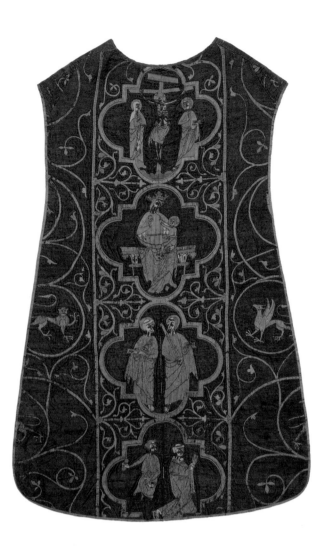

36
**The Clare Chasuble
(with details below)**
Silk and cotton, embroidered
with silver-gilt
England, 1272–94
V&A: 673–1864

37
**Page from the *Biblia Pauperum*
showing the Resurrection,
flanked by Solomon with
the gates of Gaza and
Jonah and the Whale**
Woodcut on paper
The Netherlands or
Germany, *c.*1465
V&A: E.714–1918

fanciful animals and other creatures found in the borders
of illuminated manuscripts.[17] It should be noted that
illuminated manuscripts are not the only other form of
art to share design elements with stained glass: had not
virtually all medieval wall paintings been destroyed or
whitewashed during the Reformation, more parallels
might be found in large-scale painting as well as small-
scale illumination. In addition there are stylistic links
between stained glass and monumental brasses with
architecture, and with textiles, such as the Clare Chasuble
in the V&A (pl.36), whose quatrefoil scenes against a
ground of foliated scrolls seem to echo those of the
windows of York Minster chapter house.[18]

In the Middle Ages an increasing number and
variety of textual and pictorial sources became available
to glaziers, due largely to the introduction of printing.

Particularly popular works included *The Golden Legend* (*Legenda Aurea*), a collection of saints' lives compiled around 1260 by the Genoese chronicler and archbishop Jacopo da Voragine, which served as one of the key sourcebooks for late-medieval and Renaissance story-telling across the visual arts. In addition manuscripts could be used to provide source material for the stories of saints, particularly those who were less well known or locally important, such as St Cuthbert of Durham or St William of York.

Of the visual sourcebooks available, the ones most commonly used were the *Biblia Pauperum* and the *Speculum Humanae Salvationis*. First published in the Netherlands in *c.*1464–5, the *Biblia Pauperum* (pl.37) was a block-printed image Bible, with very little text, widely disseminated throughout Europe and hugely influential across a range of artistic disciplines. The *Speculum*, dating from *c.*1309–24, had more text, but was still influential for its images. Both books were clearly used by glass-painters as iconographical sourcebooks, as the evidence of surviving windows at Holy Trinity, Tattershall, and Great Malvern Priory show. Often several sources

were combined, as at King's College Chapel, Cambridge, where some windows take elements from the *Biblia Pauperum*, others from the *Speculum*, and still more from engravings by Albrecht Dürer and other printmakers.

In addition to the dissemination of print sources, a growing familiarity with European painting – thanks to the immigration of foreign craftsmen and the acquisition by patrons of artworks abroad – added to the visual sources available for stained glass. The 1468 marriage of Margaret (sister of Edward IV) to Charles the Bold, Duke of Burgundy and ruler of the Low Countries, increased awareness of Flemish painting in Britain and made available more Netherlandish books, including the *Biblia Pauperum*. Similarly, the 50 years before the Reformation saw an unprecedented rise in the number of immigrant glaziers, originating predominantly from the Netherlands and patronized by the court. We know from Bede's account of the glazing of Monkwearmouth – and from later examples, such as that of 1449, when John Utynam from Flanders was granted a monopoly to supply coloured glass for the chapels of Eton College and King's College, Cambridge – that there were foreign glass-workers in

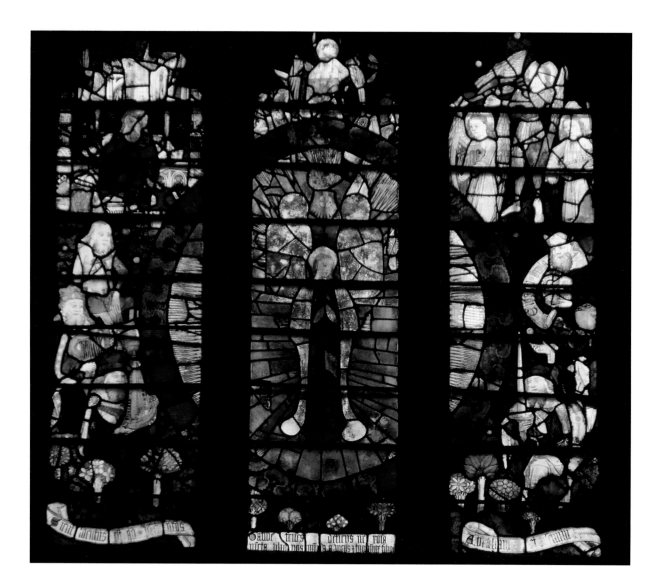

England from as early as the eighth century.[19] Until the end of the fifteenth century, however, these seem to have been relatively isolated instances. The Glaziers' Company, which regulated the craft in the City of London, only registered its first complaint against 'alien' glaziers in 1474, when there were already more than 28 foreign glaziers practising in the City.[20] The effect of this sudden influx was highly significant, because these craftsmen were being patronized by the court – and, as such, were receiving the most influential commissions.

In artistic terms this meant the arrival of a completely new approach to making stained-glass windows, which ultimately heralded the end of British medieval glass-painting. From surviving evidence it seems that English glass-painters were reluctant to allow their compositions to run across the mullions between individual lights in a window, meaning that narrative scenes – even in a monumental composition such as the Great

East Window – were all represented as individual, self-contained elements. The only surviving example by English glass-painters of a pictorial window that crosses these masonry divisions seems to be the *Magnificat* window of Great Malvern Priory, dating from 1501–2 (pl.38).[21]

Foreign glaziers had no such compunctions. Their works from the beginning of the 1500s show a rejection of the traditional relationship between stained glass and its architectural framework, in favour of a pictorial conception that traverses the masonry to create a single, unified composition taking up the entire window space. This can be seen both in the *vidimuses* in Brussels and Edinburgh (probably executed by a Netherlandish craftsman called James Nicholson) and in the surviving windows of King's College Chapel and of Fairford Church in Gloucestershire. In particular, in its busy composition and disposition of figures and elements across the

individual lights, Fairford demonstrates an awareness
of the monumental works of panel-painters such as
Jan van Eyck and Hans Memling, and perhaps a desire
to rival their achievements in glass.[22] With their sophisti-
cated approach to design, their application of the
compositions of panel-painting to glass, and their
introduction of Renaissance elements, glazing schemes
such as those at Fairford and King's College put an end
to the traditions of medieval stained glass – an end that
would in any case be unequivocally imposed just a few
years later by the Reformation.

The devastating effects of the Reformation were such
that the craft of stained glass would never fully recover
in England. Not only was existing stained glass defaced
or destroyed, but the mistrust – even abhorrence – of
imagery in churches meant that no new glass windows
were made for sacred settings, which endangered the very
craft of the glazier. Although commissions for secular
and heraldic glass for domestic settings continued (pl.39),
just as they had existed alongside sacred commissions
for many years, they could not even begin to satisfy
the demand for work from the number of glaziers now
working in England, whose livelihoods became extremely
precarious. Contemporary records recount tales of
glaziers on the poverty line, barely able to survive in the
absence of their chief source of employment. Although
attitudes changed during the reigns of James I and
Charles I, when attempts were made to revive traditional
devotional practices and ecclesiastical decoration, the
revival was short-lived, as the Civil War was accompanied
by an even greater wave of destruction.[23]

In subsequent centuries there were liturgical and
aesthetic reasons why stained glass was not revived.
With rising levels of literacy and the greater emphasis
that Anglicanism placed on the individual reading of the
Bible and the Book of Common Prayer, stained glass was
no longer so appropriate: rather than colourful picture

windows, churches needed as much light as possible and therefore required clear glass. In addition, medieval pot-metal glass was supplanted from the seventeenth century by clear glass painted with enamels. This was partly caused by problems of supply, created by the destruction of coloured glass-houses in Lorraine, but was also due to the artistic and economic advantages of enamel paints, which provided glass-painters with a broader colour palette as well as the ability to paint on large rectangles of cheaper clear glass (see pl.39). These factors, combined with the reduced need for lead (which now served a purely functional purpose, rather than being an integral and decorative part of the design), meant that glass-painting became conceptually less autonomous as a discipline and more likely to be practised by non-specialist painters, leading to a further decline in the craft.

Only in the second half of the eighteenth century, with the beginnings of antiquarianism and the popularity of the 'Gothick' style, did medieval and Renaissance glass begin to appear significantly desirable again, primarily to collectors. Antiquarians and collectors such as Horace Walpole and William Beckford acquired panels of medieval stained glass while making their 'Grand Tour' on the continent. The destruction of religious buildings in France during the Revolution led in particular to large quantities of stained glass arriving on the art market. Enthused by their acquisitions, and seeking to integrate them into antiquarian architectural schemes such as Walpole's Strawberry Hill in Twickenham (pl.40), these collectors commissioned contemporary glass panels to complement their 'ancient' pieces, leading to the first serious interest in the way medieval glass had been made.

This interest gained particular momentum with the Gothic Revival during the reign of Queen Victoria, when thousands of churches were constructed or restored in the medieval style. Championed by politicians, architects and critics such as A.W.N. Pugin and John Ruskin, the Gothic style was seen as the most Christian and authentically British artistic and architectural mode. For Pugin and others, design was a deeply moral issue, and good design could only result from a good society. Gothic, they argued, was the sole British style that could be considered truly moral, because it pre-dated the Reformation and the subsequent rise of capitalism, which they perceived as having led in their own age to a materialistic, unchristian society.[24] Not only were huge numbers of churches built or refurbished in the Gothic style, but so too were many grand civic buildings, most

impressively the new Palace of Westminster, designed by
the architect Charles Barry, assisted by Pugin himself.

Stained glass was key to re-creating authentic-feeling
medieval environments. As a result of the restoration of
much medieval glass, as well as experimentation with raw
materials, by the mid-nineteenth century a new kind of
'antique' glass was being produced, which for the first
time in centuries could genuinely be called pot-metal
glass. In design terms, however, its use was heavily reliant
on the direct imitation of medieval windows, and it was
only with William Morris (and the broader Arts and
Crafts movement) that stained-glass painting would
reach a level comparable to anything seen since before
the Reformation. Morris may not have shared all of
Pugin's concerns, but he fervently believed that beautiful
objects could only be made by craftsmen who found
pleasure and beauty in the act of creating them. For
Morris, this was impossible in the industrial age of the
specialized labour force, where speed and uniformity
were paramount; instead it necessitated a return to the
medieval concept of the individually creative craftsman.
Small workshops were set up as a reaction against large
industrialized factories, and used traditional manufac-
turing techniques in a range of artistic disciplines. The
panels manufactured by Morris, Marshall, Faulkner &
Co. (established in 1861), often to designs by artists such
as Edward Burne-Jones and Dante Gabriel Rossetti, were
made using the recently revived techniques of stained
glass. They also represented a stylistic move away from
the mere copying of medieval glass, towards a new
freedom and subtlety of artistic approach. Rather than
turning to specific medieval windows for direct models,
Burne-Jones and others sought to evoke the spirit of
medieval glass in their own designs, using a distinctive
figural style and a subtle palette that set their work
apart from that of their historicist predecessors and
contemporaries, and showed that stained glass was not

confined to the past, but could serve as a modern
artistic medium (pl.41).

Although stained glass may be less prevalent today
as an artistic medium than it was in the Middle Ages, it
nonetheless remains present. The work of stained-glass
artists can now be found not only in churches, but in
secular, corporate architectural projects – most notably in
the work of Brian Clarke, whose 'brilliantly orchestrated
grids of colour' show a complete understanding of
stained glass as a medium of light, and of the fundamental
relationship between stained glass and its architectural
context.[25] If there was any doubt about the relevance of
stained glass in the twentieth and twenty-first centuries,
that doubt disappears when looking at perhaps the most
significant stained-glass commission of the twentieth
century, which paved the way for artists such as Clarke
and others.

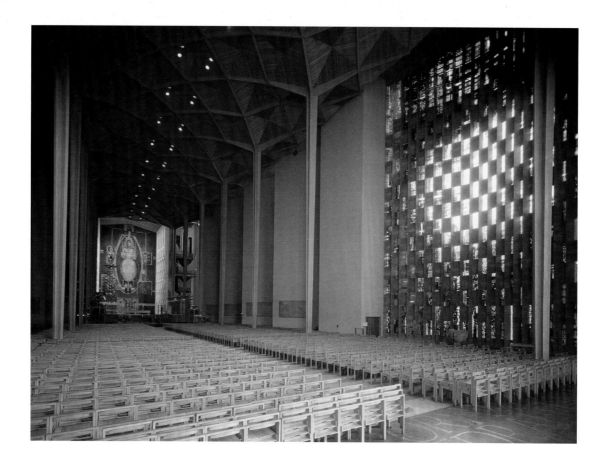

Coventry Cathedral, bombed during the Second World War, is one of the most symbolic buildings of the post-war reconstruction period (pls 42 and 43). The construction of the new cathedral in Coventry, to a scheme by the architect Basil Spence, involved contributions from some of the leading artists and designers of the time. The huge tapestry of Christ that hangs at the liturgical east end of the new cathedral was designed by Graham Sutherland, while Hans Coper made the monumental ceramic altar candlesticks (see Chapter 3). For the windows of the new baptistery the designer was John Piper, who had already been engaged as an Official War Artist to record the devastating effects of the bombing of the old cathedral. Piper had previously collaborated with the stained-glass artist Patrick Reyntiens on windows for Oundle School, and it was with Reyntiens that he again chose to work. From a young age Piper had been profoundly influenced by medieval stained glass, as his writings reveal:

> Ever since I was taken to Canterbury Cathedral as a child, my heart beats faster when I see blue glass in church windows, especially when it predominates in a window in the thirteenth-century manner … That excitement, that heightening of emotion always occurs: the blue seems to be there in the

window, firmly there in its painted glass form, and yet not there at all, except as a symbol of infinity, but infinity that has become intensely real instead of an abstraction.[26]

At Coventry this influence becomes abundantly clear. Not in Piper's design, for it is entirely abstract, with no narrative content; but in concept and inspiration. The palette displays the rich reds and blues so familiar from Piper's beloved thirteenth-century windows, just as visible in a scale model (pl.43) as in the final window itself. Knowing that no narrative subject would easily be able to cross the thick, heavy masonry framework and still be comprehensible to the viewer, Piper decided to go back to the fundamental essence of stained glass as the illuminating medium of the church. As he wrote, it is 'a blaze of light, framed and islanded in colour; a blaze of light symbolizing the Holy Spirit'.[27]

42
View down the nave of Coventry Cathedral,
designed by Basil Spence, showing the Baptistery window by John Piper and Patrick Reyntiens, and the tapestry of Christ in Glory by Graham Sutherland

43
Model for the baptistery window of Coventry Cathedral,
designed by John Piper and made by Patrick Reyntiens
Wood and stained glass
England, 1962
V&A: C.63–1976

Caroline Benyon

Born 1948. Lives and works in Middlesex.

Can you tell us how your making begins?
I studied with my father, Carl Edwards, and worked for Moira Forsyth. The largest new window that I worked on during my apprenticeship was my father's Great West Window in Liverpool's Anglican Cathedral, which I mostly painted, with its three 16-metre (52-foot)-high lights and 9-metre (30-foot)-wide fanlight, including slab glass, and the leads up to 4 centimetres (1½ inches) wide. I assisted Moira Forsyth on smaller commissions in the adjacent studio to mine at the Fulham Glass House by cutting her glass, which she painted with feathered strokes made with ichneumon brushes. Moira drew her cartoons with charcoal, and my father drew with precision in pen and ink. 'Paint what is there, not what you think is there' was the repeated instruction as he passed through the workshop. They both took different routes to achieve the same purpose – the modulation of transmitted light – and developed their own palettes and methods along the way, as all artists should.

I realized my apprenticeship was complete when Rowan LeCompte, the American artist, wanted my father to manufacture a large clerestory window to his design for Washington Cathedral. I was handed a postcard-sized copy of the design and told to make it, and during the process I was amazed not only by how much I had learned, but by how much I enjoyed making the window.

I have been working with my hands since I was a child and derive great pleasure from doing so, and I would not like that fact to be underestimated. A stained-glass studio may be a hard-edged environment to work in, but it is my natural habitat. Restoring nineteenth-century rose windows was an informative experience for me: taking them apart and understanding why some glazing was successful and some failed.

What are your preferred raw materials?
I acquired an archive of mouth-blown slabs and English Antique glass – no longer made in this country – from the Fulham Glass House after my father had incorporated the Arts and Crafts firm of Lowndes & Drury into his studio. Changes in taste over the last 100 years had resulted in different types of glass being abandoned at the rear of the building, and sourcing old glass has now become an obsession of mine. I have found it in a variety of places – including a stock of slabs that had remained unused in a cellar for 50 years. I mix the old glass with modern, mostly from Germany, but also from France.

The variegation, or gradation, of English Antique glass as it changes in depth of colour across each sheet offers the glass-cutter great opportunities to enliven a window, along with streaks, which are created by mixing metal ores with a clear base glass, and odd imperfections (including random bubbles suspended in each sheet to hold or refract the light). The selection of the glass impacts on the style of glass-painting or surface decoration, as a painted line may hold on a quiet, even glass, but may need the support of additional parallel lines or tone when applied to a more visually active or diffusive glass, such as Norman slabs.

The spatial movement of warm and cold glass in different light conditions, the optical mixing of certain colours if not separated with deep tints, the massing and spreading of blues and rubies, and the reaction of neutral passages to primary and secondary colours are just a few of the technical problems that uniquely concern stained-glass craftsmen. Most can be resolved with experience.

What are your main technical challenges?
Techniques for glass painting are as diverse as those employed by canvas painters, and all manner of implements can be used to achieve the required results. Their application depends on the glass-painter's ability to draw, as every mark or scratch must be executed with control, precision and for a reason.

Medieval cathedral windows would have been impossible to understand because of the effects of halation (a blurring of light around bright areas), had the craftsmen involved not been masters of modulating transmitted light using glass selection, lead cames or strips, and glass paint. Although some modern artists use opaque glass to obtain an optical stillness, I prefer the controlled movement of pure colour, enabling the glass to sing and achieve the scintillation of jewels – from a distance.

A patina of time and the effects of corrosion also modulate the passage of the light through the glass, and cause ancient glass to glow. While restoring old glass, nineteenth-century painters attempted to reproduce the diffusing effects of a patina on new glazing, using a variety of antiquating techniques. It was their demand for a new mouth-blown glass, to reproduce the qualities of old glass, that led to a transformation of the

right
Detail of the window of
The Life of St Columba
and the Virgin Mary,
St Albans Cathedral
Stained and painted glass
England, 2006

below
Detail of the Charter
window, of the Temple
Church, London
Stained and painted glass
England, 2007/8

glass-manufacturing industry, to the later benefit of designers.

The continuing improvement of glass during the nineteenth century provided Edwardian designers with the finest-quality mouth-blown glass, as well as the widest palette ever manufactured in Britain. Norman and Priors slabs – both types of bottle glass – had excellent diffusing qualities that impacted on painting techniques, and as the twentieth century progressed, the increased damage of smog and acid rain to the exterior surface of stained glass were better understood, and some designers compensated for the accelerated decay of the glass by adapting their designs accordingly.

The effect of transmitted light on ancient glass became apparent to students visiting medieval glazing schemes in the nineteenth and early twentieth centuries, before the invention of colour transparencies and colour reproduction in books. They recorded windows by painting watercolour studies,

and inevitably noted the sun's impact on the glass as it constantly changed its position and intensity. A single photograph of a window may identify its subject matter, but it will fail to satisfy those wishing to understand properly how it works, just as a single Muybridge photograph explains nothing about human movement. It is essential to visit a window under different light conditions – and not to judge it by the same criteria that you would apply to a canvas, painted and lit by reflected light. Scale and the impact of viewing distance on the realization of a design are also of great importance. The glass-painter's skills in these circumstances are similar to those of a theatrical scene-painter, whose work will make little sense when viewed close up – but comes together from beyond the footlights. A window far from the eye will be painted differently from one seen close to. In desperation, I have drawn a chalk line across the floor of my own studio, which clients may not cross when they come to view a finished window. If they stand as close to the glass as possible, all sense of the design is lost.

far left
Detail of the East Clerestory
window of the Temple
Church, London
Stained and painted glass
England, 2008

left
Detail of the window of
The Life of St Columba
and the Virgin Mary,
St Albans Cathedral
Stained and painted glass
England, 2006

Do you think of your work as being part of a heritage?

I am familiar with Constantin Brancusi's saying that 'Nothing can grow under large trees', but designing and making stained glass is a unique process. I feel supported by the designers and craftsmen I have met and worked with, rather than restricted by them. Many different voices enrich my thoughts as I design or work on the bench, including those of my father, his master James Hogan (to whom he often referred) and, through him, his master John Brown, who worked for William Morris prior to his move to Merton.

The acquisition of whatever design and craft skills I possess took place through a process of osmosis, achieved by working, watching and listening alongside experienced craftsmen and designers. I think of the continuation of tradition as inspirational, rather than as a negative force that strangles creativity, but mine is only one approach to stained glass, which has many different designers working in a variety of different styles and under different circumstances.

Having said all that, while stained glass may no longer be a mainstream decorative or public art as it used to be, referring to it simply as a 'heritage craft' does it an enormous disservice; it is very much alive. Some people have begun to call it 'architectural glass', in an attempt to shake off associations with the Victorian era, but that ignores the rich variety of approaches to stained-glass design and manufacturing that took place throughout the nineteenth century. Georgian or Arts and Crafts glass is very different from the stereotypical, dull and heavily matted windows that are simplistically associated with Victorian stained glass.

How does your work relate to art, craft and design?

Stained glass consistently develops and redevelops a contemporary relevance, adapting to changes in building construction and to the fluctuations of popular taste, without being at the cutting edge of gallery art. Unlike John Piper, who thought that only artists should be able to paint glass, I believe that fine artists mostly disappoint when they turn their hand to stained glass – even when they work with experienced craftsmen to realize their designs.

Artists, unlike stained-glass designers, have little or no knowledge of the inherent qualities of the materials involved, or of the impact of transmitted light upon them. Nor do they have the craft skills that would enable them to supervise the manufacturing of their own designs by other craftsmen – who might lead them in a direction of their own choice, to the detriment of the design.

I have found the study of stained glass from all periods to be an enriching experience, and I believe that my ability to design grows partly in proportion to the expansion of my manufacturing knowledge, the increase in my craft skills and the amount of contemporary and historical glass that I see every year.

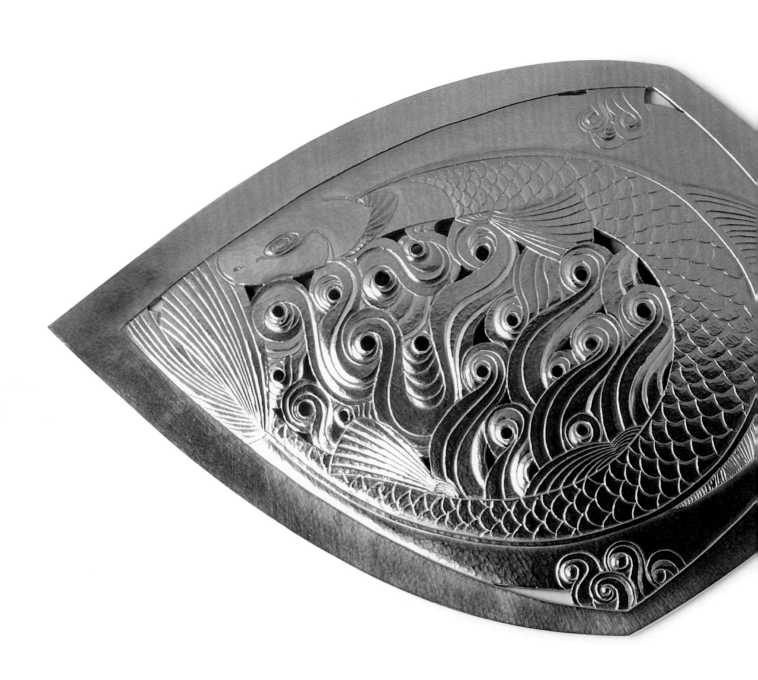

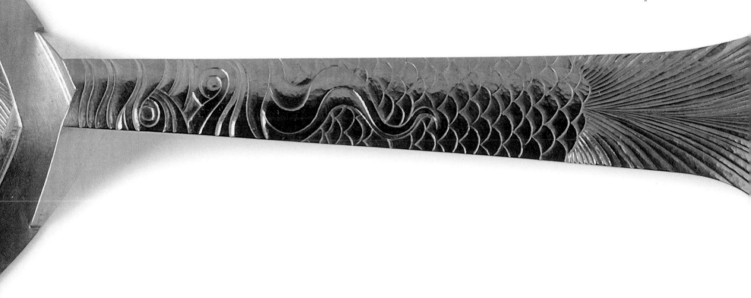

metalwork

44
Iron Bridge, Coalbrookdale
by Abraham Darby III
Cast iron
England, 1779

45
The Corieltavi Bowl
Silver
England (found at Hallaton,
Leicestershire), probably
made 100 BCE–100 CE
Harborough Museum,
Market Harborough

In 1779 the world's first iron bridge was opened at Coalbrookdale in Shropshire (pl.44). Built by Abraham Darby III – the third of his name in three generations of Quaker iron founders – the bridge proudly proclaims its origins in an inscription on its ribs: *THIS BRIDGE WAS CAST AT COALBROOK-DALE AND ERECTED IN THE YEAR MDCCLXXIX*. The statement was not an insignificant one. Although, with a span of only 100 feet (30 metres), the Iron Bridge may seem small to our eyes (accustomed as we are to far more monumental structures), its construction entirely from cast iron in 1779 was a revolutionary achievement. It represented the culmination of 70 years' experimentation and growth in ironwork in Coalbrookdale by three generations of the Darby family, Abraham Darby I being the first founder to succeed in smelting iron with coke, rather than coal, facilitating the huge expansion of the iron industry. But it also heralded the birth of the Industrial Revolution, by demonstrating the unprecedented possibilities that metal could offer. With the exploitation of its potential as an engineering material, metal would become firmly rooted at the heart of British manufacturing, being used for structures ranging from park benches to railway stations, prefabricated and exported all over the Empire. But the building of the Iron Bridge was in many ways just one step in a much longer-established tradition of metalworking, which had for centuries been a crucial part of British artistic production, and which continues to this day.

The properties of different metals – their strength, malleability, value and recyclability – have long made them the most desirable medium for an extraordinarily wide variety of uses, ranging from tools and weapons to domestic objects and architectural ornament. By the time of the Iron Age, metals (including copper, tin, iron, gold and silver) were being used to make not only useful tools, but also pieces of jewellery, coins and refined objects such as the Corieltavi Bowl (pl.45) – the earliest silver bowl known to have been handmade in Britain, excavated in 2000 at Hallaton in Leicestershire as part of the largest British hoard of Iron Age coins, now known as the Hallaton Treasure and housed at the Harborough Museum in Leicestershire.

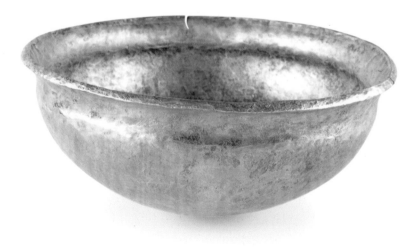

Even at this time the chief methods of the production of metals to make them workable were already known. In around 500 BCE the modern method of extracting iron arrived in Britain, having originated in the Middle East and travelled across continental Europe, thereby ending the earlier reliance on rare meteoric iron. The new technique was smelting: heating small lumps of iron ore together with charcoal to about 1200°C in a furnace provided with a limited oxygen supply – resulting in the emission of carbon monoxide and the reduction of iron oxide to a lump or 'bloom' of iron. This bloom would be reheated and hammered to remove any residual impurities, turning it into a tensile, malleable material with a very low carbon content. It could then be wrought (worked) into shapes by hammering, to create objects ranging from tools and weapons to the Capel Garmon Firedog (pl.46), dating from c.50 BCE–50 CE and one of the most important early pieces of decorative ironwork to survive in Britain. Originally one of a pair, which survived thanks to its burial in a peat bog that protected it from rust, the firedog is constructed from 85 separate wrought-iron pieces, with finials in the form of horse or bull heads, and displays an extremely high level of craftsmanship.

Like iron, silver also had to be extracted from its ore in order to be worked. This was done by heating the ore to above its melting point, a process that would separate the silver from the impurities, so that it could then be worked by a silversmith. As pure silver is too soft to be used for functional objects, it would always be used in alloy with other, stronger materials (usually copper), its silver content being guaranteed by a marking or assaying process.

It was silver and iron that would prove to be the two most commonly used metals for functional, yet decorative objects, and even from a very early date the primary functions of each were established: silver was used principally for coinage, or for objects that reflected its high monetary value, while iron was prized for its strength. This made iron eminently suitable not only for weapons and tools, but for other types of objects that served as security or protection. A late fourth-century window grille now in the British Museum, but originally from a Roman villa in Hinton St Mary, Dorset, would have acted as

a convincing deterrent to potential intruders, being equipped not only with a lattice of iron bars, but also with small iron spikes forming crosses or stars at each junction.

Similarly, it was security that was the underlying motivation for some of the earliest decorative hingework in Britain, found at St Helen, Stillingfleet in Yorkshire (pl.48) and at All Saints, Staplehurst in Kent. Both these churches retain their original doors, decorated with wrought-iron hinges that are not merely ornamental, but narrative, with figurative elements that may refer to Christian symbolism or Norse mythology. A twelfth-century crescent hinge now in the V&A, but originally from the slype door – a slype being a covered passage, usually linking a cathedral transept to the chapter house – of St Albans Cathedral in Hertfordshire (pl.47), is purely ornamental, but equally sizeable, extending from the functional part of the hinge in large and complex swirling S-scrolls. In each of these cases the hinges serve a dual purpose: to decorate a wooden door and to strengthen it by covering as much of the surface as possible with ironwork, protecting it from the blows of

46
The Capel Garmon Firedog
Wrought iron
Britain (Celtic), c.50 BCE–50 CE
National Museum of Wales, Cardiff

47
**Hinge from St Albans
Cathedral, Hertfordshire**
Wrought iron, engraved
England, 12th century
V&A: 356–1889

48
**Upper part of the door to
St Helen, Stillingfleet, Yorkshire**
Wrought iron and oak
England, 12th century

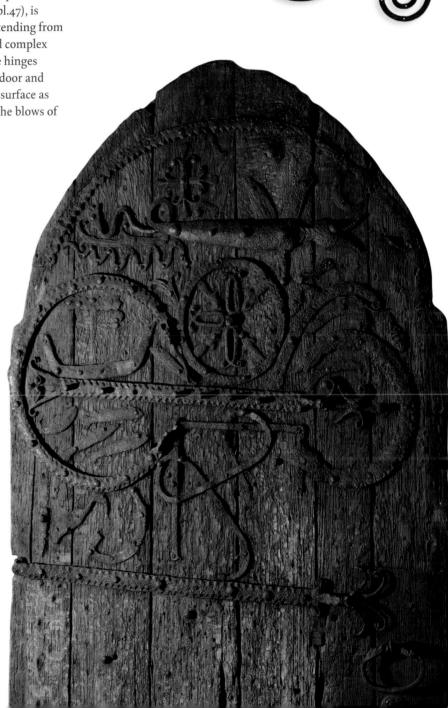

49
The 'Beddington' Lock,
probably by Henry Romayn
Iron, wrought, carved and gilded
England, c.1539–52
V&A: M.397–1921

hammers and axes. The same principle was applied on a smaller scale to lockable chests and cupboards, used to safeguard valuables in the home and the church, while locks and keys were also made of iron, or steel (a form of iron with a slightly higher percentage of carbon). Whether on chests, cupboards or doors, iron locks could be remarkably intricate, such as the carved and gilded 'Beddington' Lock (pl.49), which was probably made by Henry VIII's locksmith Henry Romayn for the door of the great hall at Beddington House, a manor that Henry seized in 1539.

Wrought iron was also used for protection and security in medieval churches in another way: for the construction of screens and grilles. Although very little medieval ironwork remains in Britain's churches, thanks to the ravages of the Reformation and centuries of change in liturgical practice and church furnishing, the rare examples that do survive *in situ* or in museums give us a clear indication of the kinds of decoration and level of quality embodied by them. Despite the abundance of iron – the earth's most common metal – the difficulty of its extraction and working made it extremely expensive, so it could only be afforded by wealthy patrons of the Church. In the context of medieval Catholicism in Britain, when cathedrals, abbeys and major churches often housed the relics of particular saints and thus served as pilgrimage sites, iron screens served a crucial function. They allowed visual – but not physical – access

to particular parts of the church, protecting the richly decorated sacred shrines from the vast numbers of pilgrims who were eager to benefit from their attributed miraculous properties. A grille originally in the retrochoir of Chichester Cathedral, removed in the nineteenth century and now in the V&A (pl.51), is thought perhaps to have been made as part of the 'costly clausures' erected in 1276 to screen the tomb of St Richard, the former Bishop of Chichester who was canonized in 1262 and whose shrine was destroyed in 1538 during the Reformation.

The finest thirteenth-century grille still in its original location is that surrounding the tomb of Eleanor of Castile, queen of Edward I, in Westminster Abbey (pl.50), commissioned to protect the queen's tomb from pilgrims clambering over it to reach the nearby shrine of St Edward the Confessor. This exquisite piece of craftsmanship is all the more extraordinary because we know who made it: Thomas de Leghtone, a blacksmith from Leighton Buzzard, who was paid £13 for making, transporting and installing the grille in the Abbey. His skill can be judged by the technical virtuosity of his work, which uses scrollwork decorated with stamped motifs, a technique that imitates contemporary goldsmiths' work. Like the Chichester grille, that of Eleanor of Castile served a specific purpose: to protect the tomb it screened, but also to adorn it and enable it to be seen.

Metal was also used in the medieval church to make the vessels needed for Catholic services. Chalices and

50
**Iron grille over the tomb of Eleanor
of Castile, Westminster Abbey,**
by Thomas de Leghtone
Wrought iron with stamped details
England, 1294

51
Grille from Chichester Cathedral
Wrought iron with traces of
pigment and gilding
England, c.1250
V&A: 591–1896

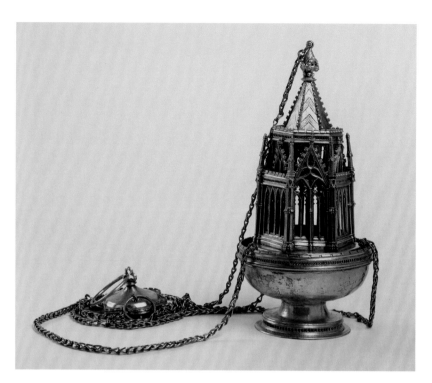

52
**Censer from Ramsey Abbey,
Cambridgeshire**
Silver and silver-gilt
England, c.1325
V&A: M.268–1923

53
The Studley Bowl
Silver, engraved, chased,
partially gilded
England, c.1400
V&A: M.1–1914

54
The Gloucester Candlestick
Copper alloy, cast and gilded;
niello, glass
Probably England (possibly
Canterbury), 1107–13
V&A: 7649–1861

patens to serve the bread and wine of the Mass, pyxes and monstrances to store and display the Host, reliquaries for the display of holy relics, incense burners for the ritual cleansing of the church, and candlesticks and altar lamps for its illumination: all were made of metal – and silver, with its highly reflective surface and high monetary value, was the most desirable metal for churches that could afford it, excepting only rarer and more expensive gold. Unfortunately barely any medieval silverware survives, partly because of its monetary value: as a result of the spoliation of monasteries, shrines and other ecclesiastical foundations during the Reformation, Henry VIII is said to have acquired 289,768⅞ ounces of plate and jewels.[1] A few rare survivals, often saved only because they were lost or deliberately hidden, show the richness and style of medieval decoration in precious metals. A censer from Ramsey Abbey in Cambridgeshire (pl.52), dating from around 1325 and dredged from nearby Whittlesea Mere in 1850, is considered the finest surviving piece of English Gothic ecclesiastical metalwork. It is entirely gilded, its form imitating the Gothic architecture of a chapter house, with miniature crenellations and tiny windows of decorated tracery.[2] This imitation of architecture in metalwork can also be seen nearly a century later in the iron in John Tresilian's gates for the tomb of Edward IV at Windsor Castle, where the intricacy of cold-cutting – a technique borrowed from clock- and watch-making – was used to create a marvel of Perpendicular architecture in iron.

As a precious metal, its monetary value being directly linked to that of coinage, silver has long represented a practical and adaptable medium for the production of luxury goods. It functioned as a demonstration of wealth, immediately obvious to all who saw it. It could be melted down, either in times of financial need when it would be turned into coinage, or when changes in taste demanded that outmoded pieces be refashioned in the latest styles. As such, it is not only ecclesiastical silver that fails to survive from the Middle Ages, but also domestic silver, apart from rare survivals such as the Studley Bowl (pl.53). Later donated to Studley Royal Church in North Yorkshire for use as an alms bowl, this is one of the finest and earliest pieces of medieval silver in existence. Probably originally made for eating porridge or for drinking, the Studley Bowl is partially gilded and engraved with the letters of the alphabet separated by wreaths of foliage, implying that it may have been made for a noble child, serving an additional purpose as an alphabet primer.

Although these works represent only a minuscule fraction of the metalwork that would have adorned medieval churches and homes, they demonstrate some of the techniques already in use by British goldsmiths and silversmiths at this time. Just as wrought iron was worked by hammering, so were other metals, including silver. The basic method used to make a silver vessel was raising: hammering a piece of sheet metal over a rounded anvil to create a hollow form. This could then

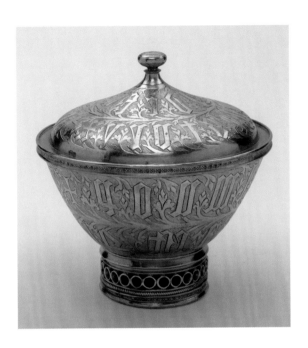

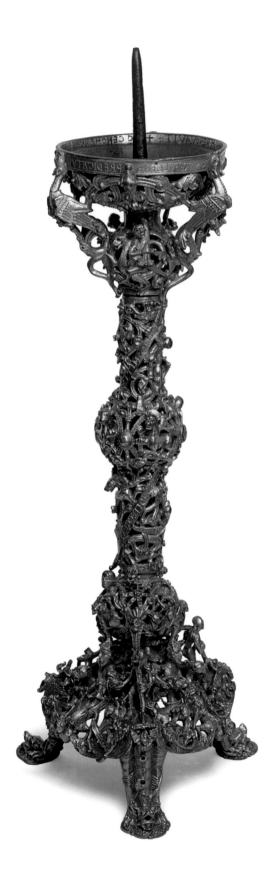

be decorated using a range of techniques: engraving – employing a steel tool to cut a line design into the surface of the metal; or chasing – using a light chasing-hammer and punches to push a relief design into the surface without any loss of metal. Silver could be made more precious by the application of gilding. Until it was banned in the 1920s this was a highly toxic process that involved painting an amalgam of mercury and gold onto an object made of silver (or another metal), before placing it over a fire or in an oven. The heating process caused the mercury to evaporate, leaving behind a fine layer of gold on the surface of the object or on selected parts of it.[3]

Objects in silver and other metals could also be created in a variety of shapes through the method of casting. This involved heating the metal to its melting point and pouring it in liquid form into a hard, heat-resistant mould, then allowing it to cool and set, producing forms ranging from whole vessels to individual elements such as finials or figures, which could then be soldered to the body of an object. The principal advantage of casting was that it enabled complex shapes to be produced quickly, easily and comparatively cheaply in identical multiples. It could be used either for base metals such as pewter or alloys of copper – such as for the fantastical creatures that cover the surface of the twelfth-century Gloucester Candlestick (pl.54) – or for precious metals such as silver and gold.[4] But until the late fifteenth century one metal that could not be cast in Britain was iron. Only with the arrival around this date from Europe of the blast furnace,

55
The 'Fowles' Fireback,
possibly by Nicholas Fowle
Cast iron
England (probably Sussex),
mid-16th century
V&A: M.120–1914

56
The Dolphin Basin, marked
by Christian van Vianen
Silver, burnished, chased
and embossed
England (London), 1635
V&A: M.1–1918

driven by water-powered bellows, could a furnace temperature be reached that was high enough to melt iron, which could then be run off as liquid, either directly into moulds for objects, or into intermediary moulds (known as 'pigs'), from which it could be melted down again and recast at a later stage.

With the invention of cast iron, the potential of metalwork to fulfil an even wider array of practical functions increased. Because cast iron absorbed carbon as it melted, it had a much higher carbon content than wrought iron: 2–5 per cent rather than the 0.2 per cent of wrought iron. This made it hard and brittle, shattering easily, but also more resistant to heat than wrought iron. Initially cast iron was used for military purposes such as the manufacture of cannon and ordnance. However, its superior heat resistance and capacity for mass production also made it suitable for the production of firedogs, stove-plates and firebacks. Firebacks were a fifteenth-century invention that resulted from the development of the chimneyed-wall fireplace: placed at the back of the fire-place, they both protected the brickwork of the chimney and reflected heat back into the room.[5] Made by casting the iron in a mould of damp sand on the floor of the foundry, firebacks provided ample opportunity for relief decoration on their large, flat surfaces, which were lit up by firelight. This decoration could take a variety of forms, as can be seen from a number of surviving examples in the V&A dating from the sixteenth century onwards. Some allude to particular political and historical events – such as the Armada, the Union of England, Scotland and Ireland, and the Restoration; others are decorated with heraldic arms or motifs. The 'Fowles' Fireback (pl.55) is decorated with a row of stylized birds, thought to be a pun on the name of Nicholas Fowle, who had a furnace

and forge in Kent; while the Lenard Fireback of 1636, housed at the Anne of Cleves House Museum in Lewes (and of which a later version exists in the V&A), bears the image of a founder with the tools and products of his trade.

As well as cast iron, a range of metals was commonly used for objects in the home. Wrought iron was used for cooking implements: for trivets on which to stand pots, and for pot hooks to be hung over the fire, sometimes decorated with images of the blacksmith and his tools. Lighting implements such as candlesticks, sconces and lanterns were produced in a range of different metals to suit different budgets: although they could be made of iron, a more reflective material such as brass was usually preferred. Pewter was the material of choice for many domestic objects, including plates, being both durable and economical. At the highest social level, however, many of these functions were carried out by silver. This use of silver would increase dramatically with Spanish and Portuguese expansion in Central and South America in the sixteenth century. Previously, as there were only limited deposits of silver in Britain and continental Europe, much silver had to be recycled. With the opening up of Central and South American mineral deposits – such as the silver mines of Potosì in Bolivia – the quantity of silver in circulation in Europe significantly increased.

Following the Reformation the nature of silverware that was produced in Britain changed. Although the Protestant Church still required vessels for use in the Eucharist, such as communion cups, objects like reliquaries and monstrances became obsolete, and the level of decoration on church plate remained restrained, in line with the teachings of the Protestant Church. Recusant Catholics continued to commission liturgical silver for

their private chapels, but usually from the continent rather than Britain, and to a very limited degree. It was therefore in the secular sphere that silver achieved its full potential in the seventeenth and eighteenth centuries. Silver was already established at court as the principal medium for objects given as diplomatic gifts, or for those displayed in *Kunst-* or *Wunderkammern* – rooms containing collections of natural history, exotica and precious objects, which it was common practice for European rulers to build up at this time. Charles I was the first British ruler to collect silver significantly, and although most of his collection was sold off or lost after his execution, some vestiges remain. A remarkable silver basin made by the famous Utrecht goldsmith Christian van Vianen, who established a workshop in London in 1630, was kept by Charles I in his cabinet rooms as part of his collection of 'pictures and rarities'. Although a functional object, originally paired with a ewer (now lost), the Dolphin Basin (pl.56) is such a virtuosic piece of work – raised from a single sheet of silver, intricately chased and embossed with the figures of dolphins – that is not difficult to see why Charles should have valued it so highly as a work of art.

After the Restoration of the Stuart monarchy in 1660, silver became even more important and visible at the highest levels of society. From around this date France began to wrest supremacy in the arts from Italy, thanks largely to the creation of the Gobelins workshops by Louis XIV and his minister Jean-Baptiste Colbert. The Gobelins supplied the highest-quality luxury goods – ranging from tapestries to furniture and silver – to both the French and foreign courts, and succeeded in their aim of establishing Paris as the centre of production of the most desirable luxury goods and the fashion capital of Europe. Having spent part of his exile in Paris, Charles II returned to Britain in 1660 with a knowledge of Parisian and continental fashions. He brought back both a knowledge of the latest design styles (such as the classicized baroque that was popular in France) and of the latest trends in eating, drinking and other aspects of courtly etiquette, for which new and expensive items of silver were required.

As in earlier periods, but particularly during the war-dominated seventeenth and eighteenth centuries, silver was the most practical medium employed to express wealth, its financial value guaranteed by the Assay Office,

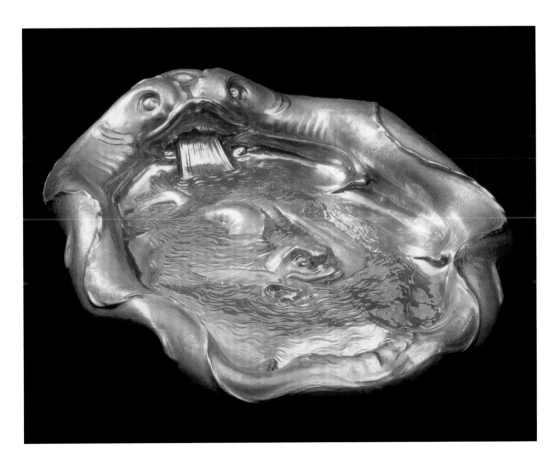

part of the Goldsmiths' Company, which tested and marked every silver object made in Britain: indeed, Louis XIV was forced to call on this financial value and melt down all his silver, in 1689 and again in 1709, to finance his military campaigns. Silver also had other advantages. Its reflective qualities perfectly equipped it for use in interiors where the only light came from candles or the fire. As such, the late seventeenth century saw the profusion of silver firedogs, candlesticks and sconces and even – at the very highest level – silver furniture (pl.57), all of which would have glistened when they caught and reflected the light of the flickering flames. Silver was also prized for its sterility, which made it an appropriately hygienic medium to use for toilet services: table dressing sets used by noble ladies for the ritual of the morning *levée*. Above all, the combination of value, reflectivity and sterility made silver the ideal material for the production of tablewares.

Until around 1700 it was rare to find a dedicated dining room in European palaces and stately homes. Meals were served in different rooms according to the occasion, being furnished for events such as banquets with a sideboard (or buffet) display of silver, which provided the main visual focus of the room. Although such displays of plate had been seen since the Middle Ages, they reached their apogee in the late seventeenth and early eighteenth centuries. The centrepiece of this theatrical display was the silverware for the serving of wine. At this date wine glasses were not placed on the table, to be filled up by servants when empty, but were brought to diners and then removed, once the contents had been consumed, to be refilled. On the buffet stood a wine fountain, from which water would be drawn to rinse diners' glasses over a cistern that caught the excess water. Below the fountain and cistern stood a large wine cooler, packed with ice, which chilled the bottles of red and white wine used to refill the glasses. These three pieces, usually made as a matching set, represented the ultimate expression of conspicuous consumption: the single greatest expenditure that a nobleman would make. In 1720 Thomas Parker, the new Earl of Macclesfield, paid more than £1,200 for his wine set (pl.58) (now the only matching set still in existence in Britain) in comparison with the £60–120 that he would have paid for a coach, deeming such expenditure not only worthwhile, but even necessary to celebrate his recent elevation to the peerage.

57
Table, mirror and candlestands in the King's Bedchamber at Knole, Kent, made for the Countess of Dorset by Gerrit Jensen and others
Embossed and chased sheet silver with oak carcase, replacement mirror glass
England (London), 1676
Knole, The Sackville Collection (The National Trust)

58
The Macclesfield wine set, marked by Anthony Nelme
Silver, raised, embossed, chased, engraved and cast
England (London), 1719–20
V&A: M.25–1998 (fountain, shown large),
M.26–1998 (cistern),
M.27–1998 (cooler)

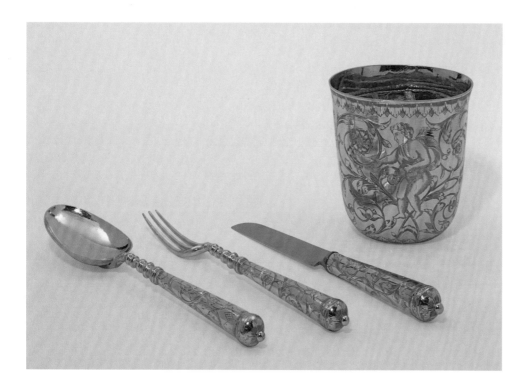

59
Travelling canteen set,
possibly marked by Thomas Tysoe
Silver-gilt, engraved
England (London), *c*.1690
V&A: M.62–1949

The wealth and taste that such an investment represented were a serious business, not only individually but politically. It was common practice for the Jewel House to equip ambassadors with a set of dining plate for their embassies: as the role of the ambassador was to represent his monarch, he had to have vessels that befitted this role, to prove that the British ruler was of an equal standing to his continental peers.

By 1700 the visual focus of the dining ritual was beginning to shift away from the buffet and towards the table itself. This was largely a result of changes in dining practices that originated at the French court. The introduction of new, more subtle foods created a need for specialized forms of tableware, such as tureens and sauceboats, in contrast to the communal dishes from which diners had previously helped themselves. A rising awareness of hygiene led to the provision of an individual setting for each diner, and the proliferation of individual sets of cutlery. Forks were a relatively late arrival in Britain – the earliest hallmarked example dates from 1632 (see V&A: M.358–1923) – but by the latter part of the century matching cutlery sets were either provided by hosts or carried by individuals, such as a travelling canteen set from *c*.1690 in the V&A (pl.59), which contains a knife, fork and spoon and would also originally have included a spice box, nutmeg grater and corkscrew.

Across Europe the French style of dining – *à la française* – took hold as the fashionable way to eat (pl.60).

According to this etiquette, all the dishes were placed in a rigid geometric arrangement on the dining table before the start of the meal, each diner serving himself from the dishes laid out before him. The table would only be cleared and reset once the main part of the meal was over and the dessert began: a course of fruit and sweetmeats, for which silver-gilt dishes were often used, to guard against tarnishing from fruit acids. The middle of the table was adorned with a centrepiece, or *épergne* (pl.61): a composite piece of silverware that developed out of the medieval standing salt, as the visual focus of the table. Just as, in the Middle Ages, the salt cellar had been a status symbol – its splendour matching the expense of the precious commodity it contained – so the centrepiece proclaimed the wealth and taste of its owner. Placed in the middle of the table, it would be viewed from all sides by all diners, who could admire its complexity, inventiveness and craftsmanship at the same time as making use of its interchangeable elements (including dishes, casters, cruets and candlesticks), which served the whole dinner and dessert.

In 1685 Louis XIV revoked the Edict of Nantes. This Act of 1598 had allowed French Protestants, known as Huguenots, to practise their faith without being charged as heretics. Its revocation put an end to an era of limited religious tolerance and led to waves of persecution, with the Huguenots fleeing France in their masses for nearby Protestant countries that would be sympathetic to their

60
**A table of 15 or 16 covers
for a supper**
From Vincent la Chapelle,
*The Modern Cook (Le Cuisinier
moderne)*, 3 vols (London, 1733), p.22
British Library

61
Épergne, marked by Thomas Pitts
Silver with cut glass
England (London), 1763–4
V&A: M.1703–1944

A Table of fifteen or Sixteen Covers for a Supper.

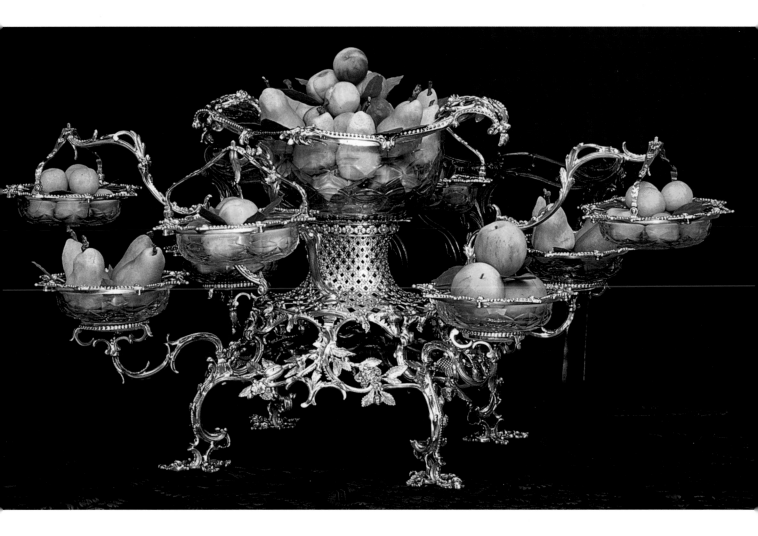

plight. A number of Huguenot goldsmiths and silver-smiths arrived and set up workshops in London, where their knowledge of the latest French fashions, their superior levels of craftsmanship (acquired thanks to the rigorous training operated by the French guilds) and their low prices, which undercut those of native smiths, meant they were instantly in demand. Their success was aided by the replacement in 1697 of sterling silver by the higher Britannia Standard, a softer alloy that was closer to the standard of French silver – with which the Hugenots had trained. Goldsmiths such as David Willaume, Peter Archambo, Paul Crespin and above all Paul de Lamerie exploited these advantages to the full, supplying the aristocracy with dining and other vessels and teawares in the latest styles, first baroque and then rococo, which they were responsible for introducing to British silverwork in the 1730s (pl.62).

62
Silver helmet-shaped ewer,
marked by Paul de Lamerie
Raised, embossed, cast and
chased silver
England (London), 1742–3
The Rosalinde and Arthur Gilbert
Collection, on loan to the
Victoria and Albert Museum, London
V&A: LOAN: GILBERT.721–2008

63
**The sideboard and table in
the Parlour at Dunham Massey,
Cheshire**

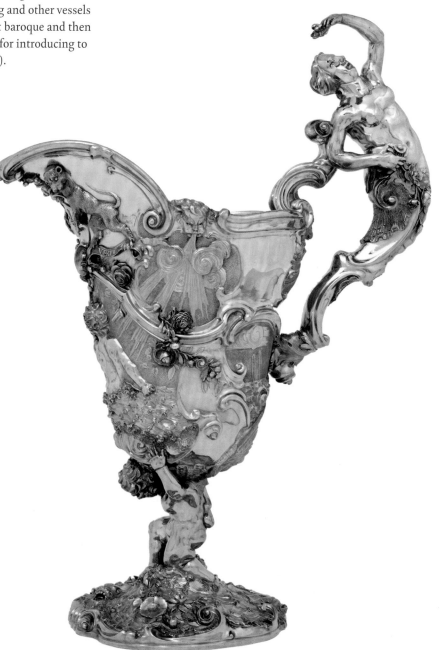

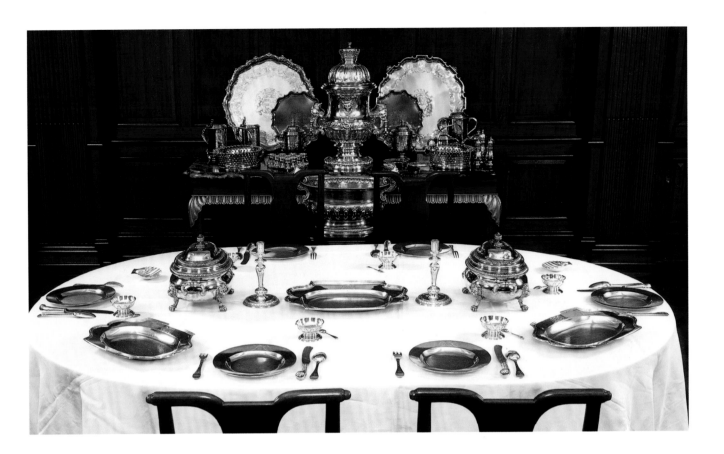

Although the Huguenots were not allowed to join the Goldsmiths' Company, they circumvented this restriction by joining other guilds, such as the Butchers', and using their tight family networks to establish themselves as a distinct community. The quality of their work and their introduction of new forms to Britain (such as the helmet ewer) and new techniques (such as cut-card work) made them unpopular among many native goldsmiths, who petitioned the Goldsmiths' Company against them; but it made Huguenot products eminently desirable to a ready London market that was insatiable in its demand for the kinds of French silver seen on travels to the continent.[6]

One of the greatest surviving collections of Huguenot silver is housed at Dunham Massey, the Cheshire country seat of the second Earl of Warrington. The earl spent 50 years building up a comprehensive collection of silver to equip his whole house – from chapel to kitchen, from tearoom to bedchamber – all decorated with his heraldry (pl.63). Having inherited huge debts together with his seat, his principal concerns were to make money in order to pay these off and, once he had done so (largely thanks to a highly advantageous, if unhappy, marriage), to make it visible by refurbishing his house in the latest style and

equipping it with a suitable quantity of plate, which he inventoried in the *Particular of my Plate* in 1750. It is not surprising that, in choosing where to acquire his silver (an important signifier of taste as well as wealth), the earl should have favoured Huguenot craftsmen, being impressed by their superior skills, French styles and economical prices.

It was not only in the field of silver that the Huguenots made their mark, but also in base metals. When William and Mary took the British throne at the Glorious Revolution, they chose Hampton Court as their principal residence, employing the architect Sir Christopher Wren to rebuild the palace in the fashionable baroque style. Employing the most skilled craftsmen in their field to provide fittings for the refurbished palace, they turned for ironwork to another Huguenot, Jean Tijou. Inside the palace, Tijou provided wrought-iron balustrades for the king's and queen's staircases, a new use of iron in the seventeenth century, which began in Britain with the Tulip Staircase at the Queen's House in Greenwich, designed by Inigo Jones in *c*.1637. Tijou's most magnificent work at Hampton Court, however, was produced for the palace gardens: the wrought-iron screen and gates to the new Fountain Garden.

64
**Masks from the Fountain Garden
Screen at Hampton Court**
by Jean Tijou
Wrought and embossed iron
England, *c*.1690
Hampton Court Palace – Historic
Royal Palaces, on long-term loan
to the V&A

William and Mary were keen gardeners, spending more than £88,000 on gardens between 1689 and 1699, and the new garden was reserved for their sole use: as such, Tijou's screen was intended not only to adorn it, but to secure it from intruders.[7] In its construction Tijou was responsible for introducing to Britain an entirely new iron-working technique: *repoussé* work, also known as embossing. This technique was already used in the working of precious metals and could be employed to great effect (as in objects like Christian van Vianen's Dolphin Basin, see pl.56), but had never been used on iron in Britain. It involved resting a piece of sheet iron on a bed of pitch mixed with a solid material such as plaster of Paris (providing a soft but resistant working surface) and hammering a design in relief into the iron from the reverse, creating extraordinarily three-dimensional effects. Scrolling acanthus leaves, tasselled lambrequins (short ornamental pieces of drapery hung from the top of a shelf, door or window) and grotesque masks all adorned the Fountain Garden Screen, which may originally have been painted a steely blue and gilded, displaying Tijou's mastery of *repoussé* work to the full. Although the screen has been moved from its original location and has been much restored, the quality of Tijou's craftsmanship can be judged from individual detached elements that survive (pl.64), while the high regard in which he was obviously held can be seen from the level of payment that he received for his work: an astonishing £2,160 2s. ¼ d.[8]

Like the Huguenot goldsmiths, Tijou was responsible for introducing to Britain not only new ironwork techniques, but a new style: the classicized baroque that was fashionable at the court of Louis XIV. For a wave of new baroque palaces and country houses – all equipped with sequences of state rooms, ceremonial staircases and formal gardens – Tijou's style of ironwork offered the most up-to-the-minute form of embellishment, ending the reliance on Gothic motifs that still endured in British

65
**Design for a staircase and two
elements from the Fountain Screen
at Hampton Court**, engraved by
Michael Vandergucht after Jean Tijou
Engraving, from *A New Booke of
Drawings* (London, 1693), plate 12
V&A: 25082:9

ironwork as the other crafts had moved on. Tijou made sure that his designs were known as widely as possible by publishing a book of his designs, the first pattern book for ironwork in Britain (pl.65). With his *New Booke of Drawings*, published in London in 1693, Tijou was indulging in what was commonplace on the continent, but had not previously been employed in Britain for ironwork. Although it is impossible to know whether it was chiefly the book or his actual works that influenced his followers, the book would certainly have made his

designs more readily available to a wider public. Tijou's introduction of a new style for ironwork clearly encouraged a number of followers in various parts of the country. In 1710 the smith William Edney produced a pair of gates for the church of St Mary Redcliffe in Bristol; a year later Thomas Robinson made a gated screen for New College, Oxford; and in 1719 the Davies brothers produced gates for Chirk Castle in Wrexham. Robert Bakewell spent five years from 1707 working on his best-known work, the so-called 'birdcage', a wrought-iron arbour in the gardens

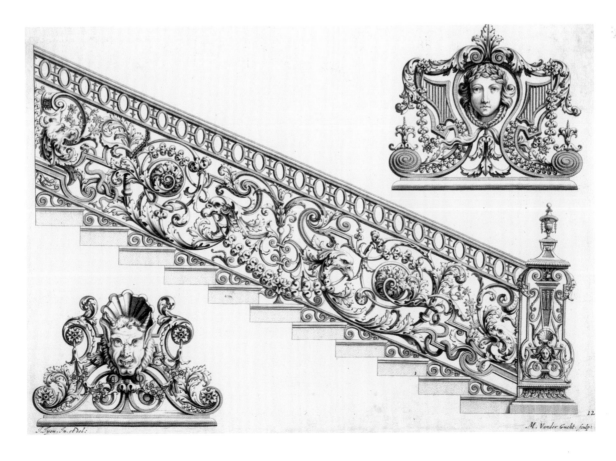

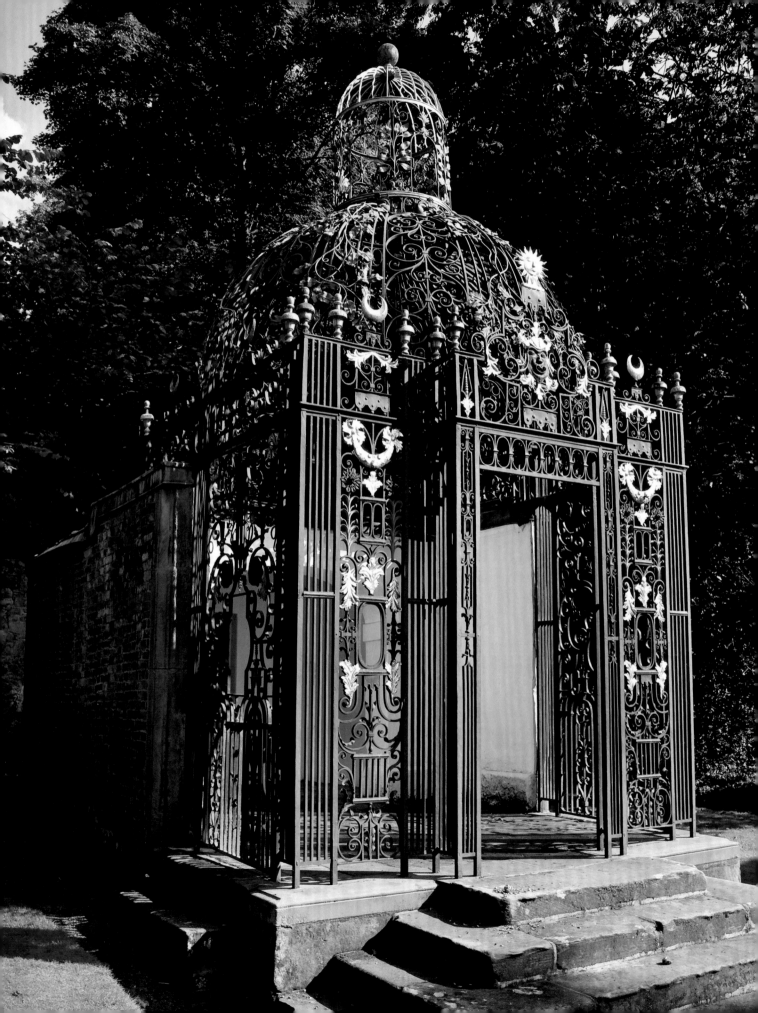

of Melbourne Hall in Derbyshire (pl.66). Each of these smiths followed Tijou in combining simple vertical uprights with *repoussé* elements such as acanthus leaves, although generally in a more restrained style, as suited British taste.

During the latter half of the eighteenth century a new style took over, which revolutionized art and design in Britain. Inspired by recent archaeological discoveries such as those at Pompeii and Herculaneum, neoclassicism offered a cool, ordered alternative to the dramatic opulence of the baroque and the asymmetrical playfulness of the rococo. Architects and designers borrowed from ancient Greece and Rome to create a new design language known as the 'antique manner', which suited the tastes of contemporary antiquarians and collectors and could be produced across the widest possible range of luxury goods. Goldsmiths and silversmiths took their inspiration from newly fashionable forms such as the vase, which became the archetypal neoclassical motif in a wave of such popularity that it became known as 'Vasemania'.

In 1774–5 the actor David Garrick purchased a quantity of silver from the goldsmith Henry Shepherd, including a silver tea service (pl.67). Every piece of this service, from the hot-water urn to the sugar bowls, displays the influence of neoclassicism in its use of vase forms and restrained, elegant decoration combining swags and festoons with fluting. Regarded by some of their contemporaries as social climbers, Garrick and his wife were obviously keen to establish themselves as members of fashionable society: they probably acquired the tea service, as well as other luxury goods, to furnish their new residence in the Adelphi, the most fashionable architectural development of its day. This block of terraced houses, situated between the Strand and the Thames, was designed by the architect Robert Adam and his brothers, John, James and William, and presented a unified façade that was characteristic of much Georgian urban architecture. Such façades, whose effect was created through repetition and unity, lent themselves to decoration with iron: identical balconies, railings and lamp-holders harmoniously punctuated and enlivened the streets of Georgian London as well as Edinburgh, Bath and Cheltenham.

Since what was sought for this kind of architectural decoration was not the individual but the identical, it was not wrought iron, but cast iron that proved the most appropriate medium. Cast iron was used sporadically for architectural ornament from the beginning of the eighteenth century – the first set of cast-iron railings being those of around 1714 outside St Paul's Cathedral. Another

66
Garden arbour at Melbourne Hall, Derbyshire, by Robert Bakewell of Derby
Wrought and embossed iron
England (Derbyshire), 1707–11

67
The Garrick Tea Service,
marked by James Young and Orlando Jackson
Silver, chased, with ivory handles
England (London), 1774–5
V & A: M.24–1973

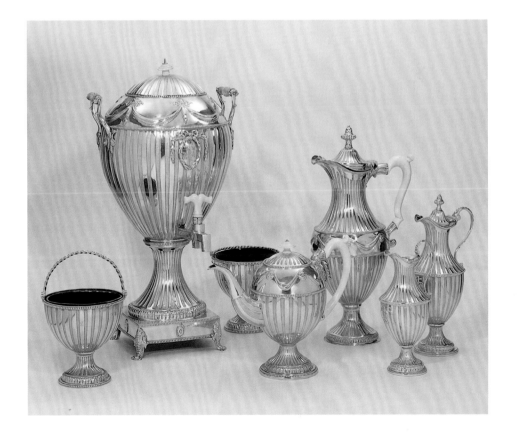

set of railings outside the Senate House in Cambridge, of
*c.*1730, combined massive cast-iron uprights alternating
with more slender wrought-iron verticals, topped by
individual decorative finials. For the Adam brothers,
however, there was no need for such alternation or
individuality: what was required were balconies and
railings that fulfilled a decorative function, but all
looked the same and were relatively easy and cheap
to produce in bulk.

The Carron Company in Falkirk, in collaboration
with the Adam brothers, made this their occupation.
Established in 1759 on the banks of the River Carron –
a location rich in deposits of coal, iron ore and limestone
– the Carron Company began, like many foundries,
by producing cast-iron ordnance, giving its name to a
particular type of cannon known as a 'carronade' and
supplying the army and navy with weaponry and ammuni-
tion, after production in earlier cast-iron manufacturing
centres such as Sussex and the Weald had practically
ceased.[9] Refounded in 1773, the Carron Company had as
one of its directors John Adam, and as such became the
supplier of choice for the cast-iron elements of the Adam
brothers' architectural projects: balcony fronts decorated
with the motif of the classical palmette or anthemion (an
ornament formed of a symmetrical group of spreading
fronds, resembling palm leaves or honeysuckle petals),
pedestal stoves that imitated antique vases, and hob
grates decorated with classically inspired decoration
(pls 68 and 69). The publication by the Adam brothers
of their projects in *The Works in Architecture*, in several
volumes from 1773, enabled the widespread circulation
and imitation of their designs and use of cast iron. The
anthemion became one of the most popular motifs used
to decorate new buildings for the next half-century, while
the *Works in Architecture* inspired the publication of other
pattern books, such as I. and J. Taylor's *Ornamental
Iron Work, or Designs in the Present Taste, for Fan-Lights,*

70
*Regency Fete, or John Bull
in the Conservatory*
by Charles Williams
Hand-coloured etching
England (published in London), 1811
The British Museum

Staircase railing, Window-guard-irons, Lamp-irons, Palisades, & Gates, published in the 1790s, which contained designs for as wide a range as possible of cast-iron elements that might be desired by architects.[10] With the developments in manufacture pioneered at Coalbrookdale, such as smelting with coke, cast iron became increasingly useful as a practical and decorative form of architectural embellishment right into the nineteenth century.

Coinciding with these developments in architecture were shifts in dining practices and in the consumption of silver in Britain. Throughout the eighteenth century the continued popularity of dining *à la française* had ensured the production of silver and silver-gilt dining and dessert services to meet a widening social market, with an ever-increasing range of specialized equipment. By the early nineteenth century astonishingly lavish silver services

adorned the tables of the richest members of society. In 1816 the Portuguese presented the Duke of Wellington with a monumental service of nearly 1,000 pieces, costing £27,000, in thanks for their nation's liberation from the French, to which the duke added with acquisitions from Garrard's in later years. The Prince Regent proved himself the first British monarch to rival Charles I as a collector, commissioning huge quantities of silver from the firm of Rundell, Bridge & Rundell, including four dinner services that cost an eye-watering £111,351 8s. 1d. (pl.70).[11] At a lower social level, the middle classes – aspirational and still seeing silver as a good investment, but lacking the same degree of income – purchased silver pragmatically, buying the minimum number of pieces needed to equip a polite home, if they could not afford to buy more.[12]

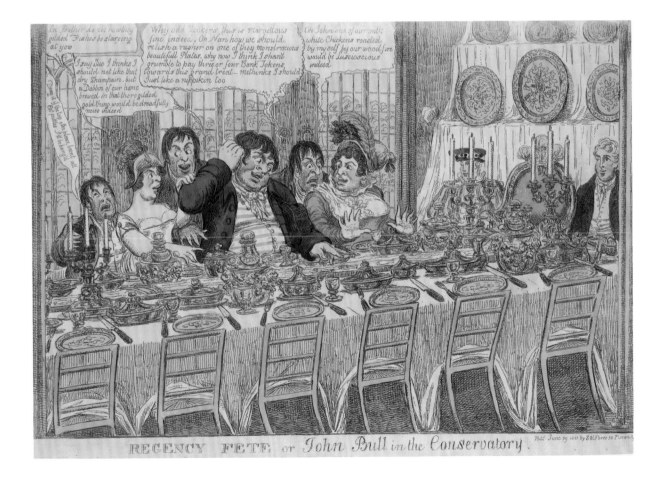

DINNER TABLE—OLD-FASHIONED STYLE.

However, perceptions of silver were changing. Gradually dining *à la française* was replaced by a new style of dining that was becoming popular on the continent: dining *à la russe* (pl.71). Rather than diners serving themselves from dishes placed in a formal arrangement, which remained on the table for the whole meal, in dining *à la russe* each course was brought in in turn and served to the diners by servants. The British were initially unwilling to accept this new mode of dining – so much so that it even led to a debate in the Letters pages of *The Times* in 1859. Their reasons were several: the loss of dining *à la française* removed the possibility of displaying one's wealth through a fixed arrangement of plate on the table; meant that servants needed to be hired; and led to an atmosphere of greater formality over dinner, because of the servants' presence. But it also brought with it certain practical benefits. Food was less likely to be wasted, and more likely still to be hot when it arrived at the table – an increasingly important concern in the nineteenth century, when awareness of the potential dangers of food poisoning was growing. Despite initial reluctance, and although the two dining styles coexisted for several years, by the 1860s dining *à la russe* had been largely embraced by polite society, with new etiquette manuals being published to teach the inexperienced how to perform it.

Alongside this change came challenges to silver from other materials: the visual interest of the table was no longer to be found solely in a massed display of silver, but in individual place settings and a variety of materials: porcelain, creamware, glass and even fresh or artificial flowers. Only cutlery remained immune: silver was still considered the best material, especially with the continued proliferation of specialized utensils throughout the nineteenth century, some more widely accepted than others – for example, fish-eaters, which were regarded as decidedly nouveau riche.[13] At the same time, silver itself was becoming a more democratic material. In 1742 Sheffield plate had been invented: a fusion of silver and copper that could be rolled out into thin laminated sheets and stamped with designs using steel dies (pl.72). This had offered a pleasing substitute to silver for those who aspired to own it, but could not afford it, and was promoted by makers such as Matthew Boulton, whose Soho factory near Birmingham produced wares to the same designs in both silver and Sheffield plate, in order to capture the elite and wider middle-class market.

In the mid-nineteenth century an even more successful substitute to silver appeared on the market. When George Richard Elkington and his cousin and partner, Henry, discovered that electricity could be used to deposit silver onto base metal, electroplating was born. Patented in 1840 and presented at the Great Exhibition of 1851, Elkington & Co.'s electroplate was not regarded merely as a cheap silver substitute, but as a technological

innovation. It could be used to produce objects ranging from beer tankards for the restaurant of the new South Kensington Museum, to replicas of the silver lions in Rosenborg Castle in Denmark, made as part of a programme by the Museum to create electrotype copies of historical silver objects (pl.73). To maintain their artistic credibility Elkington & Co. continued to make fine, high-quality silverware, but it is their electroplate for which they are known, and which presented a serious threat to the supremacy of silver by opening up, to a lower level of the market, the possibility of owning silver – albeit silver plate.

The Great Exhibition not only provided the opportunity for manufacturers such as Elkington & Co. to

72
Teapot made by
Matthew Boulton's
Soho Factory
Copper, plated with silver
England (Birmingham), *c*.1810
V&A: M.210–1920

73
Replica of a lion from
Rosenborg Castle, Denmark,
made by Elkington & Co.
Electroplated copper, silvered
England (Birmingham), *c*.1885
V&A: REPRO.1885–194

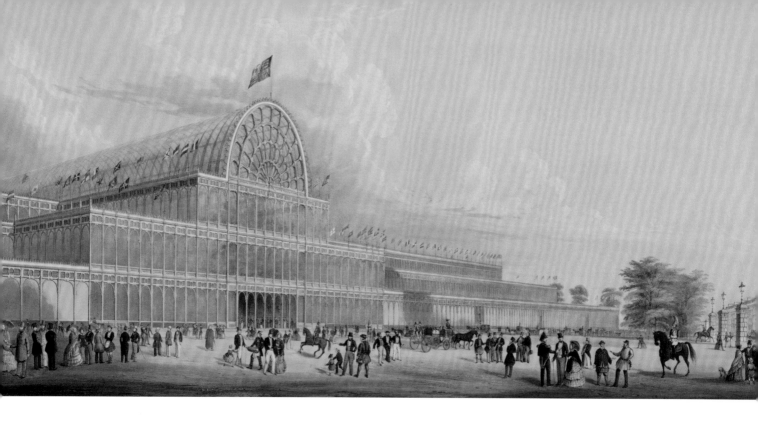

showcase their products and technological innovations, but was in itself an extraordinary feat of technology. If Abraham Darby III's construction of the first iron bridge in 1779 had shown what cast iron could do, the nineteenth century saw an increased use of wrought iron on an industrial scale, as machines were invented that could roll it out in sheets, to be used to clad ships and trains. Iron started to be used as a construction material not only for bridges, but for buildings, being particularly popular in civic buildings such as railway stations and commercial buildings like the London Coal Exchange – its extraordinary domed rotunda in cast iron designed by James Bunning, but sadly demolished in 1962. Glasshouses, such as the Palm House at Kew, designed by Richard Turner and Decimus Burton and built in 1844–8, played to the different strengths of wrought and cast iron – cast iron being strong in compression, for columns, and wrought iron being strong in tension, for spans – and combined them with glass, creating light, airy structures that were perfect for the cultivation of newly fashionable hot-house plants. The Crystal Palace, made to house the Great Exhibition, was the most impressive of all these glass and iron structures (pl.74). Designed by Joseph Paxton, with ironwork by Sir Charles Fox of Fox & Henderson, it showed new possibilities for iron as a modular structure. Erected from prefabricated sections

bolted together, the Crystal Palace paved the way for the later nineteenth-century manufacture and shipping (by companies such as the Saracen Foundry of Walter Macfarlane in Glasgow) of prefabricated iron structures – ranging from railings and gates to fountains and bandstands – across the world to the most distant parts of the Empire.

With the arrival of the Gothic Revival, and a reaction against the industrialization represented by cast iron, the use of wrought ironwork in the Church was also revived. More than 100 churches were built each year from 1840 to 1900, while older churches were restored, expanded and refurbished. As the preferred style was that of the Gothic – considered the only truly authentic Christian style by its proponents, such as A.W.N. Pugin – it was chosen for gates and screens made to furnish these new ecclesiastical environments or embellish existing ones. One of the most impressive examples is the Hereford Screen, designed by Sir George Gilbert Scott and made by Francis Skidmore of Coventry for Hereford Cathedral (pl.75). The screen, which took its inspiration from the medieval stone and timber screens that so rarely survive, was intended not to imitate but to outdo its medieval prototypes, and to showcase the very latest technology. It combined a timber structure with glass and marble mosaics, hardstones, electroform figures, cast-iron

columns and wrought-iron tracery, the whole being painted and partially gilded to proclaim its splendour as a triumph of Victorian technology and design. When shown at the International Exhibition of 1862, even though not quite finished, it was declared 'the grandest and most triumphant achievement of modern architectural art … a monument of the surprising skill of our land and our age'.[14]

Despite the positive effects of the Gothic Revival on the production of liturgical silver, by the late nineteenth to early twentieth century silver was beginning to see a decline in popularity, which even the encouragement of craftsmanship by the Arts and Crafts movement did not succeed in halting. Silver was expensive: as it was not mined in Britain, it had to be imported or recycled; it was also no longer regarded as a safe investment, but as 'capital lying dead'.[15] Harsh electric light did nothing for it, making it lose its lustre and look flat and unappealing.

Historical silver was still considered desirable, but was put on the market by the aristocracy and churches that could no longer afford not to sell. Modern and contemporary tastes were catered to so effectively and cheaply by electroplate – especially when everyday electroplate objects were being created by designers such as Christopher Dresser (pl.78) – that it was hard to see what silver could offer. Iron, conversely, began to be used again for some of its original domestic functions, such as firedogs and candlesticks, and took on a new lease of life with the Art Nouveau movement, to which its sinuous lines were perfectly suited (pl.76).[16] However, despite the widespread use of cast-iron ornament on Art Deco architecture, with the Second World War and the rise of modernism the role of iron as architectural ornament ceased to exist, there being no place for it in modernist and much post-war design.

Since the second half of the twentieth century, and particularly since the 1970s, there has been a revival of metalworking in Britain. The immediate post-war period brought a reform to art-college teaching and a new relationship between hand-crafting and industrial design, the effects of which can be seen in silver of this period. Although stainless steel has taken over from silver in

many areas, such as cutlery, several of the eminent designers in stainless steel from the latter part of the twentieth century – such as Robert Welch and David Mellor – trained and practised as silversmiths, as well as designing for industry. Today, although handmade silver objects have perhaps become the preserve of a rather niche art market, many of them display an innovative combination of contemporary design and age-old techniques, for example in the work of smiths such as Rod Kelly (pl.77) and Chris Knight. Kelly produces finely chased decorative designs on his works, often inspired by flowing natural forms, which deliberately retain the signs of hammering in order to highlight the process of making. In contrast, Knight works to remove these signs as far as possible, through polishing, creating domestic objects that subvert the traditional expectation of the relationship between form and function. In very different ways both smiths, and many of their peers, succeed in producing works that are both functional and artistic objects, which demonstrate their maker's skill in traditional smithing techniques alongside contemporary design ideas.

In iron, although many blacksmiths are engaged in traditional conservation and restoration work, often in

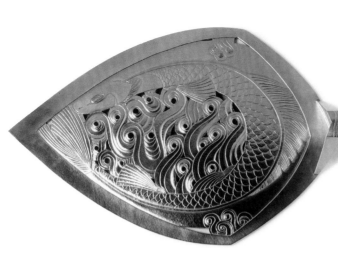

77
Fish slice by Rod Kelly
Silver, partially gilded
England (East Harling), 1989
V&A: M.57–2008

78
Teapot by James Dixons and Sons,
designed by Christopher Dresser
Electroplated nickel silver with
an ebony handle
England (Sheffield), c.1879
V&A: M.4–2006

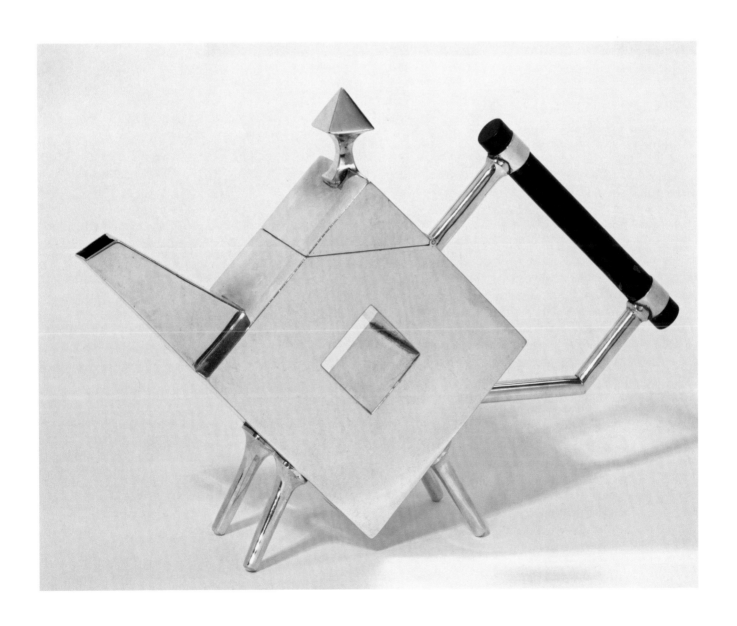

the manner of eighteenth-century wrought iron, others are exploring more contemporary ideas. As wrought iron is now scarce, being very labour-intensive to produce, most ironworkers now work predominantly in mild steel, a form of iron with around 0.15–0.25 per cent carbon (a little more than traditional wrought iron, but considerably less than cast iron), which has similar properties to wrought iron. Since the 1970s, which saw a concerted attempt – by the V&A, the Crafts Council and the newly formed British Artist Blacksmiths' Association (BABA) – to encourage innovative design in ironwork, blacksmiths have explored the potential of new technologies to conceive new possibilities for ironwork. Artist smiths such as Antony Robinson and James Horrobin, and designers such as the ironwork and jewellery designer Wendy Ramshaw (pls 79 and 80), seem to bring the past history of iron together with its future potential. Using power-hammers for forging, or water jets for cutting the mild steel, they employ novel technologies as well as traditional hand-crafting techniques, while their works speak to the ancient use of iron for specific purposes, but in an entirely contemporary way. Fire baskets, gates and screens all hark back to the archetypal function of the metal as a material to secure and protect, and yet acknowledge that this function remains in contemporary life and can be fulfilled in the most innovative and forward-looking way.

79
Maquette for Double Screen
made by Qualart, designed
by Wendy Ramshaw
Steel cut by water jet, set with
optical glass lenses, spray-painted
England (Sheffield), 1995–6
V&A: M.85–1997

80
**Necklace for *Portrait of
a Woman* (by Picasso)**, designed
and made by Wendy Ramshaw
'Oxidized' silver and
black Colorcore
England (Sheffield), 1989
V&A: M.29–1998

Chris Knight

Born 1964. Lives and works in South Yorkshire.

opposite
'Lest We Forget' chalice
Silver and stainless steel
England (Sheffield), 2010
Museums Sheffield

Can you tell us how your making begins?
A lot of my work starts by deconstructing the basic object. I search for its prime function, its fundamental formal needs. From there, I start to reconstruct the object by exploring how to 'push' a prime functional attribute. However, with the candelabra (overleaf) I stop short of fully forming the design. My intention is that they remain suspended within the process; poised uncomfortably between precise making and a casual sketch. I want to play with our visual perception, as these candelabra are all constructed from exact geometry. Each component is almost engineered. Yet, through the seemingly haphazard way in which they are thrown together, they appear unstable in a frozen movement. They balance on the aesthetic boundary between organic and geometric.

When I design I do not go through a lengthy process of design development in which I labour to overcome one idea. I generate numerous possibilities – many of them weak and irrelevant – and, through the considered rejection of these, the true brief or object starts to come into focus.

My latest work explores historical and contemporary iconography through a series of decorative vessels. By combining the pristine stainless-steel elements with the rough-cast silver I aim to visually devalue the precious and concentrate the viewer's mind on the piece's meaning rather than its value. The work is part of the tradition of commenting on society through the form of a static vessel, intimating function, but offering little in reality.

The 'Lest We Forget' chalice (opposite) draws on my experience of designing domestic objects, and its context as a functional object clarifies that there is more to it than mere convenience and traditional beauty. A lack of comfort is very important in this piece. Although it was not designed for everyday use at an altar, it is a sacramental vessel that expresses its function both practically and symbolically – the two aspects of form and function are absolutely combined. Its expected function strengthens the visual metaphor: surely a chalice should draw you in – to a constant security – to offer spiritual sustenance? Visually this chalice draws you in, but physically you are cautious. The heavy rough-cast body of silver studded with hundreds of stainless-steel crosses presents a strong visual image, yet creates a conflict in its utility. The form of the cross is veiled by contemporary concerns, attitudes, scandal and prejudice. It was my intention to echo the muddy battlefields of the First World War and the mass cemeteries that commemorate them.

More importantly than all this, I hope my objects offer enough ambiguity to enable each viewer to read, understand or question their relevance from their own standpoint.

What are your preferred raw materials?
Silver is somewhat emotive as a material. It carries its own class distinction, yet also has romantic associations, often being described as feminine and the luminescence of the moon. Being naturally an anti-microbial agent, silver is functionally clean and feels warms to the hand. We celebrate its beauty, yet often ignore the negatives of its manufacture, history, status and – of course – its ability to tarnish.

When I first started to use silver, its status as a metal was partly a pleasing confirmation that I had reached a level of making that meant I could work with such a material, but its financial implications were a hindrance. Working in silver sharpens your eye to exacting standards, but while you are focused on being worthy, that anxiety can cause your creativity to stagnate; your mind switches from taking risks to managing results.

Having become familiar with the material, I am able to appreciate the more mundane qualities that make it so desirable to work with – it is clean on both hand and eye; when working in copper or brass, the tarnish and smell of the metal transfer to your skin, and marking and measuring on base metals are comparable to working on coloured rather than pristine white paper.

More importantly, silver offers a greater creative freedom than modern household materials such as stainless steel, through its practical dexterity within the workshop. Silver is highly malleable and ductile, so it can be formed with the most rudimentary of hand-tools, which offers the practitioner the ability to adapt their ideas mid-process, work exclusively on one-off pieces or produce limited-edition runs – all without any significant investment or a commitment to design dedicated tooling. In turn, this enables a designer silversmith to take more creative risks with objects and to speculate more with ideas.

What are your main technical challenges?

My initial experience of making was one of absolute fascination, excitement and determination to glory in the making process. I strove for the absolute: a perfect solder seam, an immaculate round of planishing (smoothing the metal by rolling or hammering it) – qualities that could be judged and compared against contemporary and historical practice. This drive for perfection in manufacture – initially driven by my fear of wasting silver – was enhanced by the introduction of tool-making and machine processes that guaranteed the results.

Within my workshop I use most traditional silversmithing processes, such as raising, spinning, box-work and general fabrication techniques. These are often partnered with more modern techniques, such as laser-welding, CNC-machining, photomechanical etching, laser-cutting and rapid prototyping. But while my practice is rooted in the rewards and satisfaction gained through exacting hand-skills, I attempt to deny this to the viewer. The clean lines and surfaces of my work suggest the machine-made rather than the handmade. The contradiction in my partnership between hand, material and eye is that I do not wish the manufacture to be visually celebrated. I remove all traces of craft, preferring a more engineered aesthetic. For now, you will not see a hammer-mark, and my handmaking is removed by the final polish. I believe that, once established, merit based on craft skills can be taken for granted. It does not need to be publicly celebrated repeatedly. I enjoy the process, and it informs

the development of the design, but this is a private experience. As the maker, I am unable to quantify an aesthetic outcome denied of any reference to process – but ultimately the object should be appreciated and used without its making in mind.

Do you think of your work as being part of a heritage?

Past objects inspire and inform me through their functional attributes, but I take no inspiration from their aesthetic or artistic reference. I want my objects to speak of today by other means, and not be merely a modern styling of another artist's visual reference or flourish.

When making my early tableware, I began to explore how our understanding of the relationship between form and function affects our programmed recognition of the partnership between me, the object and its viewer. Our familiarity with everyday objects, and the common formal language they have carried throughout history, enables me to design ambiguity or tension into their perceived utility.

The teasets I have designed are examples of this enquiry; through their reference and subversion of traditional forms they highlight the effect on the 'user's' feelings when objects do not conform to our expectations. 'Rocking Tea Service No.2' (above, left), for example, seeks to disturb our assumptions regarding the scale, position and presentation of the handle, adding function by its instability. The form, composition, materials and

manufacture engage with theories regarding the 'affordances' of domestic objects.

Formally, I moved through organic forms, finding their qualities too subjective, and explored concrete geometric forms. Maybe I gained security in the use of geometry to study form, proportion and scale. I have overused technical drawing in the past – which for me, as with craft skills and functionality, is an absolute.

How does your work relate to art, craft and design?

When I first made the decision to centre my creativity around silversmithing, I chose to express my ideas through functional items: domestic objects that, although indulgent in terms of their material and manufacture, remained true to a basic function.

For such items, beauty, originality or interest is created through a conversation between the qualities of form and function. If each is treated in isolation, we arrive at utilitarian kitchenware or over-embellished objects, such as those typical of the early nineteenth century – where aesthetic or artistic elements were applied in order to disguise the objects' naked utility.

Silversmithing is sometimes thought of as a relatively conservative subject within the field of art and design, but the material and the craft skills required to work with it can become a barrier to the expression of broader issues – people think that if an object is made badly or from throwaway materials, then the

'art' of the object must surely have a greater importance. Conversely, if an object is made of fine materials and formed with exemplary craft skills, then it will be considered for these attributes only, and there is no need to speak of anything more. This is a major dilemma within craft practice – almost a prejudice that we struggle against, and yet often hide behind. After all, our prime material celebrates, if not demands, lengthy hand-skill.

I originally subscribed to an approach that allowed the functional element to be part of the visual expression, enabling that the chosen form should provide a visual instruction, and be celebrated for what it did. The spout would be exalted for the way it poured, the handle praised for the way it felt when held. I have subsequently realized that there could be more depth to an object: it could move beyond being well made and implicitly functional. I could make an

object that pursued an overall concept; a conversation between me, the viewer and the subject, where the object was merely a punctuation mark.

My work is concerned with relationships between visual and tactile qualities, and I explore the emotions or anxieties that visually aggressive objects can establish. I endeavour to create objects that induce a nervous flutter through the dichotomy between how they look and how they function: objects that may hurt, but at the same time towards which you are strangely drawn.

Although I choose to work within a very traditional form of the applied arts, and one whose material seems to carry its own historical and political baggage, I want to produce objects that don't just pander to the ostentation of owning silverware. It is unavoidable to some extent, but I strongly believe there is a need for something more.

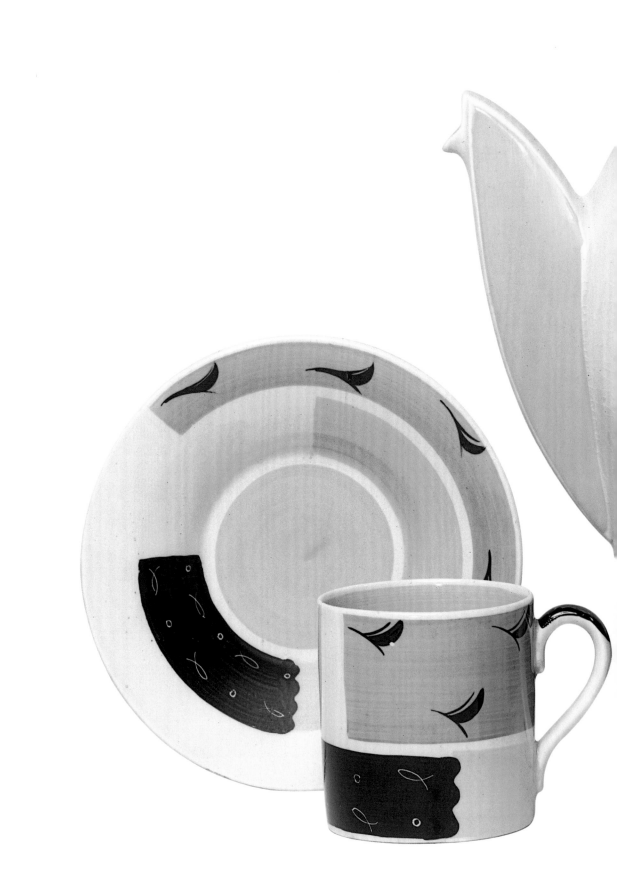

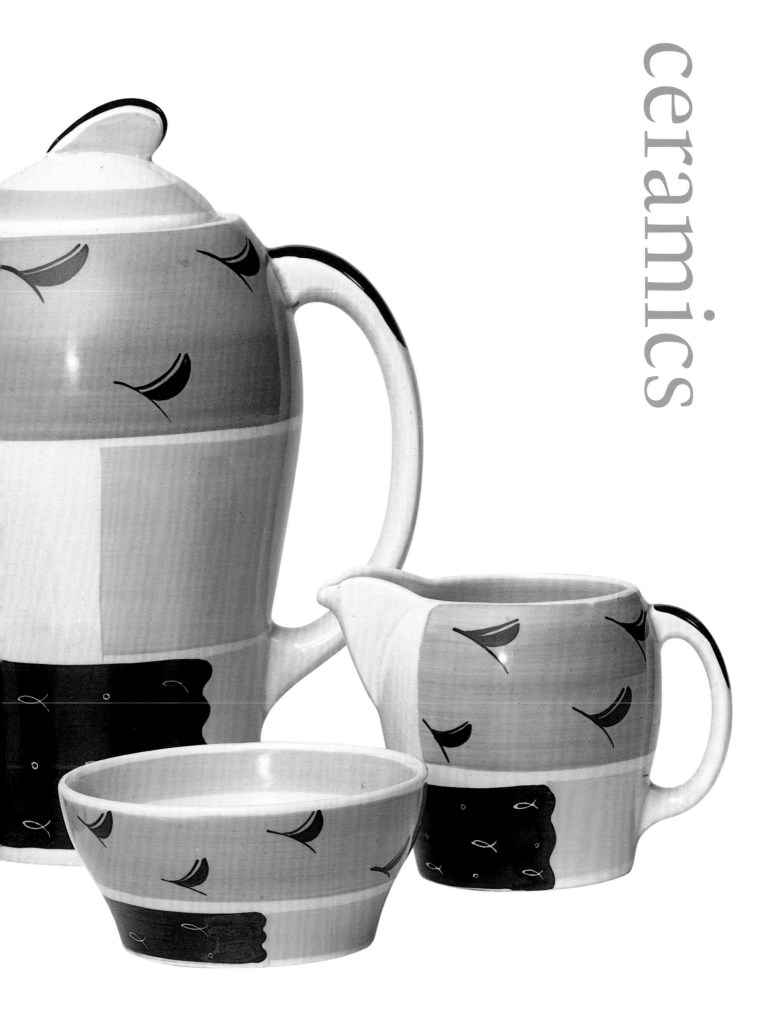

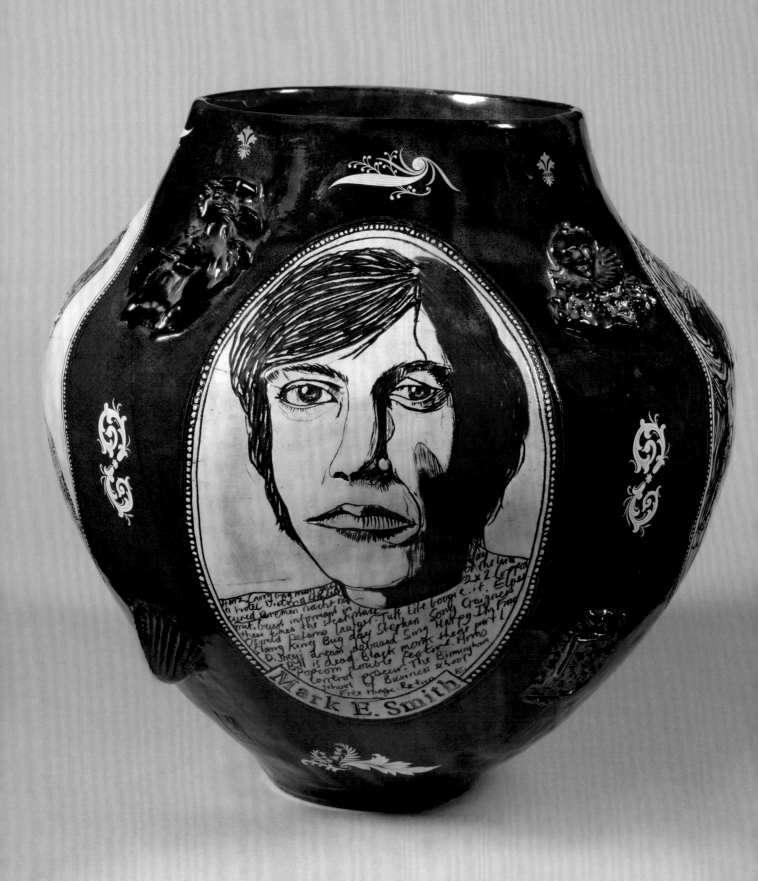

Mark E. Smith

81

'My Heroes' by Grayson Perry
Earthenware, coil-built, incised and
applied decoration, coloured slips
and glazes, enamel, gilding
England (London), 1994
V&A: C.10–2009

82

Food vessel with
whipped cord decoration
Earthenware
Britain, early Bronze Age
Museum of London (A10681)

In 2003 Grayson Perry won the Turner Prize (pl.81) – the first time in its 20-year history that a potter had been awarded the prestigious contemporary art prize. Perry's win placed ceramics firmly and indisputably at the heart of the modern art world, able to stand with confidence alongside the traditional categories of 'fine art'. The win cemented the success of the twentieth-century studio-pottery movement in Britain, yet also spoke to a much longer history of ceramics in the country. Perry's use of the traditional technique of coiling to create classical ceramic forms, and his application of complex surface decoration – built up from incised and applied work, transfers, enamels, coloured slips and glazes – goes back through centuries of developments in ceramics. At the same time, his work encapsulates some of the possibilities of contemporary ceramic art. His use of ceramics as his chosen medium to tackle politically and socially challenging subject matter, ranging from his own transvestism to child abuse, deliberately subverts the expectations of what is perceived as a traditional, unthreatening, domestic craft. The disparity between the formal simplicity and decorative complexity of his works, between their seductive beauty and the often-shocking messages they reveal on close examination, offers a contemporary approach to the age-old question inherent in ceramics of the relationship between form, decoration and function.

Clay, formed from the very earth itself, is transformed by firing from a soft, malleable substance to something that is hard and brittle, in what can seem an almost alchemical process. Ceramic objects are both unalterable and ephemeral: once fired, their form remains fixed, unable to be deconstructed and refashioned, and yet they are easily broken. Clay's transformation from an earthy and intrinsically valueless substance into highly refined, desirable and expensive objects provides one of the enduring fascinations of ceramics as an artistic medium. Despite their inherent potential for breakage, ceramics have been used for thousands of years as everyday objects that are necessary to our daily lives, associated with some of our most basic human functions.

We know from archaeological finds in London and elsewhere in Britain that from nearly 6,000 years ago clay was being used to make tiles and bricks for housing, and pots for storage, cooking, eating and drinking (pl.82), as well as burial urns for the ashes of the dead – all functions that remain associated with ceramics to this day. Handmade from sausages of clay, coiled to build up the shape of a vessel, smoothed to create an even surface and fired on an open fire, the earliest pots were often decorated with patterns imprinted by the fingertips and fingernails, cord or bird bones. From the Neolithic period onwards, experiments were made with different ceramic materials containing flints, chaff, sand or shells to produce stronger, finer wares. The potter's wheel, introduced in the first century BCE, enabled a range of cylindrical and globular shapes to be produced more quickly and easily than by hand-building. Under the Romans the intro-duction of new ceramic forms, and more sophisticated wheel and kiln technologies, increased the possibilities for ceramic production. But although archaeological finds reveal something of the pottery dating back to the

Neolithic period, its fragility means that we have only a partial picture, and one that becomes even more incomplete over the subsequent 1,000 years. The particularly brittle composition of Anglo-Saxon and early medieval pottery – using chaff, sand or ground shells – means that little survives, and it is really only from the fifteenth century that we have enough physical evidence to acquire an overview of how ceramics developed in Britain.

By around the year 1500 pottery industries existed in various parts of the country, situated close to clay beds and serving primarily local markets with functional pots, jugs, beakers and other domestic goods. Towards the end of the sixteenth century one of these was firmly established on the borders between Surrey and Hampshire, where potteries used local seams of white and coarse red clays to produce domestic wares, often decorated with a green lead-glaze made by adding copper filings to lead-sulphide in suspension; this both helped to make the pots more watertight and added to its decorative properties. Named after the location of its manufacture, 'border ware' was widely supplied across the south-east of England, with stamps on some surviving objects showing that orders were also made by institutional bodies such as the Inns of Court (pl.83). But although native productions such as 'border ware' supplied cheap functional pottery to many households, it was not enough to satisfy the British market for ceramics. Since the thirteenth century imported continental ceramics had supplied Britain with a range of useful and decorative objects, providing certain qualities that native ceramics could not. German stoneware offered a strong and watertight material in the form of cheap drinking mugs and bottles, while the increasing desire for decorated pottery was catered to by lead-glazed earthenwares from France, with relief-moulded or incised *sgraffito* decoration (scratched through the surface to reveal a contrasting colour beneath), and by tin-glazed earthenwares from Italy and the Netherlands.

83
Candlestick decorated with the badge of the Inner Temple, London
Earthenware, partially lead-glazed
England (Surrey/Hampshire borders), 1580–1620
V&A: 4326–1901

Originating in Iraq and imported to mainland Europe via Moorish Spain, polychrome tin-glazed earthenwares were made and exported, primarily from Italy, from the fifteenth century onwards. They were distinguished from lead-glazed earthenwares by their opaque milky-white glaze, created by adding tin oxide to a conventional lead-glaze. This was the first truly white surface in European ceramics – and, as such, the perfect blank canvas for potters and artists to experiment with pictorial possibilities in a way that had not previously been possible. Italian potters moving to other parts of Europe took their knowledge and craft with them, disseminating their techniques and styles to locations including Hungary, Spain and, especially, the Netherlands – where Antwerp, one of the richest sixteenth-century cities in Europe, with a thriving merchant population and trade links to the export market via the North Sea, proved an extremely profitable market for their wares.

84
Pharmacy jar
Tin-glazed earthenware, painted
England (probably London),
1675–85
V&A: C.187–1991

85
Tile by Jasper Andries
and Jacob Jansen
Tin-glazed earthenware,
painted in colours
England (possibly Norwich),
1564–8
V&A: 4603–1863

Over the course of the sixteenth century Antwerp became an increasingly dangerous place to work. Following the Protestant Reformation, the Catholic Habsburg rulers of the Spanish Netherlands carried out waves of persecution against their Dutch Protestant subjects, who increasingly came to regard Protestant England as a safe haven. In 1567 two such Protestants, the Antwerp potters Jacob Jansen and Jasper Andries, arrived in Norwich, where they established themselves as manufacturers of tin-glazed earthenwares. Although a petition to Queen Elizabeth in 1570 for the right to practise their trade on a riverside site in London was unsuccessful, Jansen established a pottery in Aldgate the following year, where he was assisted by six other Flemish potters; meanwhile Jasper Andries, together with his brother Lucas, set up his own pottery in Colchester. They found a ready market for their goods, particularly for pharmacy jars and decorative tiles (pls 84 and 85), for which the clean white, washable surface of tin-glazed wares was considered appropriately hygienic. Their work paved the way for the seventeenth-century development of the tin-glazed earthenware industry in Britain, largely due to one key factor that changed the course of Europe ceramics.

86
Kraak-style ewer with
silver mounts
Wan Li porcelain with
silver mounts
China (mounts England),
c.1600–10
V&A: M.220–1916

87
Design for a china closet
by Daniel Marot
Etching
The Netherlands, c.1700
V&A: E.1672:20–1888

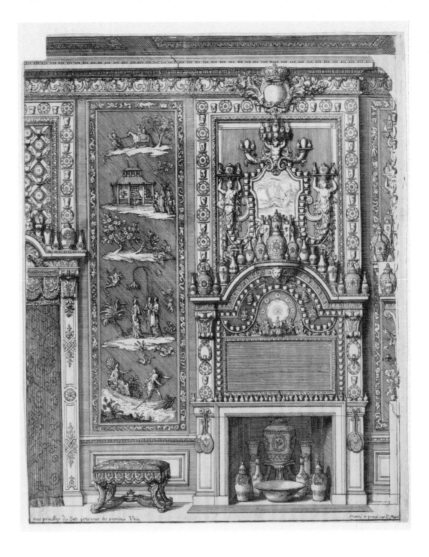

In 1602 the Portuguese galley *San Iago* was captured by the Dutch. Its contents – a cargo of Chinese porcelain – were auctioned to great excitement in Europe, as were those of a second captured ship, the *Santa Caterina*, two years later. Chinese porcelain was rare and already highly prized in Europe, but the capture of these two galleys created a significant new market for blue-and-white Chinese pottery. To meet the demand the Vereenigde Oostindische Compagnie (Dutch East India Company), founded in 1602, began importing porcelain commercially from China from 1610, followed by the English East India Company from 1637, both companies later also importing it from Japan. Exotic, finely potted, hard and strong, of a more perfect white than had ever been seen on ceramics in Europe and almost translucent at its thinnest, oriental porcelain seemed almost magical. It rapidly became the desirable commodity of choice, acquired and collected at the very highest levels of society (pl.86).

Lacking knowledge or understanding of its composition or manufacture, native manufacturers tried to capitalize on the market for Chinese porcelain by developing their own rival ceramic goods. Tin-glazed earthenwares were the European ceramics most visually similar to Chinese porcelain, and pottery manufacturers adapted accordingly. In the Netherlands polychrome decoration was largely discontinued in favour of blue-and-white, often incorporating Chinese-inspired motifs, and was exported from Delft in such large quantities that it became known as Delftware. British tin-glazed manufacturers – mostly based in London, but with links to the Netherlands – followed their example.

Delftware catered in particular to one specific aspect of the 'porcelain mania' that built throughout the seventeenth and eighteenth centuries: the vogue for small-scale interiors entirely decorated with blue-and-white ceramics, which was taken up enthusiastically in aristocratic circles across Europe (pl.87). In France, Louis XIV built a garden pavilion for his official mistress, Madame de Montespan, in 1670–71, decorated with blue-and-white ceramic tiles and known as the Trianon

88
**Plaque showing Charles II
in the 'Boscobel Oak'**
Tin-glazed earthenware,
painted in colours
England (probably London),
c.1660–70
V&A: C.360–2009

89
Charger showing Charles I,
probably made by the
Pickleherring Pottery
Tin-glazed earthenware,
painted in colours
England (Southwark, London),
1653
V&A: C.71–1998

de Porcelaine. Following the Glorious Revolution of 1688, Queen Mary brought her already extensive collection of Delftware to Hampton Court, where she had a Delftware closet and a dairy decorated with tiles, vases and other vessels supplied by the 'Greek A' factory of Adrianus Kocks in Delft.

In Britain tin-glazed earthenware was used for an increasing range of functional and decorative wares. In addition to pharmacy jars, tiles and tablewares, it was used to make large display dishes, painted with figurative and narrative subjects including Bible scenes, allegorical figures and episodes from ancient history, often based on contemporary prints. Tin-glazed earthenware also became the material of choice for celebrating significant political or historical events.

One specific plaque is typical of commemorative ceramics of this type (pl.88). It celebrates a particular moment in the Civil War: the flight of Charles II from parliamentary troops after the Battle of Worcester, and his successful escape from capture by hiding in an oak tree in Boscobel in Shropshire. The plaque bears the image of Charles II and the three crowns of England, Scotland and Ireland within the branches of the Boscobel oak. Mounted in a frame made from the bark of an oak

tree, it proclaims the anonymous owner's loyalty to the royalist cause and celebrates the restoration of the rightful monarch to the throne. Sometimes such royalist ceramics can be rather more subversive than they initially seem. At first glance a charger such as pl.89 appears relatively innocuous: it bears a portrait of Charles I with his three male heirs, and as such one might assume it to have been made during the king's reign. However, by 1653 (the date at the top of the dish) Charles I had been dead for four years, executed for high treason in 1649. At the time the charger was made, such an overt display of royalist loyalty would have been a treasonable offence, but the plate's survival provides us with a clear indication of the continuing current of royalist support during the Civil War and Commonwealth.

Although tin-glazed earthenwares were capable of imitating the decorative aspects of porcelain, they had several practical drawbacks. They were soft and chipped easily, but more problematically they were porous and unable to withstand high temperatures. Prior to the seventeenth century these were not particularly serious problems: they could be used to serve food if not to cook it, and to serve drinks such as posset (spiced ale curdled

with milk) that were warm rather than hot. During the seventeenth century, however, this became a key concern. When Chinese porcelain was first imported to Europe it was prized in part for its association with another commodity that would irreversibly alter British habits: tea. Although the East India Company did not begin to import it commercially until 1678, tea was already well established at the English court by that date, thanks particularly to its promotion by the restored Charles II, who had acquired a taste for it while in exile in France, and his queen Catherine of Braganza, who was familiar with it from imports to her native Portugal. New, exotic and attributed with medicinal properties, tea was extraordinarily expensive and so could only be afforded by the very wealthiest members of society.

At this elite level, tea-drinking rapidly became the ultimate fashionable ritual (pl.90). Although it was often drunk after dinner by ladies, while men indulged in alcoholic drinks, it could be served at any time of day, providing the opportunity for a social gathering accompanied by polite conversation. Most importantly, it enabled hosts to demonstrate their wealth, social status and refinement through their possession of the new and expensive equipment required for the preparation, serving and drinking of tea. In addition to a teapot, cups and saucers, tea canisters, a milk jug, sugar bowl and slop basin were also required – all objects new to Britain. Some of these were supplied by porcelain imports, such as tea bowls (used as handleless teacups), while others were initially made in silver – the expense of the vessels befitting that of the drink they held. As the consumption of tea extended to a wider social sphere, British makers sought to cater to this new market – and that for other hot drinks introduced to Britain in the seventeenth century: coffee from Turkey and chocolate from Mexico, imported via Spain.

In China the material most commonly used for teapots was a type of red unglazed stoneware made in the town of Yixing (see pl.94). These red stonewares were valued for the preparation of tea because, despite their lack of glaze, they could withstand heat and, as a Chinese tea connoisseur of the time wrote, 'they drive away the smell of boiled water but do not rob the tea of its aroma'.[1] We know from examples embellished with silver mounts after their arrival in Europe that Yixing teapots were imported to Europe from around the mid-seventeenth century, and were soon being imitated in Holland.

In 1672 the Oxford-educated lawyer and chemist John Dwight, one of the greatest ceramic experimenters of his age, discovered how to make salt-glazed stoneware and immediately patented it. Originally imported to Britain from Germany via the Netherlands, stoneware was extremely strong, its particles fusing into a semi-vitreous and impermeable substance when fired at a very high temperature. As such, it was ideal for drinking vessels (pl.91), for it was watertight even when left unglazed.

The invention of salt-glazing, discovered in the Rhineland in the fifteenth century, made stoneware even more useful. Adding salt to the kiln created a glaze that fused with the stoneware body, making it even stronger and more resistant to heat and liquids. Dwight's Fulham Pottery produced a range of vessels in brown and white stoneware in the style of traditional German forms, such as bottles and gorge mugs for strong ale. His white stoneware was the first British material to be sufficiently refined to imitate Chinese porcelain. He realized its potential, employing professional modellers to produce a series of delicate ceramic sculptures, including two figures of his daughter Lydia (pls 92 and 93), who died in 1674 aged six. These two figures, one showing Lydia lying on her deathbed and the other triumphantly resurrected, display an astonishing quality in the modelling of the figures and the delicacy of details. They reveal Dwight's ambition for his new material as a medium for artistic and sculptural objects as well as functional wares, something previously unseen in British ceramics.

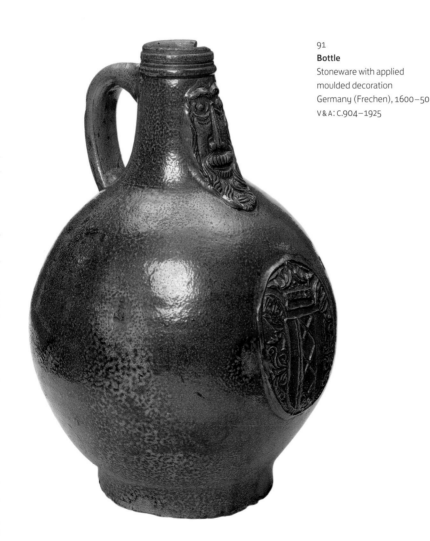

91
Bottle
Stoneware with applied
moulded decoration
Germany (Frechen), 1600–50
V&A: C.904–1925

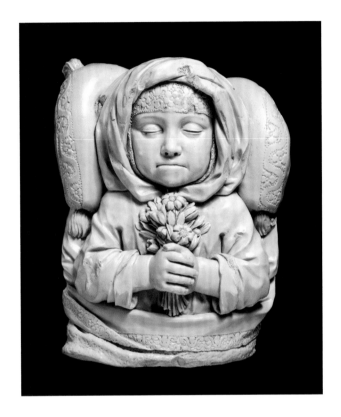

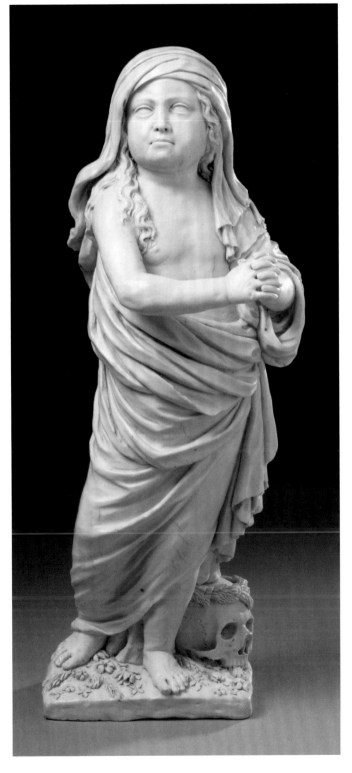

92
Lydia Dwight Dead
Stoneware, hand-modelled
and salt-glazed
England (John Dwight's
Fulham Pottery, London),
1674
V&A: 1055–1871

93
Lydia Dwight Resurrected
Stoneware, hand-modelled
and salt-glazed
England (John Dwight's
Fulham Pottery, London),
1674
V&A: 1054–1871

In addition to his salt-glazed stonewares Dwight took out a patent in 1684 for what he called 'opacous redd and dark coloured Porcellane or China' – the same kind of red stoneware used in Yixing wares (pl.94). Six years later two silversmith brothers of German origin, John Philip and David Elers, who had settled in the Netherlands before moving to London, discovered an iron-rich seam of red clay at Bradwell Wood in Staffordshire, which meant that they too had the natural resources required to make red stonewares (pl.95) – in contravention of Dwight's patent. As silversmiths, they lacked throwing skills and were unwilling to employ professional throwers because of the risk of industrial espionage, so the Elers brothers chose instead to preserve the secrecy of their operation, adapting silversmithing techniques to the ceramic production process, notably casting. Slip-casting, as it became known, involved pouring 'slip' (liquid clay) into a mould to create a thin clay lining, which would then be left to dry, shrinking as it did so. This could be used for a variety of hollow and solid shapes, which could then be pieced together to form complete vessels, finished by turning them on a lathe to even out their surface. When used to create cylindrical or spherical forms such as gorge mugs and teapots, this process

required several stages of casting and was extremely labour-intensive, in marked contrast to throwing, which could produce a similar shape in just a few minutes on a wheel. While the technical capabilities of the Elers brothers were considerable, as the thinly potted shapes and delicate sprigged decoration (imitating the *Prunus* blossom of Yixing ceramics) of their wares show, their lack of understanding of traditional potting techniques made their production of ceramics commercially unviable. In 1700 they were declared bankrupt, but their legacy was not insignificant, as it paved the way for future potters in two key respects: the use of slip-casting and lathe-turning, and the production of high-quality, finely potted ceramics in Staffordshire.

Staffordshire had been home to small-scale potteries from the mid-seventeenth century, being well suited to the production of ceramics due to ready supplies of clay and coal. In the second half of the century several specialized producers of slipwares were based in the region. Influenced by Dutch imports, these earthenwares were made using two contrasting colours of clay. The body of a dish or pot was made in one colour, and then liquid slip in a contrasting colour was trailed or dotted over the surface, using a pointed tool or a spouted jug to

94
Teapot by Hui Mengchen
Red stoneware, hand moulded, with applied sprig-moulded decoration and silver-gilt mounts
China (Yixing, Jiangu Province), 1627 (with later European mounts)
V&A: C.16–1968

95
Teapot by David and John Philip Elers
Red stoneware, slip-cast, with applied sprig-moulded decoration
England (Bradwell Wood, Staffordshire), 1690–98
V&A: C.17–1932

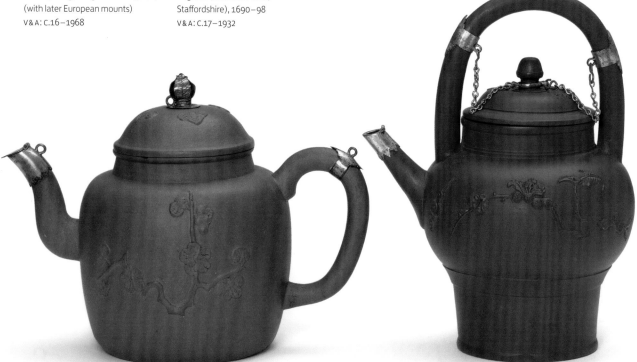

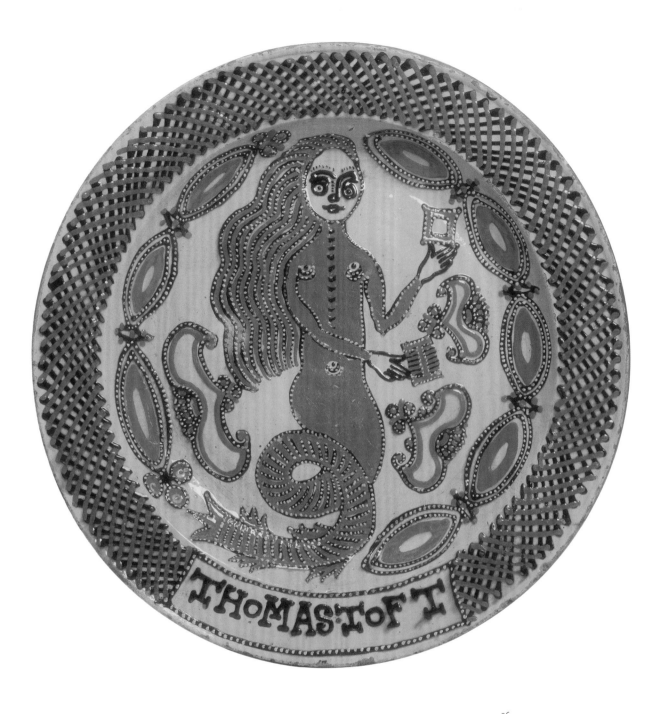

create a decorative pattern, ranging from dots, lines and
cross-hatching to free figurative designs, as seen on some
of the most ambitious slipwares: large display chargers
such as the Mermaid Dish (pl.96), signed by its maker
Thomas Toft, which show a particularly sophisticated
level of design and execution. The signatures on these
chargers, together with the fact that they reveal little
evidence of use, imply that they can only have been made
for display; indeed, the prominence of the maker's name
suggests that they may have been made for marketing
purposes, advertising their everyday wares, such as jugs,
bowls and posset pots.

96
The Mermaid Dish
by Thomas Toft
Lead-glazed earthenware,
with trailed slip decoration
England (Staffordshire), 1670–89
V&A: 299–1869

97
**Teapot in the form
of a cauliflower**
Lead-glazed earthenware,
moulded
England (Staffordshire),
c.1760
V&A: 414:1066–1885

Until the early eighteenth century Staffordshire was, like other rural centres of pottery production in Britain, a relatively small-scale and localized operation, in contrast to the more sophisticated Delftware manufacturers based primarily in London. It was far from the trade routes and from the influence of fashionable developments on the continent, yet over the course of the eighteenth century Staffordshire emerged as the very nucleus of the British ceramics industry. North Staffordshire had coal measures and clay, but the local clays were a coarse reddish-brown and yellow, rather than the white-firing clays needed to produce more sophisticated and desirable goods. In the first half of the eighteenth century improvements to transport networks, including the opening of turnpike roads and, particularly, the opening of the River Weaver to navigation in 1733, increased access from the Potteries – as the six towns that make up Stoke-on-Trent would come to be known – to the wider world. The new river route to Liverpool meant that white-firing clays could be shipped from south-west England to the Potteries where, mixed with ground flints and then salt-glazed, they could produce the type of hard white stonewares that Dwight had pioneered at Fulham. These could in turn be transported to the metropolitan markets of London – using the new turnpike roads – or through the waterways to Liverpool and on to the American colonies.

At the same time the techniques of manufacturing ceramics in Staffordshire were changing dramatically, as the workforce became ever more specialized and production processes more discrete. Moulds (in the manner of the Elers brothers) were used increasingly from the 1740s in order to make forms that could not easily be thrown on a wheel. Slip-casting and press-moulding – pressing clay into moulds by hand, creating thicker and heavier forms than slip-cast vessels – could be used to produce complicated forms in bulk, while techniques such as lathe-turning, stamping and 'sprigging'

– applying separately cast pieces of low-relief ornament to the body of a vessel, using slip to fix them – could be employed to decorate and finish them. New, less-toxic glazes were created; two-stage firing (which allowed for greater product control and further specialization of labour) was introduced; and, in the early 1750s, transfer-printing began to enable large numbers of ceramics to be decorated cheaply and quickly with identical high-quality designs in the latest styles.[2]

The Staffordshire ceramics industry flourished by continuing to meet the demand created by new eating and drinking habits established in the previous century. The expanding market for drinks such as tea, coffee and chocolate meant a steady demand for fine, strong vessels that could withstand hot liquids and play a role in the elegant rituals of their consumption. In addition, gradual shifts in dining practices led to a greater proliferation of different types of dining vessels, and towards a wider range of materials on the table. Initially the desire for variety was catered to by oriental porcelain at the highest levels and by tin-glazed earthenware at lower levels, but during the latter part of the eighteenth century the ceramic manufacturers began to cater to an ever-expanding market for fine, robust and attractive tablewares.

Since the first imports of Chinese porcelain, European pottery manufacturers had sought to discover the secret of how to make this 'white gold', which was so superior to their own ceramics in both aesthetic and practical terms. When Johann Friedrich Böttger succeeded in doing so in 1708 – working under the sponsorship of Augustus the Strong, Elector of Saxony – the Meissen factory near Dresden not only began to produce and export the first European hard-paste porcelain, to great demand, but also encouraged a porcelain race between other rulers and aristocrats to establish their own manufactures to do the same and tap into this lucrative market. With Meissen secrets being spread through industrial espionage

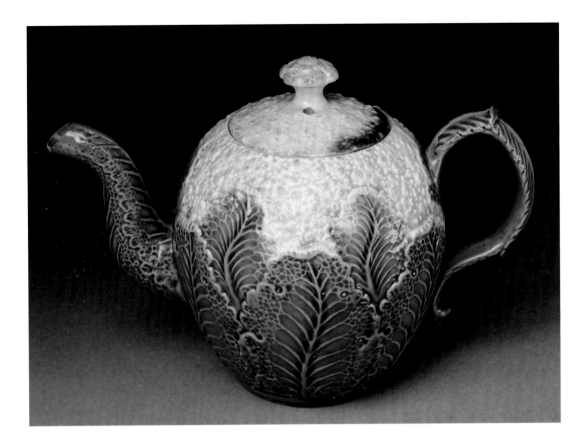

and the defection of workers, factories were set up across Europe.

In Britain the first porcelain manufactures were established in the 1740s at locations ranging from London to Liverpool and from the West Country to Suffolk, their sites being chosen for their access to markets (principally London), the coast (for access to materials and American colonies) or Staffordshire (with its available and trained workforce).[3] Not knowing where the crucial ingredients of china clay and china stone might be found, these manufactures (like many of their continental counterparts) could not produce true porcelain, but made 'soft-paste' – an imitation material that combined white-firing ball clays with various materials, such as glass, sand and calcined flint – to mimic the effect of the elusive china stone. By the later 1750s each manufacture had developed its own formula: Chelsea, Longton Hall and Derby used glassy bodies; Bow used bone-ash as a strengthening and whitening agent; and Bristol and Worcester incorporated soaprock, a natural mix of china clay and magnesium silicate.[4] But although soft-paste porcelain was a relatively successful imitation, it was fired at a much lower temperature (about 1100–1500 °C) that was difficult to control, and was a much more volatile body, which led to large numbers of kiln-wasters. Only in 1768 with the patenting of hard-paste porcelain

by William Cookworthy of Plymouth, who had discovered china clay and china stone in Cornwall, could true porcelain start to be produced in Britain.

Into this already expanding ceramics industry – spread across the country, linked by an improved transport infrastructure, advanced by technical innovations already made in Staffordshire and elsewhere, and with the first products of the new porcelain factories appearing – arrived Josiah Wedgwood. The wealth of documentation that exists around him has led to a privileging of his importance above those of his peers in furthering British ceramic production, but it is certainly true to say that his artistic and entrepreneurial ambition, tireless experimentation and canny marketing, as well as the range and quality of his wares, mark him out from many of his competitors.

In 1754 Wedgwood went into partnership with the potter Thomas Whieldon at Fenton Vivian, having been apprenticed to his older brother Thomas Wedgwood in 'the Art of Throwing and Handleing' 10 years earlier.[5] Josiah immediately began to experiment with ceramic materials and glazes – as he did all his life – most notably producing a green lead-glaze, introduced in 1759, which he applied to tea and tablewares, including 'cauliflower' wares (pl.97), which were then in vogue. However, it was when Wedgwood set up on his own that his experiments

really started to bear fruit. In the 1730s the Staffordshire potteries began to produce a kind of earthenware that had a similar composition to stoneware – a combination of white-firing clays and calcined flints – but was fired at a lower temperature and glazed with a clear lead-glaze, fixed with a second firing, to make it watertight. Wedgwood succeeded in perfecting the material to such a degree that it was pale enough to provide the ideal surface for decoration with enamel painting or transfer-printing, but could also be left undecorated. As such, creamware (as it became known) was ideal for tablewares. Pale, smooth and clean,

it was cheaper and more refined than stoneware, and so offered the perfect solution to those parts of society that could not afford expensive porcelain, but had a taste for elegant wares. In 1766 Wedgwood supplied a creamware tea service to Queen Charlotte, which enabled him to style himself 'Potter to the Queen' and to rename his creamware 'Queen's Ware' – instantly rendering it even more desirable, and lifting earthenware for the first time in Britain to a status similar to that enjoyed by porcelain.

Creamware, possibly Wedgwood's greatest contribution to the development of British ceramics, captured

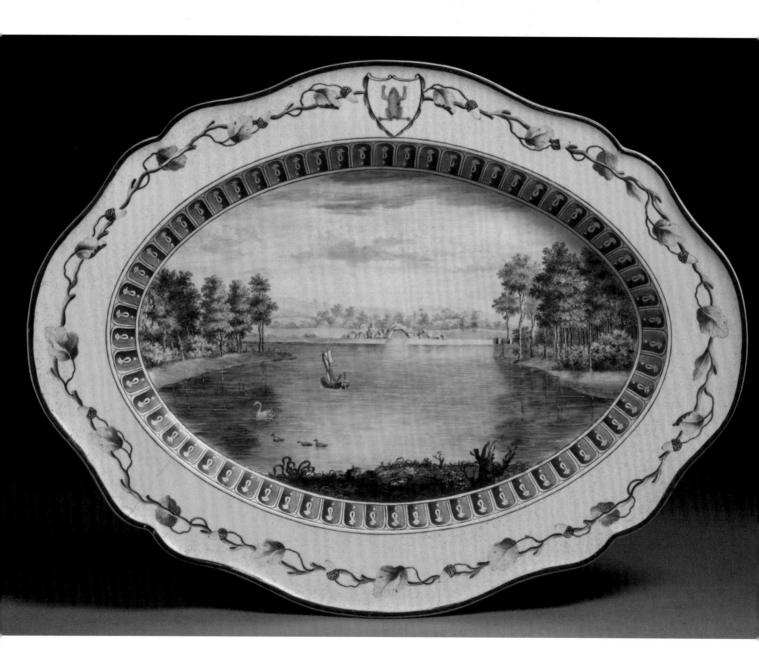

98
Plate from the
'Frog Service' made by
Josiah Wedgwood's Factory
Creamware (Queen's Ware),
painted in enamels
England (Staffordshire
and London), 1773
V & A: C.74–1931

a significant market not only in Britain, but also abroad. Catherine the Great, Empress of Russia, commissioned Wedgwood to make a creamware dinner and dessert service for her new summer palace at Kekerekeksinen ('Frog Marsh' in Finnish) in 1773. The palace was built in the newly fashionable Gothic Revival style, in keeping with the empress's taste for all things English. The Frog Service, as it was called, was not the first ceramic order that Wedgwood had supplied to Catherine: in 1770, largely through the agency of Lord and Lady Cathcart (the ambassador to St Petersburg and his wife), he supplied her with a 24-setting dinner and dessert service of creamware with enamelled decoration. However, the Frog Service was an entirely different scale of commission: rather than 24 settings, it needed to serve 50 people, and had to be decorated in monochrome enamels with a different scene of Britain on each piece, as well as the green frog motif that gives the service its name (pl.98). Sourcing and executing enough views to decorate 952 pieces of cream-ware represented a considerable challenge and financial outlay, with no guarantee of payment on completion, but Wedgwood was able to turn it to his advantage, fully exploiting the Frog Service's marketing possibilities at home. When selecting views he not only chose Gothic buildings, landscape gardens and contemporary industrial sites (such as Coalbrookdale) that were designed to appeal to Catherine's 'Anglomania', but also the estates of the aristocracy and gentry – particularly those of Wedgwood's patrons and neighbours – intending to ensure their continued support. Wedgwood further capitalized on the commission by exhibiting the service at his Greek Street showroom in London (by ticketed admission only, to ensure its exclusivity) before it was sent to Russia. To avoid the possibility of alienating any viewers whose estates had not been depicted, the service was exhibited unfinished, so that if complaints were made, there was

time to rectify any omissions in the 150 pieces that remained to be decorated.[6]

This kind of astute marketing marked Wedgwood out from his competitors, and he was greatly aided in it by his partnership, from 1768 to 1780, with Thomas Bentley. Equipped with the necessary classical education to provide him with connections to the highest levels of society, Bentley was the perfect complement to Wedgwood's practical and technical skills. Through him, Wedgwood was linked to a network of leaders of taste of the day, knowing that if his wares were successful at the upper levels of society, then the 'middling' classes, which offered a larger market, would follow their example. Throughout their partnership Bentley based himself in London, where in 1769 they opened a showroom to exhibit and market their wares, profiting from the new vogue for shopping as a fashionable pastime, particularly among ladies. From London, Bentley could inform Wedgwood about the latest styles and fashions, meaning that Wedgwood could adapt his wares to suit. Through Bentley, Wedgwood was introduced to some of the most important aristocratic antiquarians and collectors of the period – such as Sir William Hamilton, the British ambassador to Naples – who as well as patronage, provided source material for new designs through their collections. Additionally they could grant access to their architects, most notably Robert Adam, James 'Athenian' Stuart and William Chambers, which would prove particularly crucial during the 1770s.

Since the archaeological excavations of the ancient Roman sites of Pompeii and Herculaneum in the 1730s– 40s, interest in the classical world had been revived among collectors of antiquities and architects, who were inspired to design buildings and interiors in the new neoclassical style. The central motif of this style was the vase, which reached such levels of popularity around 1770

that the fashion for collecting and displaying vases became known as 'Vasemania'. Wedgwood sought to satisfy this demand, producing ornamental vases in a variety of materials to suit different tastes and phases in fashion: creamware, variegated wares (imitating hard-stones) and a new material, 'black basalt', first marketed in 1768. Black basalt, which Wedgwood described as 'a fine black Porcelain', was actually a fine-grained stoneware made from a black clay (it was derived from iron oxide suspended in water that had flowed through coal seams). With it, Wedgwood imitated what he thought were Etruscan ceramics (although in fact they were ancient Greek), making objects ranging from library busts to ornamental vases (pl.99). Black basalt's sombre finish provided an alternative to the 'gaudy' vases produced by the porcelain factories of the day, and appealed as tea and coffee services to ladies, whose hands would seem particularly white and delicate against the black material.

Impervious to liquids, black basalt could either be left unpainted or decorated with 'encaustic' painting, which Wedgwood patented in 1769 and was composed of a mix of enamel paints and slip, intended to imitate ancient-Greek vases.

In seeking to cater to this overwhelming demand, Wedgwood needed to ensure that his designs were sophisticated and diverse enough to satisfy the desire for fashion, novelty and invention. He looked beyond sources such as Hamilton, whose extensive collection of antiquities was published in four volumes from 1766, and took inspiration from existing vases such as those produced by the Sèvres porcelain manufacture in France, and prints by contemporary and seventeenth-century designers such as Jacques Stella, Stefano della Bella and Johann Fischer von Erlach. Together, these provided Wedgwood with a stock of forms and interchangeable details such as handles and ornaments, which he used to provide even greater

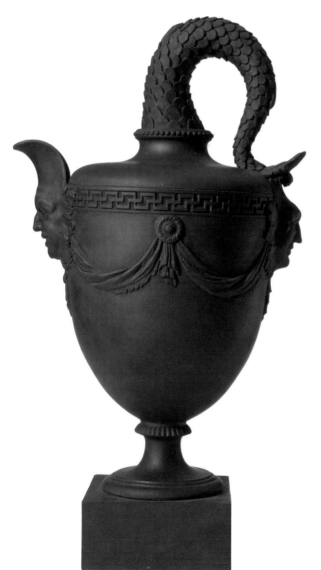

99
'Black basalt' vase made by Josiah Wedgwood's Factory after a design by Jacques Stella Black basalt with applied and moulded decoration in relief England (Staffordshire), 1769–80 V&A: 2398–1901

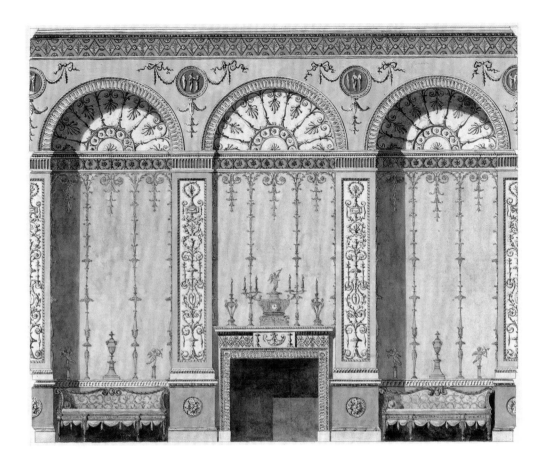

100

Design for one wall of the Book Room at Kedleston Hall, Derbyshire, by Robert Adam
Pen and watercolour on paper
England, 1768
Kedleston Hall (National Trust)

101

Tray of jasper trials by Josiah Wedgwood's Factory
79 pieces of jasper, mounted in a wooden tray
England (Staffordshire), c.1773–6
Wedgwood Museum, Barlaston

variety and choice for his customers. By August 1772 he had built up a repertoire of more than 100 forms of vase, in his self-proclaimed aim to become 'Vase Maker General to the Universe'.[7]

Wedgwood also sought to appeal to neoclassical taste by developing an entirely new ceramic body that would complement the fashionable interiors designed by the architects Robert Adam and James Wyatt (pl.100). These integrated design-concepts unified interiors in all their movable and immovable elements – from ceiling decoration to carpets, furniture and ornaments – and employed strong colours, influenced by the study of surviving classical interiors. Wedgwood devoted himself to developing a stoneware body that could be stained with pigments to match neoclassical colour schemes, and decorated with white low-relief ornament: jasperware (pl.101). He hoped that it would prove popular not only with consumers, but also with the architects themselves. Making jasperware did not prove straightforward: numerous problems were encountered in firing, resulting in blistering, cracking, crazing and irregularities in its surface and colour. Additionally, because cobalt (the principal colouring agent needed for blue jasper) was

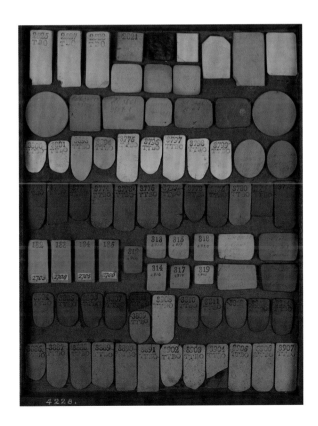

102
'First Edition' copy of the Portland Vase by Josiah Wedgwood's Factory, modelled by William Hackwood and Henry Webber (with base, below) Jasper with black 'dip' and white reliefs England (Staffordshire), *c.*1790
V&A: CIRC.732–1956

103
Tea service, made by the Spode Ceramic Works Bone china painted in enamels and gilded England (Staffordshire), *c.*1825
V&A: 557–1902

extremely expensive, there were serious doubts about its commercial feasibility, until Wedgwood discovered the technique of creating a jasper 'dip', by using a coarser white body that was then dipped in coloured jasperware slip. This meant that less cobalt was used, and also strengthened the ceramic, making it more financially viable.[8]

Jasperware was the chosen material for Wedgwood's last and most ambitious achievement, a copy of the Portland Vase, at the time the most famous surviving antiquity from ancient Rome. Made in *c.*30–20 BCE from dark-blue translucent glass, with relief decoration in cameo-cut opaque white, the vase was well known for its technical virtuosity and illustrious provenance. When the vase passed to the third Duke of Portland in 1786, it was loaned to Wedgwood in order that he might study it. After three years of experimentation and problems with cracking, blistering and the lifting of the sprigged reliefs, in 1790 he exhibited his first copies of the Portland Vase (pl.102) by ticket admission. Tapping into the new vogue for exhibition-going, as he had done with the exhibition of the Frog Service, Wedgwood succeeded in promoting his astonishing technical and artistic achievement – the greatest of a British potter to date – to the most elevated audience.

Wedgwood succeeded in advancing pottery production to an astonishing extent. He deliberately made and marketed ceramics to suit a spectacular range of tastes and budgets, and was elected to the Royal Society in 1783 for his invention of a pyrometer – a scientific instrument that measured the heat of a kiln by the degree of shrinkage of the clay being fired within it, and could thus regulate its temperature. Furthermore, by his death in 1795 he had constructed a modern model factory on the new Trent and Mersey Canal, which had created water access from the Potteries to both the west and east coasts of England. His factory, which he named Etruria, was the epitome of sophisticated planning, housing the processes for the production of ornamental wares (produced in partnership with Bentley) at one end and useful wares at the other, with a series of small workshops for each arranged in the order of the production processes.

Wedgwood's success can be measured by his effect on other pottery industries: very few manufactures of tin-glazed earthenwares could survive beyond the 1780s, their goods unable to compete with the much harder-wearing and sophisticated creamware. At the opposite end of the scale the British porcelain manufactures – which (apart from Chelsea, supported by Sir Everard Fawkener, secretary to the Duke of Cumberland) lacked

the royal or aristocratic sponsorship of their continental counterparts, and so were often rather precarious commercial ventures – were often (again, apart from Chelsea, which aimed at the highest levels of society) competing for the same market as Wedgwood: the middle and lesser gentry who needed attractive, but affordable, functional wares. They could hardly compete with Wedgwood's earthenwares, which were not only more affordable and more reliable than porcelain, but also had the seal of approval of authoritative figures such as the Queen of England and the Empress of Russia. Wedgwood's was the most successful ceramic factory of the third quarter of the eighteenth century, succeeding Meissen and Sèvres – an achievement all the more remarkable because he never produced porcelain. His success would be fully appreciated in the nineteenth century, as expounded by William Gladstone in 1848: 'the greatest man who ever, in any age or country, applied himself to the important work of uniting art with industry'.[9]

By the end of the eighteenth century Britain had succeeded in producing its three greatest contributions to ceramic history: the development of creamware, transfer-printing and bone china. This last took place at the very end of the century, when the East India Company stopped importing Chinese porcelain, an event that coincided with the expiry of William Cookworthy's 1768 patent for hard-paste porcelain, enabling other porcelain and pottery manufactures to move to fill the gap in the market. In the 1790s Josiah Spode developed a formula for bone china composed from the ingredients of hard-paste porcelain and calcined bone-ash in equal quantities, making a stronger, whiter and more translucent body. Bone china was rapidly taken up by the major existing ceramics manufactures in Staffordshire, as well as the newly formed Spode and Minton, mass-producing affordable and elegant tea and dinner services in matching sets (pl.103) for polite eating and drinking rituals, not only in Britain, but around the world.

In the nineteenth century the Staffordshire potteries expanded still further into international markets for both functional and ornamental ceramics. With further shifts in dining habits – from dining *à la française* to dining *à la russe* (see Chapter 2) – and the affordability of bone china, a gradual move away from silver to ceramics on the table (together with glass and flowers) was largely

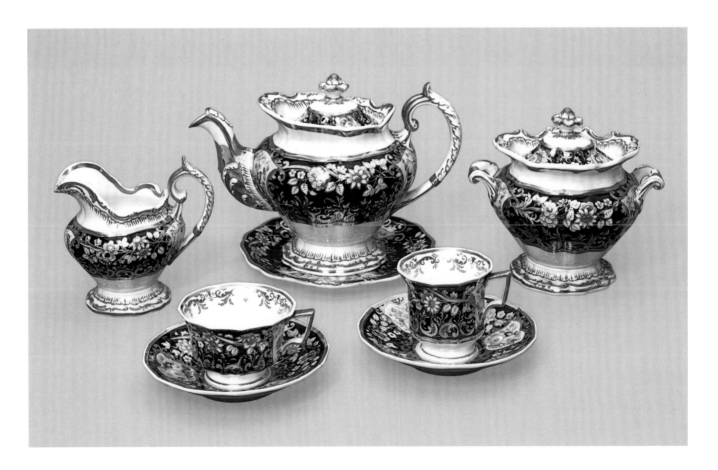

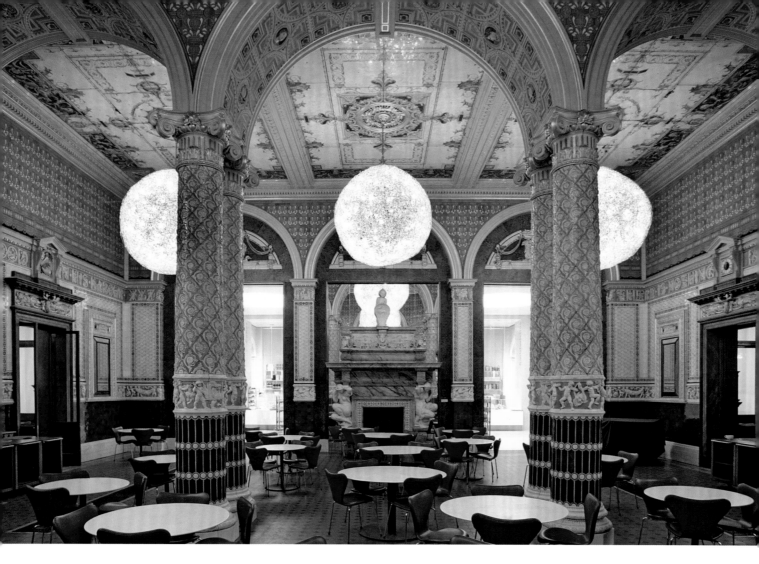

completed. At the same time, the fine porcelain figures that had developed in the eighteenth century as table decorations for the dessert – the 'harlequins, gondoliers, Turks, Chinese, and shepherdesses of Saxon China' that Horace Walpole had referred to in 1753 – were imitated on a huge scale in earthenware, and manufactured as cheap flat-back ornaments for mantelpieces.[10]

By 1850 Britain was one of the greatest producers and exporters of manufactured goods in the world. Its technical and industrial achievements were undeniable, even if there were murmurings about the quality of British design. The Great Exhibition of 1851, and other international exhibitions that followed, provided an opportunity to showcase British design and manufacturing in works of astonishing technical virtuosity, which was taken up enthusiastically by ceramic industries such as Minton & Co. Contemporaneously, with the Gothic Revival, ceramic tiles were used increasingly as interior furnishing, with screw-pressed encaustic tiles made by

Minton's (inspired by medieval examples) being used for the floors of newly constructed churches in the Gothic style – as well as for the refurbishment of certain medieval churches. Similarly the hygiene benefits of glazed ceramic tiles were acknowledged by the designers of restaurants, such as that of the South Kensington Museum – the first museum restaurant in the world. Designed by James Gamble in 1866, the Centre Refreshment Room (now known as the Gamble Room), like the museum, was intended to showcase modern design, manufacturing and craftsmanship. It was paved with encaustic tiles, its walls and columns clad with Minton tiles and friezes using their new opaque-coloured 'majolica' glazes, which they had launched at the Great Exhibition and which imitated Renaissance ceramics (pl.104). Extremely colourful, the tilework was also very practical and easy to clean.

Towards the end of the nineteenth century, as Britain's position as the dominant world power waned,

the industrialization that had been regarded so highly earlier in the century began to lose its shine for certain practitioners and designers of the decorative arts. In the 1860s the critic John Ruskin attacked the division of labour in industrialized manufacturing processes and the poverty of factory workforces, while the founders of the Arts and Crafts movement became increasingly concerned by what they saw as the subservience of man to machine in the manufacturing process, and its link to the moral decline of society as they saw it. The Arts and Crafts movement sought to revive traditional skills of hand-crafting, and encouraged a return to the idea of a direct relationship between designer and maker – lost in the multi-stage processes of industrial production. William De Morgan, who designed tiles and stained glass for Morris, Marshall, Faulkner & Co. before opening his own studio in 1872, produced new and inventive ceramics – lustrewares inspired by the rich colours and metallic glazes of Islamic pottery combined with the fantasy of a Victorian imagination (pl.105). However, these still involved (albeit on a smaller scale) a division between designer and makers, as De Morgan was reliant on his employees for their actual production and decoration, and even used industrial blanks for his tiles. A significant shift in approach did not occur until the early years of the twentieth century, when the idea of the single designer-maker re-emerged in ceramics – one individual responsible for conceiving, designing, throwing and decorating pots: the studio potter.

104
The Centre Refreshment Room at the V&A, designed by James Gamble after initial plans by Godfrey Sykes, with tiles supplied by Minton & Co. England (London), 1868–70

105
Dish designed by William de Morgan Earthenware with lustre decoration England (possibly Merton Abbey), c.1885 V&A: C.1276–1917

In 1910 the Burlington Fine Arts Club held an exhibition of recently excavated Song Dynasty ceramics. In comparison with the highly decorative blue-and-white or polychrome Ming and Qing wares that had been known in Britain since the seventeenth century, those of the Song Dynasty (960–1279) seemed extraordinarily austere. Their simple, elegant shapes, rich monochrome glazes and restrained decoration provoked widespread interest in the art world, seeming almost modernist in their severity. The same year also saw the publication of Charles J. Lomax's *Quaint Old English Pottery*. This book, and a subsequent exhibition of early English pottery held at the Royal Academy of Arts in 1914, revived interest in seventeenth-century English slipwares such as those of Thomas Toft, which now came to be seen as an 'authentic' pre-industrial form of pottery that was unsullied by the

negative effects of industrialization. These two developments inspired contemporary potters, such as Reginald Wells, to experiment with new forms, decorations and glazes, and led – after the First World War – to the forming of two distinct strands of thought about what ceramics could, and should, be. On the one hand there was William Staite Murray, an artist greatly influenced by the strong forms and seemingly modern appearance of Song Dynasty ceramics, who considered pottery the equal of painting and sculpture, and the epitome of abstract art. Utterly uninterested in making functional wares, he exhibited in major commercial galleries alongside artists such as Ben Nicholson and Christopher Wood, achieving exceptionally high prices for his ceramics – often given abstract titles that referred to his spiritual beliefs – which displayed an extremely skilled level of throwing and

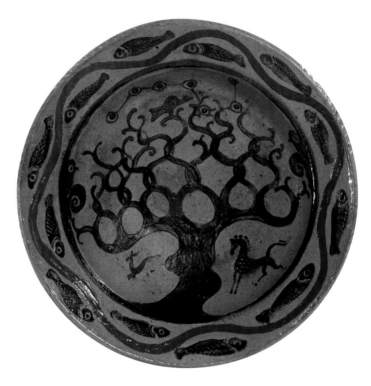

106
'Wheel of Life' by
William Staite Murray
Stoneware, with painted decoration
in shades of brown on a grey glaze
England, *c*.1939
V&A: CIRC.352–1958

107
'Tree of Life' by Bernard Leach
Earthenware, with slip decoration
in light and dark brown under
an amber glaze
England (St Ives, Cornwall), 1923
V&A: CIRC.1278–1923

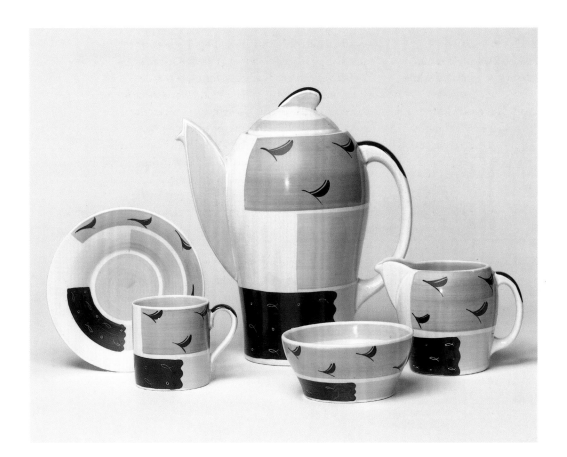

108
'Kestrel' coffee set designed
by Susie Cooper, made by
the Susie Cooper Pottery
Earthenware with
banded, painted and
sgraffito decoration
England (Burslem), 1932
V&A: C.127–1985

decoration, with consistent glazes produced by controlled firing in a gas-fire kiln that he developed and patented himself (pl.106). Head of Ceramics at the Royal College of Art from 1926, Staite Murray influenced a generation of students, but at the outbreak of the Second World War found himself stranded in Rhodesia (now Zimbabwe), where he gave up potting, and his influence on the development of British ceramics waned.

Representing the opposite approach in studio pottery to Staite Murray was Bernard Leach. For Leach, pottery was a humble and honest craft imbued with moral purpose and responsibility, the aesthetic value of ceramics being directly linked to their functional use. Leach became interested in pottery while teaching etching in Japan in 1909, having attended a 'raku' party at which a hand-formed pot was decorated and fired rapidly at low temperature. When he returned to Britain in 1920 he was given a capital loan by a wealthy Cornwall philanthropist, Francis Horne, to set up a pottery in St Ives with his Japanese friend and fellow potter Shōji Hamada. St Ives was hardly a propitious location for a new pottery: it lacked the vital resources of fuel and clay, and was too far from markets – particularly London – to be commercially viable. Leach, however, set himself the task of producing 'honest pots' inspired by Japanese and Chinese ceramics

and by traditional vernacular wares, such as those by Thomas Toft. Their influence can be seen in works such as *'Tree of Life'* of 1923 (pl.107), which combines slipware form and decorative style with a strong central motif taken from a Han Dynasty tomb decoration. The early years of the Leach pottery were extremely precarious. Problems of location and funding were compounded by Leach's lack of technical expertise, particularly in controlling the firing process, which led to unpredictable results.

Alongside the efforts and experiments of the burgeoning studio pottery movement, the factories of Staffordshire had continued to mass-produce ceramic wares, with the 1920s and '30s proving a particularly fertile period for well-designed affordable tablewares, such as those designed by Clarice Cliff, most famously her geometric and brightly coloured 'Bizarre' range, and the aerodynamic 'Kestrel' forms of her contemporary, Susie Cooper (pl.108). Staffordshire also contributed to the Leach Pottery: much to his father's horror, David Leach went there in 1938 to take a course on pottery management, and on his return implemented a number of technical changes to the St Ives pottery that improved the reliability of the production. By 1940 Leach's simple stoneware vessels, known as 'standard ware', were in

109
Bowl by Lucie Rie
Porcelain, with incised decoration
through black glaze
England (London), 1955
V&A: CIRC.336–1955

110
Vase by Hans Coper
Stoneware, with black and white
matt glazes
England (London), 1958
V&A: CIRC.154–1958

production, and his 'manifesto' was published as
A Potter's Book by Faber & Faber. This exposition of his
philosophy – expressing Leach's belief in the need for
the 'unity of design and execution'[11] in making ceramics –
contributed significantly to his influence on subsequent
generations of potters, in addition to those such as
Michael Cardew and Katherine Pleydell-Bouverie who
trained with him before setting up their own stoneware
potteries: Cardew at Winchcombe in Devon, and
Pleydell-Bouverie at Coleshill in Berkshire.

Studio pottery continued to develop after the Second
World War. Returning soldiers needed occupations and
were open to new ideas of what these might be, while
art colleges began to offer more pottery courses with an
emphasis on craft rather than on industrial design, previ-
ously their main concern. Leach's 'standard ware' found
a niche that had been left by the export of all industrial
decorated pottery after the war, and became ever more
popular in the 1950s alongside new food fashions inspired
by Elizabeth David's books of rustic Mediterranean recipes
and the opening of Cranks Health Foods in 1961. At the
same time the Leach Pottery profited from improved
transport links to St Ives – by then a thriving artistic com
munity – and the success of *A Potter's Book*, which reached
an ever-expanding audience. The impact of the war also had
a further effect, as it led to the arrival of new practitioners
in Britain, most notably Lucie Rie and Hans Coper.

Lucie Rie left her native Austria in 1938, fleeing Nazi
persecution of the Jewish community. She was already
well established as a potter, having studied at the Vienna
Kunstgewerbeschule and exhibited in Brussels, Paris and
Milan. Despite her continental reputation she was little
known in Britain, where the 1920s and '30s had been
dominated by Leach and Staite Murray. Although Rie
made Leach's acquaintance on her arrival in Britain, and
attempted to make pots in his style, she soon decided
that his thick and solid earthenwares were not for her.
Setting up a studio in Bayswater, she and her assistants
produced brightly coloured buttons and jewellery for haute
couture, reopening for business in 1945 after the hiatus
of the war, and being joined the following year by the
German refugee Hans Coper. Despite his lack of previous
experience, Coper quickly mastered potting techniques,
collaborating with Rie to produce sets of tableware that
offered a completely different approach from the tradi-
tional English and Chinese-inspired works that had
gone before. Their pieces were thinly potted, elegant and
simple in form, with restrained black-and-white glazes.
But while Rie concentrated primarily on traditional
domestic ceramic forms, producing throughout her career
elegant vases and bowls decorated with fine *sgraffito*
work (pl.109), Coper's ambitions were quite different.

Like William Staite Murray, Coper considered himself
an artist rather than a potter, and although he disliked
physically working with clay, he found that it produced
the effects that he desired. By throwing a limited range
of forms, such as spades and buds, on a wheel and assem-
bling them by hand to build highly sculptural vessels, he
revealed new possibilities for throwing, while his use of
matt glazes in a restrained palette, as well as his tech-
niques of turning, carving and sanding the surfaces of
his stonewares, created new textures (pl.110). Perhaps

Coper's greatest achievement for ceramics is encapsulated in his work for Coventry Cathedral, rebuilt following the bombing of Coventry during the Second World War. The new cathedral offered a site for artists and craftsmen to represent in their work the rebuilding of Britain following the ravages of war. Alongside Graham Sutherland, who designed the great tapestry of Christ in Glory at the liturgical east end, and John Piper, who designed the stained glass of the new baptistery (see Chapter 1), Coper was commissioned in 1962 to make the altar candlesticks. Seven feet tall, they are monumental pots, constructed from a number of thrown elements built up around a central metal rod. These engineered pieces – almost 'a-ceramic' in their approach – proclaim the possibilities for ceramic vessels outside a domestic setting, conceived as elements integral to an architectural space (pl.111).

By the time Leach died in 1979, British studio pottery was in rude health. *A Potter's Book*, which has never been out of print, continued to inspire generations of potters in the Leach tradition of making 'ethical' pots. Alongside this, a parallel tradition developed in the 1970s among some of Hans Coper's students at the Royal College of Art, where he taught from 1966 to 1975. Alison Britton, Elizabeth Fritsch, Jacqui Poncelet and Carol McNicoll became known as the 'New Ceramicists', their works focusing on the reinterpretation of the whole notion of form and function traditionally embodied in ceramics.

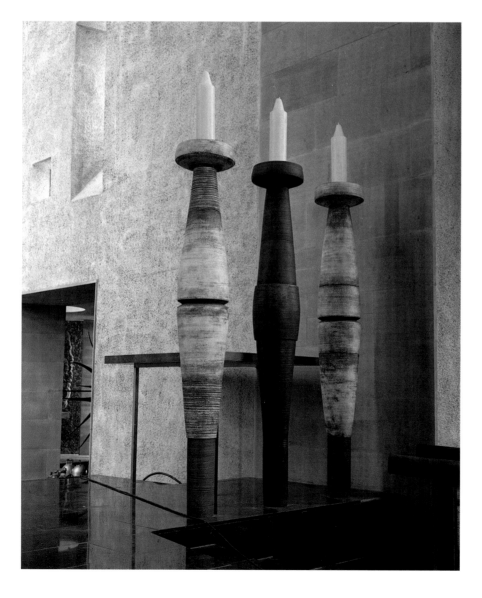

111
Altar candlesticks for Coventry Cathedral
by Hans Coper
Stoneware, with black manganese glazes and white feldspathic slip with manganese glaze
England, 1962

While Britton's slab-built vessels such as *'Big White Jug'* (pl.112) conform to traditional ideas of ceramic shapes, their lopsided, top-heavy or misproportioned forms confound their function, rendering them utterly impractical. Fritsch's *'Optical Pots'* play with perspective and volume, creating illusionistic tricks intended to confuse the viewer, while Poncelet's vessels take on disturbing organic forms and are intended to dispute the traditional place of ceramics by moving off the plinth and onto the gallery floor. McNicoll follows a long tradition of ceramic experimentation with the form of the teapot, imitating non-ceramic materials in a fantastical postmodern manner that seems to deny all possible functionality (pl.113).

112
'Big White Jug' by Alison Britton
Earthenware, hand-built
England (London), 1987
V & A: C.233—1987

113
Teapot by Carol McNicoll
Hand-built stoneware, inlaid,
incised and painted in blue,
white and brown
England (London), 1988
V & A: C.10—1989

The thriving state of contemporary ceramics at the start of the twenty-first century is demonstrated by the variety of the work made by potters – whether in the classically beautiful, yet challenging works of Grayson Perry or the satirical play on ceramic history encapsulated in the works of Richard Slee (pl.114). Edmund de Waal, who creates site-sensitive ceramic installations such as *'Signs & Wonders'* (pl.115), commissioned by the V&A in 2009 to mark the opening of its new ceramics galleries, similarly breaks with the traditional boundaries of the discipline, and yet looks back at ceramic history in an almost elegiac way. Above the main entrance to the museum a red aluminium shelf lines the inside of the building's dome, and 425 thrown porcelain vessels – all undecorated and glazed in the palest of whites, creams, greys and celadons – are arranged around the shelf, seeming to float in space. Although individually they are all functional objects, they serve as part of a collective whole, and their functionality is denied: they are deliberately situated far from reach, unattainable and unable to be used. They represent de Waal's response to the recent and distant past of ceramic history – the 'after-image' as he puts it, of the 'Chinese porcelains, eighteenth-century European porcelains, and modern pieces from Vienna, Bauhaus and the Constructivists' contained within the building of the V&A, which continue to resonate for potters today.[12]

114
'Drunk Punch'
by Richard Slee
Earthenware, coiled,
with coloured glazes
England, 1991
V&A: C.15–1992

115
'Signs & Wonders'
by Edmund de Waal
Glazed porcelain and
powder-coated aluminium
England (London), 2009
V&A: C.277–2009

CERAMICS

Edmund de Waal

Born 1964. Lives and works in London.

Can you tell us how your making begins?
Most of my work is made in response to either an idea or a place. Sometimes the idea is very abstract, and sometimes it can be a snatch of poetry or a remembered piece of music. If the work I'm making is site-specific, then I spend a lot of time thinking about how my vessels will work in relation to the light and volume of the installation's location. I love work that you find, or work that is hidden away from obvious encounters – it might be below you, or high up within a space: shadows work well with objects.

What are your preferred raw materials?
I make porcelain vessels using French clay. My installations are often housed within vitrines or aluminium- and lead-lined boxes.

What are your main technical challenges?
I never underestimate the wayward nature of porcelain. Even though I've been using it for almost 40 years, it never surprises me when things go terribly wrong! Many of the challenges in my practice are now to do with the ambitious places in which we are working. For instance, we are working on underground vitrines for a project in Cambridge, and on huge architectural commissions that involve real material challenges.

Do you think of your work as being part of a heritage?
Yes. Both the continuum of porcelain-making over the last millennium – from China via the Silk Road, the rediscovery of porcelain in the eighteenth century in Europe, and its perpetual reinvention since then – and the less well-known heritage of the placing of pots within complex architectural settings. I think of the corridors of porcelain in the Forbidden City in Beijing, of Augustus the Strong's porcelain palaces in Dresden and of the wonderful installation of functional porcelain at the Bauhaus in Germany in the 1920s. Some heritage!

How does your work relate to art, craft and design?
One of the privileges of making in the way I do is that my work belongs in several disciplines simultaneously. Making porcelain is, of course, a craft and always will be. But the imagining of how my porcelain can work in the world allies it to sculpture: my work is contemporary art and it is a conversation with the work of many other artists.

far left
Beaker
Thrown limoges porcelain with a white crackle glaze exterior
England (London), 1996
V&A: C.81–1996

left
Pot
Thrown porcelain with a celadon glaze, 2001–2
V&A: C.136–2006

opposite
'Water-shed' installation
at the Leamington Spa Art Gallery and Museum, 2010
Cabinet filled with thrown limoges porcelain pots

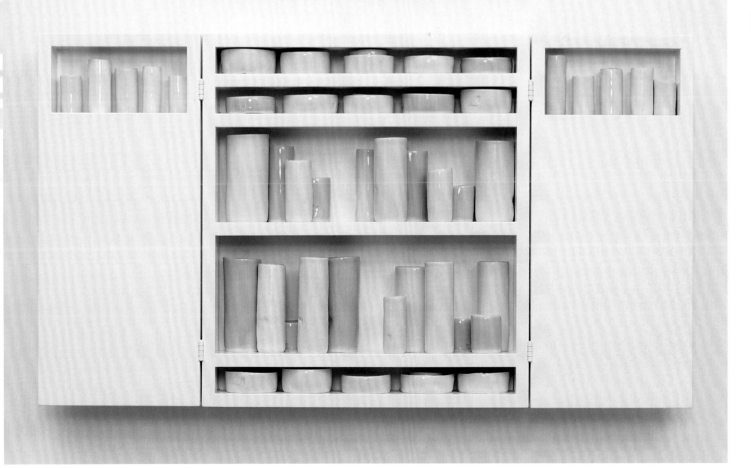

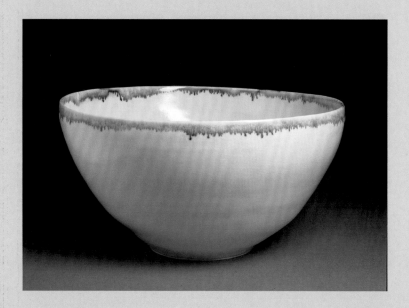

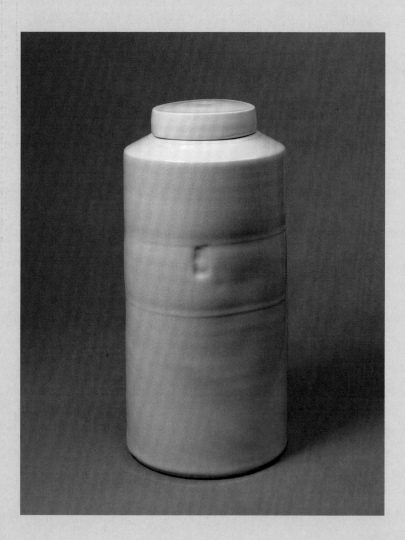

above
Bowl
Thrown limoges porcelain
with white crackle glaze
England (London), c.1995
V&A: C.48–1996

left
Tall lidded jar
Thrown porcelain with
a celadon glaze
England (London), 2001
V&A: C.40–2004

opposite
Teapot
Thrown and altered
limoges porcelain
with white crackle glaze
England (London), 1996
V&A: C.80–2004

EDMUND DE WAAL

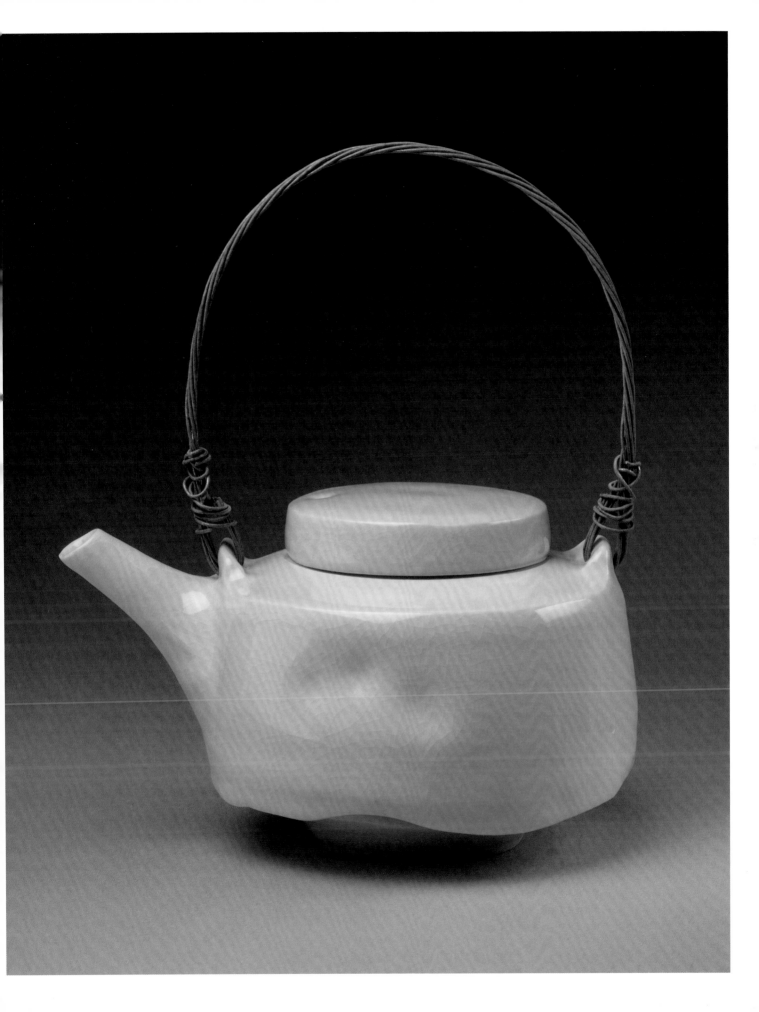

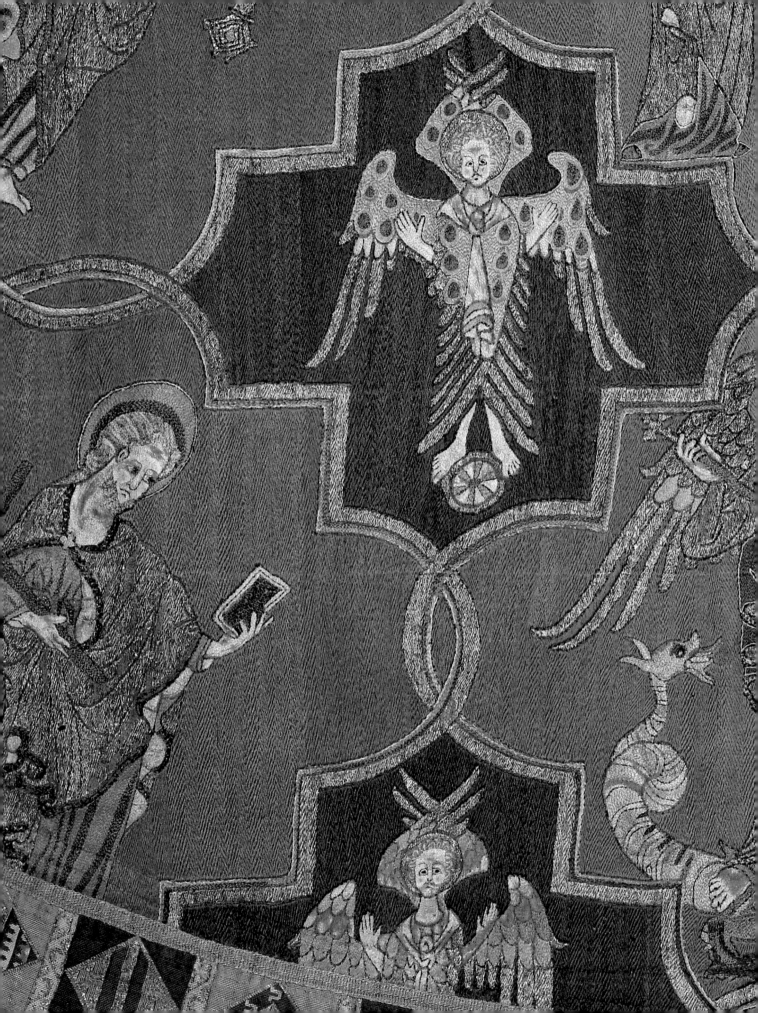

fabric

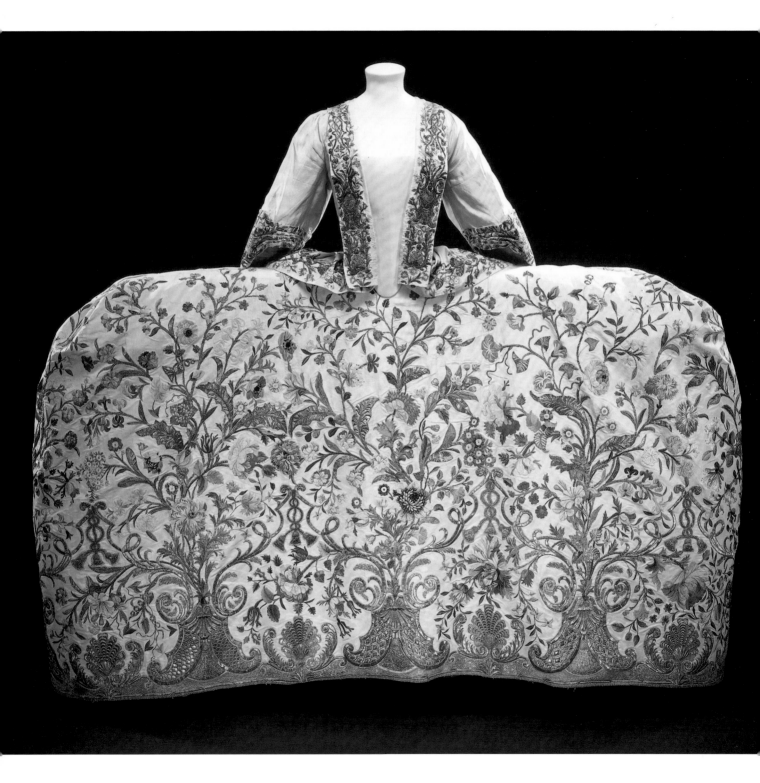

116
Mantua
Silk, embroidered with
coloured silk and silver thread
England, 1740–45
V & A: T.260–1969

117
The Art of Woolworking (detail)
by the Regensburg Master
Oil on panel
Germany (Regensburg), 1456
Regensburg Museum,
Regensburg, Germany / Interfoto /
The Bridgeman Art Library

From the plainest woollen clothing to large narrative tapestries woven with silk and gilt-metal thread and magnificent court dress, all British fabrics since antiquity have served a fundamentally practical purpose: to clothe the body or furnish the home. At the same time, textiles provide one of the most immediate means of asserting one's status and wealth, whether through the adornment of one's person (pl.116) or of one's residence. Despite the fragility of textiles, it is noticeable that what survives – usually those objects or garments that would have belonged to the wealthiest members of society – is sometimes in remarkable condition considering its age, indicating the high value accorded to textiles not only at the time of their manufacture, but also subsequently.

Although we have evidence that fabrics were produced in Britain from the time of the Roman Empire, it is only from the Middle Ages that enough information survives regarding their production to be able to build a picture of the different enterprises and the kinds of fabrics produced. It is clear that a range of natural fibres was used: vegetable fibres such as hemp, linen and cotton (this last imported from the Mediterranean and Asia), and animal fibres such as wool and silk (also imported from the Orient). Each fibre had its own particular uses: linen was the predominant material for shirts, sheets and tablecloths, while cotton might be used in its raw state for padding, or in fine cloth form for clothes and banners.[1] If silk was the preserve of the wealthiest sectors of society, wool was perhaps the most ubiquitous fibre,

used for knitting and weaving fabrics, and one with a significant economic as well as practical function. From the fourteenth century right up to the seventeenth, wool and woollen cloth were the most significant British exports and the chief source of the country's income. The importance of the wool trade was reflected in the rise of provincial towns that were the principal weaving centres for the exported woollen cloth, including the Yorkshire towns of Beverley and York and the East Anglian centres of Norwich and Bury St Edmunds. The wealth generated by the wool trade was made manifest in the commissions of newly rich wool merchants and town guilds for parish churches, such as stained-glass windows (see Chapter 1).

The fact that woollen cloth was being exported indicates the presence of a relatively sizeable weaving industry in medieval Britain. Even in its simplest form the manufacture of textiles necessitated – far more than the production of some other materials – a sequence of processes and, for any significant industry, a number of workers to undertake them. Fibres had to be prepared (in the case of wool, by carding and then by spinning) before they could be woven and, if different colours were required, before they were dyed. The weaving itself was done at a loom, operated by hand, foot or sometimes water power, and possibly requiring several people to be working at once (pl.117). Not all operations would have been producing textiles in such quantities, however; in the primarily rural economy of medieval Britain it was

principally local weavers who provided the fabrics required by the majority of the population to make up their clothes and bed coverings.

Cloth was produced in various qualities to suit different budgets (such as burel for the poor, mid-level worsted and fine, expensive scarlet), but the predominant kinds of fabric – such as those exported to the continent – were not those bought by the very wealthy. Britain did not produce the sort of textiles that were desirable to the highest markets, so valued that they not only were used for furnishings and clothing, but were also given as diplomatic gifts or collected as princely possessions. For these, Britain was reliant on imports – from Turkey and Persia for carpets, from the Middle East and Italy for silk velvets, and from the Low Countries for the finest woollen cloths and woven tapestries. The expense of some of these products was such that their consumption was restricted to only the richest patrons: the court and the Church.

As with other products, the importance of Church patronage to textile manufacture until the Reformation cannot be underestimated, because of the centrality of religion to daily life at every level of society. In the case of textiles, certain objects were required for the celebration of church services, particularly the Mass. The altar was covered by an altar cloth, while a burse (a fabric-covered case) was used to carry the corporal, a white linen cloth on which the chalice and Host of the Mass were placed. Above all, the priests who conducted the Mass and other liturgies had to be clothed in vestments appropriate to the functions they performed. As such, and like other church fittings such as stained glass and woodwork, church vestments served several functions: they visually separated the clergy from the laity; they provided another surface for decoration that could be composed of scenes from Bible stories or images of saints, thus aiding congregations in their devotions; and they added colour and narrative to the church interior, enlivening it as the priests moved through the space of the church. Most importantly, the intricate decoration of vestments, their imagery and their creation from precious materials meant that they honoured God through their beauty, richness and craftsmanship – the high value in which such vestments were held meaning that they were often the subject of specific donations from wealthy patrons to their local church.

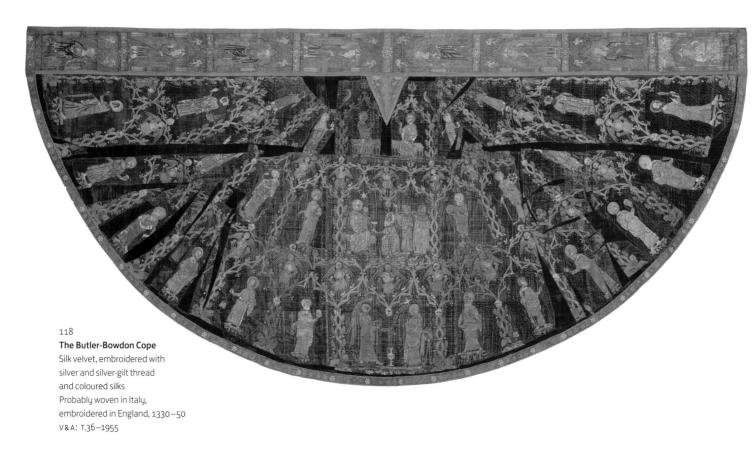

118
The Butler-Bowdon Cope
Silk velvet, embroidered with
silver and silver-gilt thread
and coloured silks
Probably woven in Italy,
embroidered in England, 1330–50
V&A: T.36–1955

The finest medieval textiles in Britain that survive are indeed church vestments, and are of a type that came to be known as *opus anglicanum*: English work. This term describes a kind of medieval embroidery in silk and gold thread that became so renowned that it was desired by, and acquired for, ecclesiastical institutions on the continent as well as in Britain. In 1295 an inventory of the Vatican listed more than 100 examples of *opus anglicanum*, and pope Alexander IV is known to have employed a British embroiderer (Gregory of London) to work in this technique in the papal household. Its status can also be judged from the number, quality and condition of *opus anglicanum* pieces that survive, despite the fragility of textiles and the iconoclastic history of Britain. The condition tells us that the textiles were carefully looked after, even if changes in liturgical practice and in the style of vestments mean that many, including the prime examples in the V&A, were altered after their original manufacture.

Opus anglicanum embroidery could be carried out on a number of different grounds, chosen according to the desired effect. Some examples use a rich ground, such as the Butler-Bowdon Cope in the V&A, dating from 1330–50 and embroidered on a red silk-velvet ground (pl.118). In contrast, others were made on plain linen, with the embroidery covering the whole of the ground (usually in gold) rather than just particular details. The Syon Cope (1300–20, originally made as a chasuble and later cut up and remodelled) is a unique example of this style, being executed in coloured rather than gilt-metal threads: the linen ground is entirely covered with green and red silk thread, although the red has now faded to brown (pl.119). These copes, like many other examples of *opus anglicanum*, used a range of stitches, but one in particular was employed for gilt-metal thread. Known as 'underside couching', it made the gold or silver thread appear in long, straight lines, as the couching stitches were not visible from the front of the vestment.

Like stained-glass windows, the iconography and style of decoration of medieval liturgical vestments was interlinked with other arts, such as wall and manuscript painting, and may have shared designers – or, at the very least, design sources. The Syon and Butler-Bowdon copes, as well as the Clare Chasuble (see pl.36) – another important piece in the V&A – all feature a combination of biblical scenes (such as the lives of Christ and the Virgin),

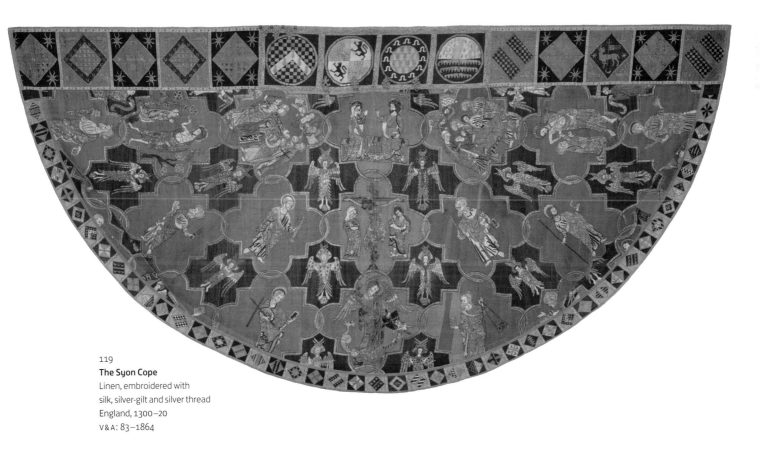

119
The Syon Cope
Linen, embroidered with
silk, silver-gilt and silver thread
England, 1300–20
V&A: 83–1864

individual figures of saints and angels and heraldic motifs, frequently set within frameworks that are reminiscent of contemporary architecture. The disposition of different motifs followed common patterns intended to suit the fall of the vestment, when worn. The key area chosen for narrative scenes was, as can be seen from the Clare Chasuble (which has been cut down, but not refashioned), a vertical band down the back. This was to maximize visibility: according to medieval practice, priests would stand at the altar with their backs to the congregation when they celebrated the Mass. As such, the centre-back part of the vestment was the most visually important area and thus the most obvious choice for key iconography, such as representations of the crucifixion. In contrast, for surface areas that would be disrupted by the folds of the vestment when it was worn – particularly for copes that were worn in procession – it was preferable to use repeated ornamental motifs, such as foliage, animals or figures such as saints and angels, which did not carry quite the same degree of religious importance (pl.120).

Apart from a very few examples, we know little about the embroiderers who created these intricate and lavish vestments; only in rare instances do we have examples of named craftspeople. We know that from 1239 to 1244 a certain Mabel of Bury St Edmunds was executing

embroideries for Henry III, and that from the 1330s Edward III had an embroidery workshop in the Tower of London, directed by the Royal Armourer, John of Cologne.[2] It seems that most *opus anglicanum* work was executed in professional workshops in London, which were usually directed by men, but had a workforce composed of both men and women, who (as with many other crafts) were required to serve an apprenticeship of seven years before they were allowed to practise. They would undoubtedly also have executed the secular embroideries – for clothing and furnishing fabrics – that we know, from inventories and other records, to have been produced, although very little survives. Outside professional workshops, embroideries were also produced in ecclesiastical institutions by monks and nuns, both for their own use and for sale: in 1314 an injunction to a convent of nuns forbade them from absenting themselves from divine services in order to embroider.[3]

Unlike weaving, embroidery can be practised entirely by individuals and does not require heavy equipment. That said, in the Middle Ages the materials required for a certain quality of embroidery – whether expensive ground fabrics or silk and gilt-metal threads – were expensive imports (probably from Italy and the Near East), so the work could only have been carried out

by craftspeople with access to such resources. The time taken to produce a piece of *opus anglicanum* also added to its cost: Henry III commissioned for the high altar of Westminster Abbey an altar frontal that it took four women three years and nine months to complete. Pieces such as the Syon Cope would have been executed by several makers, who followed a design drawn directly on to the cloth on which they were working, as can be seen in surviving vestments that have degraded, revealing the drawing beneath. Given the stylistic similarities between vestments and other forms of pictorial art, it is possible that master-painters or illuminators supplied the initial designs. The embroiderers, however, would have worked only from an inked outline, so the works that survive testify to their interpretative abilities: split-stitch was predominantly used for areas of flesh as it could follow the contours of the body, while other stitches were adopted for the flow or folds of draperies, sometimes even creating raised and lowered areas, for a truly three-dimensional effect (pl.121).

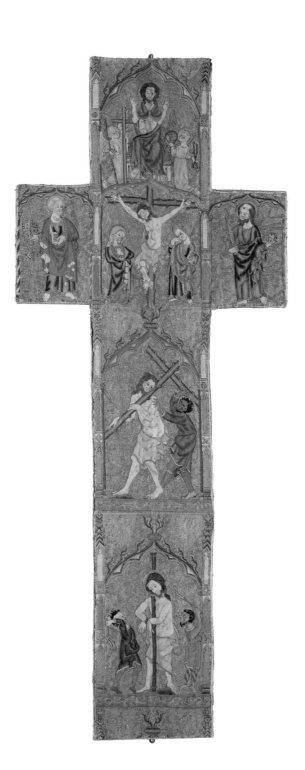

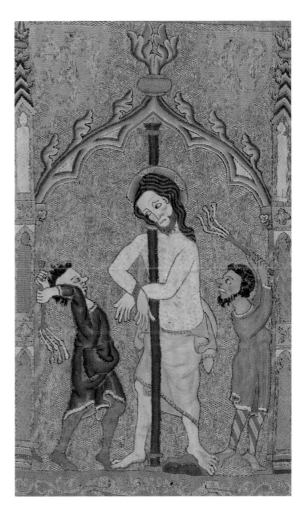

Although the best examples of *opus anglicanum* date from about 1250–1350, it continued to be produced until the Reformation. As with other church arts, however, the Reformation and its aftermath put a definitive end to the widespread production of ecclesiastical embroideries – as well as witnessing the destruction of the majority of existing pieces. The intrinsic value of examples of *opus anglicanum*, which lay in the cost of its raw materials, led to the destruction of many pieces in order to extract the expensive gilt-metal thread. That which does survive often does so in an altered state, as in the case of those pieces in the V&A, and often endures only because it was kept by recusant Catholic families after the Reformation, or was already held by owners on the continent.

122
The High Great Chamber, Hardwick Hall, Derbyshire

123
The Triumph of Chastity, possibly owned by Cardinal Wolsey or Henry VIII
Tapestry with wool warp and weft and a few silk wefts
Belgium (Brussels), *c*.1507–10
V&A: 440–1883

If embroidered vestments were the textiles seen most often in the medieval church, tapestries played the leading role in the secular environment of the court and aristocratic households, and continued to do so for several centuries. Tapestries, as with many forms of the decorative arts, were popular for various reasons, including practical concerns. In draughty stone-walled palaces they provided much-needed insulation and warmth, often being hung edge-to-edge, around corners and even over doors (pl.122). They were eminently robust and portable – key factors for courts that were largely itinerant until the seventeenth century – and were rolled up and transported from one residence to another, to be hung on arrival from hooks that were sometimes permanently fixed into palace walls. Tapestries were vastly expensive, being second in cost only to jewellery and precious metalwork in gold and silver, and thus acted as a key status symbol – an immediate indicator of their owner's wealth. They also served as the principal form of pictorial art, for their large size offered the perfect opportunity for heraldic, ornamental or narrative designs. This scope for colourful, decorative variety, combined with their cost, meant that tapestries not only offered rulers the possibility of furnishing their several residences with the most expensive form of art available, but also of using their art to project particular messages through the choice of subject matter they displayed.

British and continental rulers made a huge financial outlay on tapestry. Edward IV paid the merchant Pasquier Grenier nearly £2,500 for tapestries: an extraordinarily large sum for the time. The inventory compiled at the death of Henry VIII listed more than 2,700 tapestries, an unprecedented collection that had been amassed only partly through Henry's own acquisitions: some works he had inherited from his father (also a great collector), others he had appropriated from ecclesiastical institutions during the Dissolution of the Monasteries, or from individuals such as Cardinal Wolsey, whose extensive collection Henry acquired during the cardinal's fall from grace (pl.123).

Like those of his predecessors and European contemporaries, Henry VIII's collection of tapestries contained a wide range in terms of both design and quality. Although conceived as portable furnishings, and thus rarely commissioned for specific palace locations, tapestries tended to be used to indicate the status of particular rooms. Coarser woollen work would be used to adorn less significant locations, while the finest pieces woven with quantities of silk and gilt-metal thread were reserved for the most important rooms, or were brought out for display only on special religious or dynastic occasions.

Tapestry design fell into distinct decorative categories. 'Verdures' or 'millefleurs' were covered with naturalistic representations of foliage and flowers, sometimes

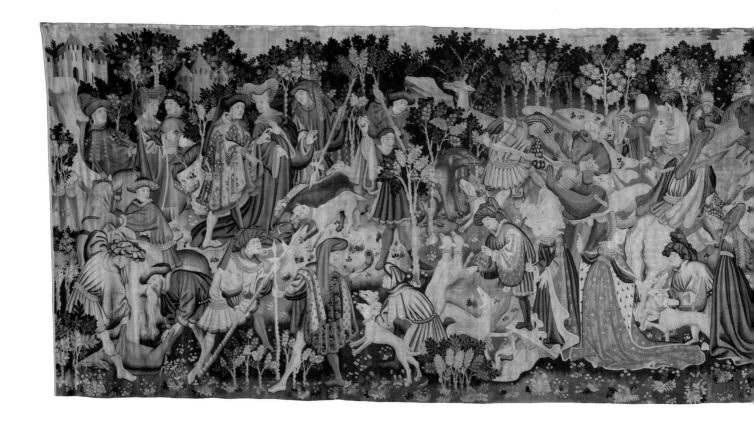

enlivened with animals or figures in more elaborate pieces. Because they adopted repeating patterns and had limited figural work, these were comparatively cheap and easy to produce (pl.125).[4] Linked to verdures were hunting scenes, a subject that was particularly popular for an aristocratic public that enjoyed hunting as a regular activity. A rare fifteenth-century group of hunting tapestries in the Victoria and Albert Museum (formerly owned by the Dukes of Devonshire and known to have been at Hardwick Hall in Derbyshire in the sixteenth century) shows the variety and abundance of hunting scenes (pl.124). The group, consisting of four tapestries from several different sets, shows scenes of otters, swans, deer, boar and bear hunts, as well as falconry. In each case the hunt is depicted with – sometimes gruesome – accuracy, and with its participants represented in contemporary court dress, showing the courtiers who would have inhabited the halls that the tapestries furnished.

The most expensive and complex tapestry designs were figural narratives, with subjects taken from classical history or mythology, the Bible or chivalric romances. They were often made in sets, so that an entire room might be adorned with scenes from one particular story. One of the most popular subjects was the Trojan War, of which sets were owned by some of the most illustrious

patrons in Europe, including Henry VIII and James IV of Scotland.[5] In some cases patrons might commission tapestries depicting events from recent, or even contemporary, history. Descriptions of Henry VII's palace at Richmond indicate that he had there at least two tapestries depicting events from his own life: his defeat of Richard III at the Battle of Bosworth Field in 1485, and his marriage to Elizabeth of York the following year – the act that ended the Wars of the Roses by uniting the houses of Lancaster and York. Such tapestries would have been clearly understood by viewers, including foreign rulers and ambassadors, as aggrandizing propaganda.

Until the seventeenth century almost all large-scale tapestry – of whatever kind – was produced in one part of Europe: the Low Countries. The weavers of the towns of Brussels, Tournai and Arras in particular (this last so renowned that its name came to be used as a synonym for tapestry) produced works of such fine execution, design complexity and artistic sophistication that they were sought-after across the continent. Tapestry-weaving was intricate and time-consuming, particularly for the production of figural works. It required significant numbers of craftspeople, a certain amount of equipment, and the space and light to facilitate the work. The key piece of technology was the loom, which normally

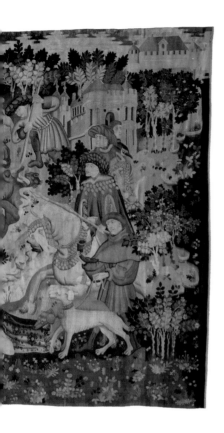

consisted of two rollers with plain load-bearing threads, usually made of wool, stretched between them. Looms could either be vertical (known as high-warp) or horizontal (low-warp), the latter being the type most commonly used by Netherlandish weavers. As with embroidery, a design was required before weaving could start, and was produced by a professional designer in the form of a full-size painting on paper, known as a cartoon. The weavers worked directly from this, tracing the pattern from the cartoon onto the warp threads, probably by 'pouncing' – that is, pricking the outlines of the cartoon with a pin, and dabbing fine charcoal or chalk through the pin-prick holes to transfer the lines of the design. If working on a high-warp loom, the weavers might hang the cartoon behind them, and work from its reflection in a mirror in front of them; if working on a low-warp loom, they would cut it (or copies of it) into strips and place them underneath the warp threads, as a guide to their work. In this case they worked in reverse, the tapestry being a mirror-image of the original design.

124
Boar and Bear Hunt, from the
Devonshire Hunting Tapestries
Tapestry woven with
wool warp and weft
The Netherlands, 1425–30
V & A: T.204–1957

125
'Millefleurs' tapestry
Tapestry woven in wool and silk
Flanders, c.1500
V & A: 232–1894

126
Fragment of tapestry made by
the Sheldon Tapestry Workshops
Tapestry woven in silk on wool warp
England (probably Warwickshire),
c.1600
V&A: T.645–1993

The weaving itself was carried out by passing a shuttle, wrapped with coloured threads known as weft (made of fine wool, silk or gilt-metal), over and under the warp threads to create a weave that ultimately completely covered the plain warp framework (pl.126). The work was carried out in sections, and was usually undertaken by a number of weavers at the same time, with each working on a different area selected for their own particular talents: foliage, landscape or figures. Even so, it was extremely time-consuming: in general a weaver could produce around one square metre (1.2 square yards) of coarse tapestry in a month, but possibly only 50–70 square centimetres (8–11 square inches) of fine-quality work (that is, with more warps per centimetre, and a higher grade of weft). A large-scale tapestry of 5 × 8 metres (16½ × 26¼ feet) might take five weavers eight months to produce, but could equally take twice as long.[6]

Because of the cost of the materials, and the time and labour they took to produce, tapestries long remained, perhaps unsurprisingly, the preserve of the Low Countries weavers who had comprehensively established their reputation. However, the expenditure they entailed, and the fact that this money was going abroad rather than remaining at home, led to attempts to establish a native tapestry industry in Britain. William Sheldon, a Worcestershire gentleman, set up a workshop in c.1560 in Barcheston (now in Warwickshire), with the aim of decreasing foreign imports while also reducing local unemployment. His master-weaver, Richard Hickes, may have been of Flemish origin, as Sheldon mistakenly boasted that Hickes was responsible for bringing the art of tapestry-weaving to England, but he was obliged to

take on local workers in order to build up native skills. Although Sheldon's tapestries did not offer the same degree of design or execution as those made in the Low Countries, and were generally more modest in scale, they were cheaper, and so could serve the needs of a middle market (pl.127). Sheldon's enterprise, like parallel projects on the continent, was assisted by religious conflict and civil wars in the Low Countries, which caused considerable disruption and fragmentation of the industry, opening up the market to countries that had benefited from the emigration of Flemish weavers and the dissemination of their skills.

Although the Low Countries retained their supremacy as the producers of the finest tapestries, from about 1600 a number of other European cities succeeded in establishing their own industries, which proved far more successful and long-lasting than that of Sheldon. In London, Sir Francis Crane, secretary and friend to Charles, Prince of Wales (the future Charles I), began work at Mortlake. Persuading around 50 Flemish weavers to emigrate to England in secret; he set them up in around 1619 in premises equipped with ground-floor accommodation for the weavers and their families, and first-floor workshops with 18 looms and a large room for a 'limner' to paint cartoons, and further large rooms on the second floor. The enterprise was given substantial royal support, possibly because King James I saw the spectacular success of a parallel industry in Paris sponsored by Henri IV of France. Royal grants were given to Crane's works in 1619 and 1623, and in 1625 a further promise was given for £1,000 a year, 'to contribute towards the maintenance and settling

127
Tapestry depicting
The Judgement of Paris, made by
the Sheldon Tapestry Workshops
Tapestry woven in wool and silk
England (probably Warwickshire),
c.1595
V&A: T.310–1920

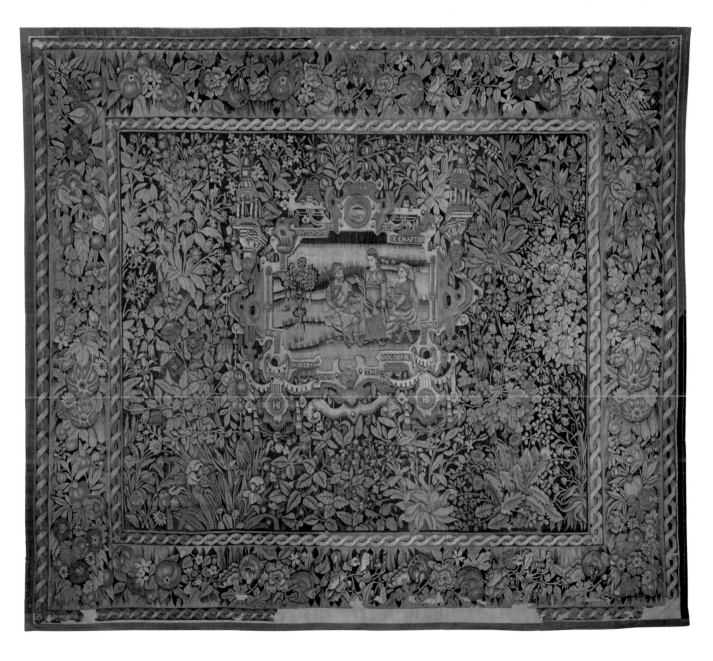

128
Cartoon for the *Miraculous Draught of Fishes* by Raphael
Bodycolour on paper
laid onto canvas
Italy, c.1515–16
The Royal Collection,
on long-term loan to the V&A

of the Manufacture of Tapestries which ... S[i]r ffrancis Crane by his Ma[jes]ties Com[m]andment, and at his owne charge did lately bring into this kingdome'.[7]

Royal support enabled Mortlake to succeed where earlier makers had not, and under the sponsorship of James I and later Charles I, Mortlake produced tapestries that were among the finest in Europe. Initially they were woven to the designs of sixteenth-century pieces in the royal collection, but soon their repertoire expanded. A key factor in this was the 1623 purchase by Prince Charles of seven of the 10 cartoons painted by Raphael and his workshop for a series of tapestries designed for the Sistine Chapel in the Vatican (pl.128). Commissioned by Pope Leo X in 1515, Raphael's cartoons depicted scenes from the Acts of the Apostles. Once the cartoons had served their primary function and the Vatican tapestries had been woven in Brussels and sent to Rome, the cartoons were sold, eventually being bought by Prince Charles from Genoa, with the specific intention of their being used at Mortlake. The sets of the Acts of the Apostles woven at Mortlake perhaps represent the height of the manufacture's achievement. To the central scenes designed by Raphael were added new decorative borders designed by Francis Cleyn (who would become Mortlake's official designer in 1626) in the latest baroque style, bringing them up to date. At more than 5 metres (17 feet) high, the Acts of the Apostles required larger looms than had ever previously been used at Mortlake,

while the large numbers of figures meant that the work was particularly time-consuming, requiring specialist work for the execution of faces and other areas of bare flesh.[8] In the case of the Acts of the Apostles and other series produced at Mortlake – such as the story of Hero and Leander, a set of the Senses, and a series known as the 'Horses' (pl.129), a virtuoso display of baroque design – successful designs were often rewoven after the first set. These later editions might be acquired by the aristocracy or given as diplomatic gifts, both to honour the recipient through their value and to illustrate the success of the English industry.

Although the Mortlake works, perhaps surprisingly, survived the ravages of the Civil War and interregnum, being revived by Charles II and lasting until the reign of Queen Anne, it never again reached the heights that it had under the patronage of Charles I. Tapestries would remain in use: they embodied longevity and heritage, and so continued to be displayed in royal residences or for particular occasions. At the coronation of James II in 1685 the richest set of tapestries in the royal collection – bought by Henry VIII and depicting the Old Testament story of Abraham – was displayed, as it was again at the coronations of William III, Queen Anne and George I (pl.130).[9] William III had antique tapestries from the royal collection hung permanently on the walls of certain palace rooms and appointed John Vanderbank, a Huguenot refugee who set up a tapestry workshop in

129
'Perseus on Pegasus' from
The Horses, woven at the
Mortlake Tapestry Factory,
designed by Francis Cleyn
Tapestry woven in wool,
silk and silver-gilt thread
England (Mortlake, London),
c.1635–7
V&A: T.228–1989

130
The coronation of James II
Published in *The History
of the Coronation of the
Most High, Most Mighty,
and Most Excellent Monarch,
James II*, London (1687)
The British Museum

London, as his 'royal arras maker' in 1689. Vanderbank's workshop produced a range of designs, including some after tapestries designed by Charles Le Brun and woven at Louis XIV's Gobelins manufacture in Paris. From the 1690s he tapped into the fascination for the exotic and oriental known as chinoiserie, producing tapestries sometimes described as 'hangings with India ffigures' that combine Chinese, Indian and Turkish elements to create an oriental fantasy (pl.131). With isolated motifs arranged on a relatively plain ground, these were fairly quick and therefore cheap to produce, in contrast to narrative figural works; and, like the floral tapestries produced by Joshua Morris's London workshop, they catered to the taste for lighter, more decorative furnishings from the beginning of the eighteenth century.

Although tapestry continued to play a significant role in furnishing homes in the early eighteenth century, it faced increasingly stiff competition from other forms of textiles. It had, of course, long coexisted with other textiles in the home. Embroidery, which had become purely secular since the Reformation, was practised both by professionals and by amateurs. It was an appropriate domestic accomplishment for girls and women, who worked on samplers to learn needlework before embroidering small objects such as pincushions, as well as panels and pictures of decorative work. The needs of amateur needlewomen were met by the increasing proliferation of printed designs and pattern books, such as Richard Shorleyker's *Schole-house for the Needle*, published in 1624. The Oxburgh Hangings – a series

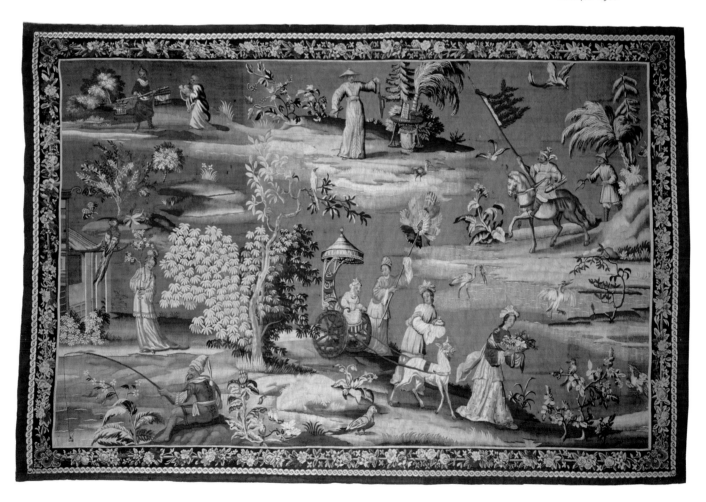

132
Panel from the Oxburgh Hangings,
possibly made by Mary, Queen
of Scots, and Elizabeth Talbot,
Countess of Shrewsbury
Linen canvas, embroidered with
gold, silver and silk in cross-stitch
England (probably Sheffield), c.1570
V&A: T.33Z–1955

133
Wedding suit of James II
Wool, embroidered with silver
and silver-gilt thread and
lined with red silk
England, 1673
V&A: T.711–1995

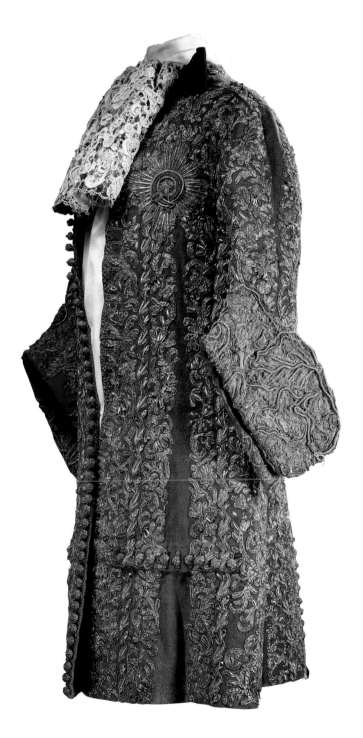

of embroidery panels that originally made up a set of
hangings, some of which were embroidered by Mary,
Queen of Scots during her imprisonment and by
Elizabeth Talbot, Countess of Shrewsbury (Bess of
Hardwick) – feature animals, birds and fish, many of
which are taken from illustrations to Conrad Gesner's
Icones Animalium, published in 1560 (pl.132).[10]

Although it is usually impossible to attach names
to pieces of embroidery, it seems likely that – as in
the Middle Ages – professionals executed the most
elaborate work. Major households employed their own
embroiderers: Bess of Hardwick, at whose house some
of the finest late sixteenth-century embroideries survive,
is known to have had at least one full-time embroiderer
on her staff, although it is likely that some of the smaller
pieces that survive there were executed by Bess herself,
and by her entourage. Embroideries functioned as wall
hangings, cushions and bed coverings, or might be used
for fashionable clothing for both men and women. The
wedding suit of James II is a particularly lavish example
(pl.133); its woollen jacket and breeches both display
panels of silver and silver-gilt embroidery, in a design
of lilies and honeysuckle that would have sparkled in
both daylight and candlelight.

Towards the end of the seventeenth century, under
the influence of continental trends introduced to Britain
by Charles II at the Restoration in 1660, and continuing
from then, upholstery began to be used in Britain.

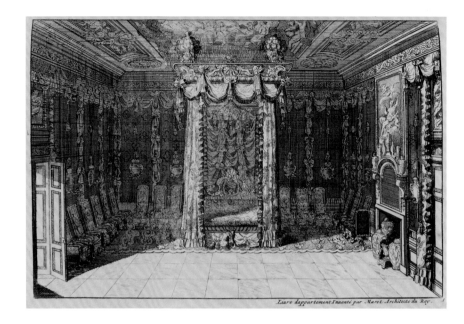

134
The Melville Bed, probably
upholstered by Francis Lapiere,
possibly designed by Daniel Marot
Bedstock of oak, tester of pine;
hangings of crimson Italian velvet
with ivory Chinese silk linings,
embroidered with crimson braid
and fringe; some textile elements
stiffened with linen; bed ticking
of linen
England (London), c.1700
V&A: W.35–1949

135
Design for a state bedchamber
by Daniel Marot
Engraving
The Netherlands (The Hague),
c.1702
V&A: E.5914–1905

Previously seat furniture had been constructed of wood, furnished with loose cushions, if required. Beds, similarly, had usually been composed of a wooden boxlike structure, with separate fabric hangings (see pl.164). Now the two became integrated. Upholstered chairs, stools and beds had permanently attached textiles that were often (at the richest levels) woven silks and velvets. The state bed formerly at Melville House in Fife and now in the V&A epitomizes this (pl.134). Its extraordinarily sculptural tester is entirely covered with fabric – on the exterior with crimson velvet, and on the interior with ivory silk embroidered in crimson. The headboard is decorated with embroidered ivory silk attached to the boards, so that textile decoration and wooden structure are not easily detached from each other.

In keeping with the baroque decoration promoted by the designer Daniel Marot, such upholstered furniture was often made *en suite*, with all elements of a room – bed, chairs, stools and wall panels – being upholstered in the same fabrics (pl.135). These were usually imported: the Melville Bed's velvet came from Italy and its silk from China. From the early eighteenth century this changed, thanks largely to the arrival of immigrant weavers fleeing religious persecution in France.

Following Louis XIV's revocation of the Edict of Nantes in 1685, French Protestants arrived in Britain in droves. In addition to goldsmiths and silversmiths (see Chapter 2), Britain benefited mainly from the arrival of Huguenots chiefly in the field of woven fabrics. The silk industry in Britain had already begun to expand in the latter part of the seventeenth century, largely to meet the demand for fashionable dress silks imported from France, which had superseded Italy as the producer of the most desirable silk. The Huguenots – who settled predominantly in Spitalfields in the East End of London and beyond the jurisdiction of the city guilds – brought with them considerable commercial acumen and hugely desirable design knowledge, enabling them to capitalize on the expansion of the silk industry. Master-manufacturers in the Spitalfields industry might employ hundreds of weavers, working three or four to a hand-loom (pl.136), with some even working in their own homes

136
'The Fellow Prentices at their Looms'
Engraving
Plate 1 from *Industry and Idleness*
by William Hogarth (London, 1747)
V&A: Dyce.2759

under the 'putting-out' system, according to which the master-manufacturers owned the raw materials, but subcontracted the work. The Spitalfields enterprises created an industry whose products rivalled those of Lyons, the silk capital of France, but also benefited from London's status as the centre of fashion, shopping and export.

Early Spitalfields silks were often so close in their design to French silks that it is difficult to identify their manufacture definitively, but by the mid-eighteenth century they had developed their own identity, in terms of design and the finished silk. An album from the first 20 years of the century by James Leman, a Spitalfields weaver of Huguenot descent who, unusually, trained and worked as a designer as well as a craftsman, demonstrates in his designs (pl.137) – which are often marked with inscriptions regarding manufacture – the contemporary fashion for asymmetrical designs with exotic motifs, known as 'bizarre'. Leman's designs contrast with those by Anna Maria Garthwaite, who worked as a freelance designer from the 1720s supplying patterns to

leading figures of the London trade. Her designs reveal a peculiarly British interpretation of the rococo style, with botanically accurate floral motifs executed in brocading, a technique that enabled different colours to be introduced into the pattern, often in very small areas: a laborious process, but one that could create more variety and liveliness, at less expense, than could be achieved using wefts running from selvedge to selvedge (pl.138). Made over 30 years, her designs also chart the development of fashionable dress design, the principal use to which Spitalfields silks were put. Both men's and women's clothing styles of this period lent themselves to the display of these intricate designs: the shapes of men's waistcoats and women's sackback dresses showed off the silks to best advantage (pl.139).[11]

In the middle and latter part of the eighteenth century a number of technological developments completely transformed the textiles industry in Britain. Since the foundation of the East India Company in 1600, Indian painted and printed cotton fabrics (chintz) had

137
Designs for woven silk
by James Leman
Pencil, pen, ink and watercolour
on laid paper
England (Spitalfields, London),
1711
V&A: E.1861–1991

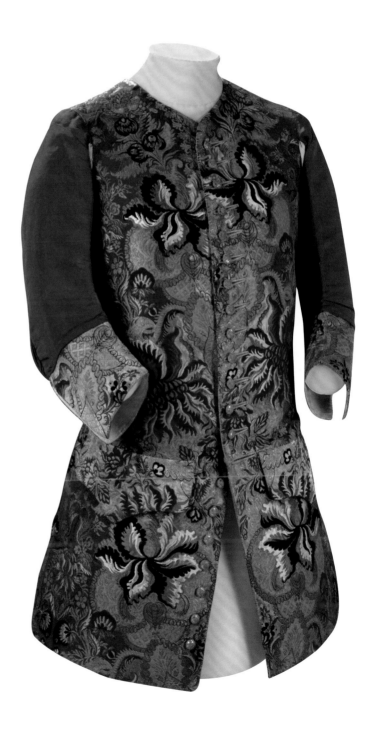

138
Dress silk designed by
Anna Maria Garthwaite
Brocaded silk tobine
England (Spitalfields, London),
1749
V & A: T.192–1996

139
Waistcoat
Silk, brocaded with coloured
silks and silver thread
England (Spitalfields, London),
c.1734
V & A: T.72–1951

been imported to Britain, which provided a ready market for their brilliant and colour-fast dyes, particularly after 1643, when the East India Company insisted to its Indian suppliers that designs be altered to suit the tastes of a British market (pl.140). These fabrics, with their colourful motifs of flowers and foliage set against a white ground, proved extremely popular for clothing and furnishings, but their popularity also engendered the desire to create British imitations that brought the trade inside the country. By the middle of the eighteenth century wood-block printing on cotton and linen had been developed, and in 1757 the Irish manufacturer Francis Nixon brought his technique of printing designs from engraved copper

plates to London. In 1783 Thomas Bell took out a patent for printing with engraved metal rollers, which instantly meant that identically designed fabrics could be produced quickly in bulk – and cheaply. Despite attempts by practitioners in the wool and silk industries to prevent the rise of printed cloths that could 'imitate the richest silk brocades, with a great variety of beautiful colours',[12] printed cottons rapidly took off, thanks in part to other kinds of technological advances (pl.141).

Until this time it was possible for weavers to work a width of fabric only as large as their arm-span (unless they had an assistant), because they needed to be able to throw the shuttle from one side of the loom and catch

140
Bed curtain
Painted and dyed cotton chintz
India (Coromandel Coast), *c.*1700
V&A: IS.121–1950

141
Bed curtain and valance,
printed by Nixon & Company
Plate-printed cotton with
linen and wool trimming
England, 1770–80
V&A: T.612&613–1996

it at the other. With John Kay's invention of the flying shuttle in 1733, larger widths of woven fabric could be produced without the need for more workers. This invention, combined with that of the spinning jenny, the water frame and the spinning mule (pl.143) in the 1760s, transformed the British textiles industry. Finer yarn could be spun quickly and with a smaller number of labourers; weaving could be carried out faster, more easily and at a greater scale; and printing could enable the rapid and inexpensive decoration of cotton fabrics. The degree of industrialization that followed these innovations meant that by the 1830s cotton had taken over from wool as the most important fabric produced in Britain, with cotton cloth and yarn making up nearly half of the country's exports (pl.142).[13]

By the time of the Great Exhibition of 1851 the British textile industry was thriving. The Industrial Revolution not only facilitated the industrialized production of luxury goods, but also opened up their consumption to a broader section of society, who used textiles as clothes and furnishings to proclaim their status. Indian fabrics were no longer a significant import to Britain; instead it was the Lancashire cotton mills that exported printed cottons to India. However, dissatisfaction with the quality of design produced by the textiles industry was also growing. A.W.N. Pugin, who was responsible for the Medieval Court at the Great Exhibition, encouraged a revival of the Gothic style of architecture and design, which proved applicable to textiles – just as it was to other arts. As the revival of the Gothic style was directly related to the construction and reconstruction of churches during the Victorian period, it was eminently suitable for ecclesiastical contexts, including textiles. Vestments of woven wool and embroidered silks offered

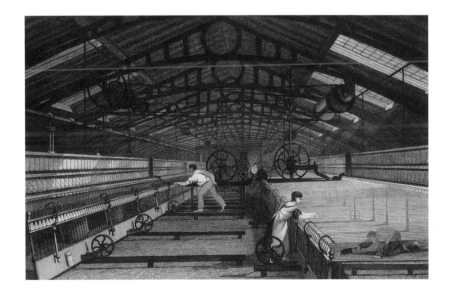

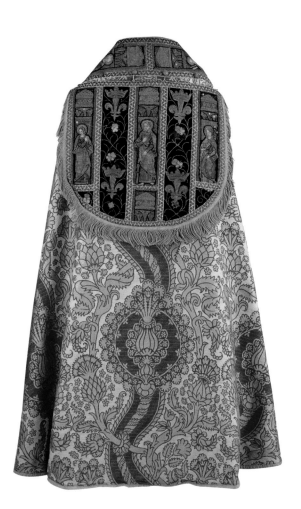

Faulkner and Co., needed to employ for the production of textiles.[14] Not only did he return to traditional methods of production, but also to traditional vegetable dyes, rather than the chemical dyes used in the factories to greater chromatic effect. As well as tapestries, carpets, embroideries and other woven fabrics, from 1881 when it moved to Merton Abbey his company also produced block-printed textiles using the ancient method of indigo discharge (pl.146). Morris's followers in the Arts and Crafts movement continued his example, particularly in hand-loom weaving from the end of the nineteenth century. Small cottage industries emerged, specializing in particular hand-weaving techniques, while other initiatives encouraged the revival of traditional forms of embroidery, such as whitework and appliqué, which were further encouraged by the publication of works such as *Embroidery, or The Craft of the Needle* by W.G. Paulson Townsend in 1899.

This revival of traditional textile crafts has continued to coexist alongside the production of commercial, industrial fabrics during the twentieth and early twenty-first centuries. The first 40 years of the twentieth century benefited from the possibilities offered by new man-made fibres, dyes and increased mechanization, as well as from a variety of design currents – ranging from the printed florals of Liberty's of London to geometric patterns

a partial return to medieval practice and style, but also – in Pugin's conception – a new approach to design that did not attempt slavish historicist imitation, but sought to evoke the spirit of an earlier era through patterns of abstract forms (pl.144).

If Pugin spoke out for the need for design reform in textiles, William Morris had a far greater impact. He was troubled by the issue of 'bad design', but also by the production processes of the textiles industry. As he saw it, the extreme specialization and division of labour resulting from industrialization had deskilled the workforce and created a total divorce between designer and maker. He sought to bring the designer back to the production process and to revive, in a significant way, traditional techniques of production – such as the hand-weaving of tapestries (pl.145). He strongly believed that designers should understand the technical issues of the medium for which they were designing, and so taught himself the crafts that his company, Morris, Marshall,

144
Cope and hood
designed by A.W.N. Pugin
Woven wool and
embroidered silks
England, *c.*1848
V & A: T.288–1989

145
The Forest, designed by
William Morris, Philip Speakman
Webb, John Henry Dearle,
woven by William Knight,
John Martin and William
Sleath at the Merton Abbey
Workshop Tapestry woven
in wool and silk on cotton warp
England (Merton Abbey), 1887
V & A: T.111–1926

146
'Strawberry Thief',
designed by William Morris,
made by Morris & Co.
Indigo-discharged and
block-printed cotton
England (London), 1883
V & A: T.586–1919

designed by Charles Rennie Mackintosh and radical abstract prints produced by the Omega Workshops. They also saw the establishment of several government-sponsored initiatives, such as the Rural Industries Bureau, which were intended to revive practice in the traditional crafts. Although the effects of two world wars were considerable, forcing textile factories away from fashionable design and towards the production of fabrics essential to the war effort – such as blackout material, parachute silk and camouflage prints – the post-war period saw a revival of both innovative design for mass-produced textiles and of hand-crafting techniques.

The 1951 Festival of Britain showcased a huge range of fabrics in natural and synthetic fibres, including the renowned 'Calyx' design by Lucienne Day (pl.147), a screen-printed fabric inspired by the work of artists such as Paul Klee and Joan Miró, which won its designer international acclaim. And when undertaking the post-war rebuilding of Coventry Cathedral, the architect, Basil Spence, turned to textiles rather than painting for the huge image behind the High Altar: a tapestry of Christ in Glory designed by the artist Graham Sutherland (see pl.42). Sutherland, along with other fine artists such as Ben Nicholson and Barbara Hepworth, was also

commissioned by the pioneering Edinburgh Weavers
company to produce innovative textile designs for
their fabrics, while screen-printed designs continued to
represent the latest trends in fashion, such as Pop Art,
or significant events, such as the moon landing –
commemorated in the 1969 'Lunar Rocket' design by
Eddie Squires for Warner and Sons (pl.148).

Domestically, in recent years traditional crafts such
as quilting and knitting have not only been revived, but
have become forms of contemporary art (pl.149). At an
amateur level, in an age of 'austerity Britain' (whether in
the twentieth or twenty-first century), the application of
these crafts, and the communal effort that often goes into
making them, can be seen to resonate with the fashion
for the homespun rather than the mass-manufactured.
For textile artists such as Natasha Kerr, Kaffe Fassett and
Tracey Emin (pl.150) they offer a variety of possibilities:
the fascination of combining a range of stitching, dyeing
and printing techniques with found objects and scraps of
fabric, to create multi-layered pieces that resonate with
textile as well as personal history; a sense of creativity
within structure, and a joy of colour and texture; and the
chance to subvert supposedly 'safe', domestic, feminine
crafts and create challenging narratives that can provide
a commentary on social or political issues. Above all, in
post-industrial Britain, textiles remain appropriate for
experimentation by the amateur as well as the professional
– a link to their original production in the home as well
as in the workshop – and, as such, continue to find
relevance and resonance in our lives today.

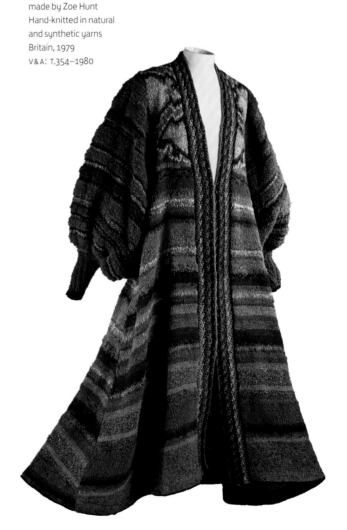

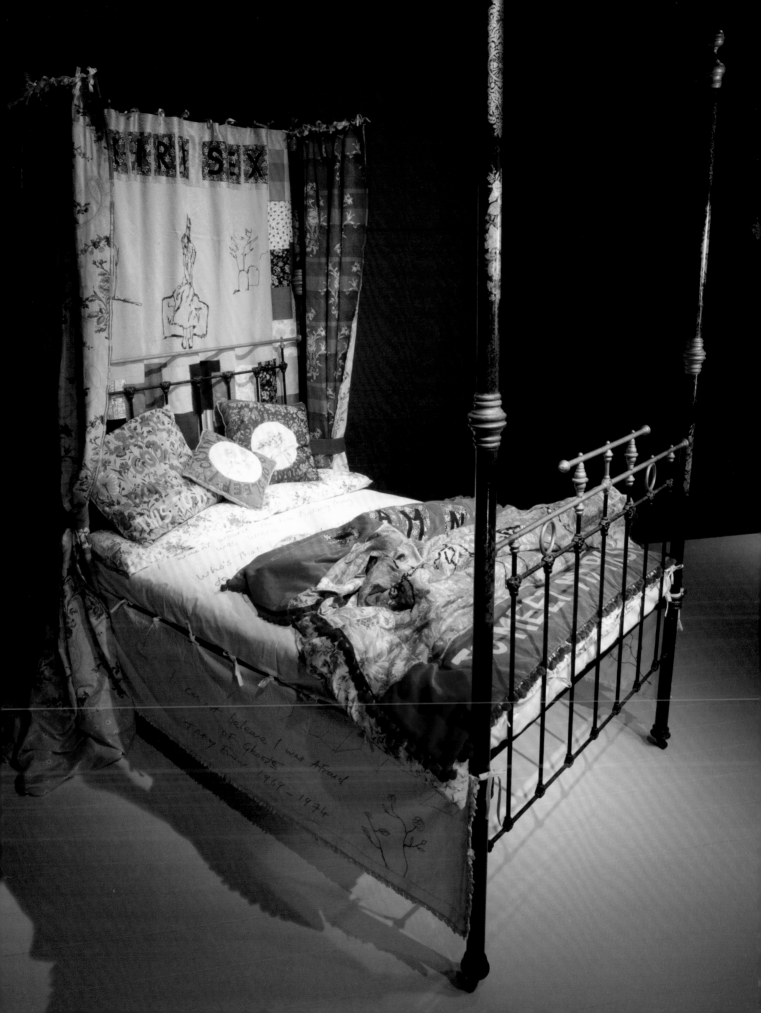

Jo Budd

Working since 1980. Lives and works in Suffolk.

Can you tell us how your making begins?
Making begins as a process of looking. I am
deeply rooted in my native East Anglian
landscape, now so ingrained in my visual
memory that, after the initial contemplation
of a subject or visual idea, the start of a new
series will be one of play and improvisation,
allowing what I have absorbed to surface
through the medium of dye and cloth.

By being playful and experimental, and
letting the wet and dry media interact, I
invite the unexpected and the serendipitous
and am guided to the next step as a musician
would improvise a melody.

I do not start a large piece by planning
the composition or sketching alternative
ideas; rather I react to a set of colours
and light at different times of the day or
season, and in the spirit of adventure see
where it will lead me. I find this freedom of
approach far more rewarding than a more
deliberately planned or 'designed' beginning.
By working in an abstract way and intuiting
what comes next, my unconscious ideas are
given scope to materialize. The freshness
and energy of new ideas are preserved,
not dissipated or 'lost in translation' from
sketchbook to finished piece.

There is a circular rhythm to the making
process, starting with experimentation
and play. I produce a body of dyed fabrics,
which leads to a series of large-scale work,
and then as the series is drawing to a close
I make smaller pieces, which I call 'sketches',
which are finished works in their own right,
but can be pointers towards a new theme
or body of work. Then I will start again with
a new batch of dyeing for the next series.
For the past two years I have been focusing
on water and weather – water because my
studio is on the edge of the Waveney Valley
water meadows, and because it is such an
amazing, fundamental, all-encompassing and
visually complex phenomenon – reflection,
refraction and transparency all rolled into
one (and every object on this planet is made
of a percentage of it!); and weather because
we have particularly wonderful skies and
weather phenomena in this part of Suffolk,
and I am fascinated by the movement of
clouds (that is, water) and of energy in the
sky and on land.

What are your preferred raw materials?
The raw materials I use divide into wet
and dry media, both of which are equally
important to me, and I describe the process
as they come together as 'painting with cloth'.

I love the feel of a household paintbrush in
my hand and of colour mixing on a large
palette with dyes. I use water-based dyes with
varying degrees of thickener, and either paint
the dyes directly onto the fabric (sometimes
wetting it first) or indirectly by painting onto
a flat surface and printing off it.

The dry medium of fabric offers varying
textural qualities, which will absorb the dyes
in completely different ways, affecting the
nature of the painted or printed mark. It also
offers various light-reflecting and refracting
and absorbing qualities, from thick matt
canvas to the smoothness and shine of silk,
to sheer translucent fabrics that I use to create
colour overlays, subtly altering the underlying
hues and adding new layers of mark.

I also enjoy using fabrics that have had
a previous life – their history of wear being
evident in a pre-cut shape, unpicked stitching,
a frayed edge or a faded surface, which adds
depth and resonance to the cloth and
a contrast with pristine new fabrics.

The feel of a threaded needle in my hand
is as exciting as the loaded paintbrush,
and has just as much potential to alter
the nature of the fabrics. It is alive with
possibilities, and potent with the resonating
history of thousands of years of stitching,
from the first thorn or bone needles, through
to many generations of fine needlewomen
– my mother and grandmother included.
I use machine threads to hand-sew the
dyed and collaged fabrics to a canvas
backing, with tiny, almost invisible stitches
and the finest of needles. The stitching is
structural, but also creates surface texture
and ripple, in response to the dyed mark.
Sometimes the stitch becomes a mark in
its own right and appears on the surface;
this might be to enhance the light-reflective
qualities of a fabric, suggesting wind-ruffled
water, or to imitate motes of dust floating
on a still water surface.

Stitching, like mark-making, is intuitive for
me – I don't use conventional embroidery
stitches and it is definitely not there as
embellishment, but is integral to both the
structure and the composition. It is the
finishing touch, which brings out the inherent
qualities of the various fabrics, making
the surfaces sing and communicate and
imparting coherence to the whole.

left
Male / Winter
Mixed reactive and
rust-dyed fabrics,
hand-sewn to
cotton canvas
England (Suffolk), 2010

above
Blustery Day 3
Procion and pigment dyes,
hand-painted on cotton
organdie, silk and plain
cotton, hand-stitched
to cotton canvas
England (Suffolk), 2012

What are your main technical challenges?
I don't see the techniques I employ as
challenging, more as opportunities for
exploration. There is no limit to the potential
of dye, cloth and thread. However, I do
consider mastery of technique and good
craftsmanship to be essential. It is only by
mastering a technique that you can safely
explore and bend the rules – and I do want
my work to stand the test of time.

One of the elements that could be considered
technically demanding, when making a large
piece, is keeping the surface tension of the
stitches even over the whole canvas, while
still varying the 3D qualities of the surface.
This is important so that the piece will hang
flat against the wall and not destroy the

visual depth or pictorial illusion of the work
with unwanted shadows. Being tensioned
between battens also ensures that subtle
nuances of textural difference, produced
by the stitch, are read correctly, without
interfering with the tonal values of the colour.

I try to make the anchoring stitches,
especially in the smaller pieces, tiny enough
to be invisible, in order to preserve a fresh
and 'effortless' feel to the work. This belies
the time-consuming and technical care with
which they are actually constructed.

**Do you think of your work as being
part of a heritage?**
It is easier to place work in context when
looking back over time, and I therefore find

it hard to say exactly where my work fits.
I am first and foremost a painter, fine-art
trained, using a painterly aesthetic, but
exploring textile media. I am nevertheless
steeped in textile traditions, through my
mother who made exquisite embroidered
pictures and taught textiles and art for
many years, and my grandmother who was
superbly skilled in all forms of stitch and
constructed textile. From a young age I was
made aware of the richness of historical
and ethnic textiles, in particular through the
collections of the Norfolk Museums Service.
So my work must therefore be seen in the
context of a textile tradition too.

right
Double Sundogs
Procion dye-painted cotton
organdie and fine cottons,
hand-stitched to cotton canvas
England (Suffolk), 2011
Private collection

far right
Snow Arriving
Rust and Procion hand-dyed
mixed fabrics, hand-stitched
to cotton canvas
England (Suffolk), 2011

left
Female / Summer
Mixed reactive and rust-
dyed fabrics, hand-sewn
to cotton canvas
England (Suffolk), 2010

As my work is held in collections such as the V&A, the Embroiderers' Guild, the Quilters' Guild and the modern-art collection at Norwich Castle Museum, I presume I must straddle all of these heritages. Perhaps I belong to a new breed of fine artists who are using traditional craft media to cross boundaries?

How does your work relate to art, craft and design?
I can say that I am not a designer, as the processes I use are not planned, refined and then reproduced, as most design processes are; and while craftsmanship is important to me, I don't see myself as a craftsperson either, as I am not exploring a specific genre or textile tradition. My work has changed and evolved over the years according to the demands of my subject matter, and no material would be out of bounds in my practice if the subject required it.

I consider myself an artist, because I work intuitively with a painterly approach. I work in series, which enable discoveries to grow and develop, usually until an endpoint or final statement is reached, such as Male/Winter and Female/Summer (above), which were the culmination of my Rust series 2006–10, which explored rust techniques and notions of duality, contrast and harmony. Rigid definitions between art, craft and design can be misleading. I prefer a more fluid approach and believe that any work in any medium can become a work of art, whether it is essentially functional or not, if it is of sufficient quality and carries timeless inherent qualities of truth and beauty, to which we all instinctively respond. This is certainly true of the best of the quilt-making tradition – for instance, historical examples of quilts by the Amish, or the Gee's Bend quilts, made by unknown makers with limited resources for functional purposes, but undeniably in touch with an innate aesthetic and a mastery of the language of colour and design.

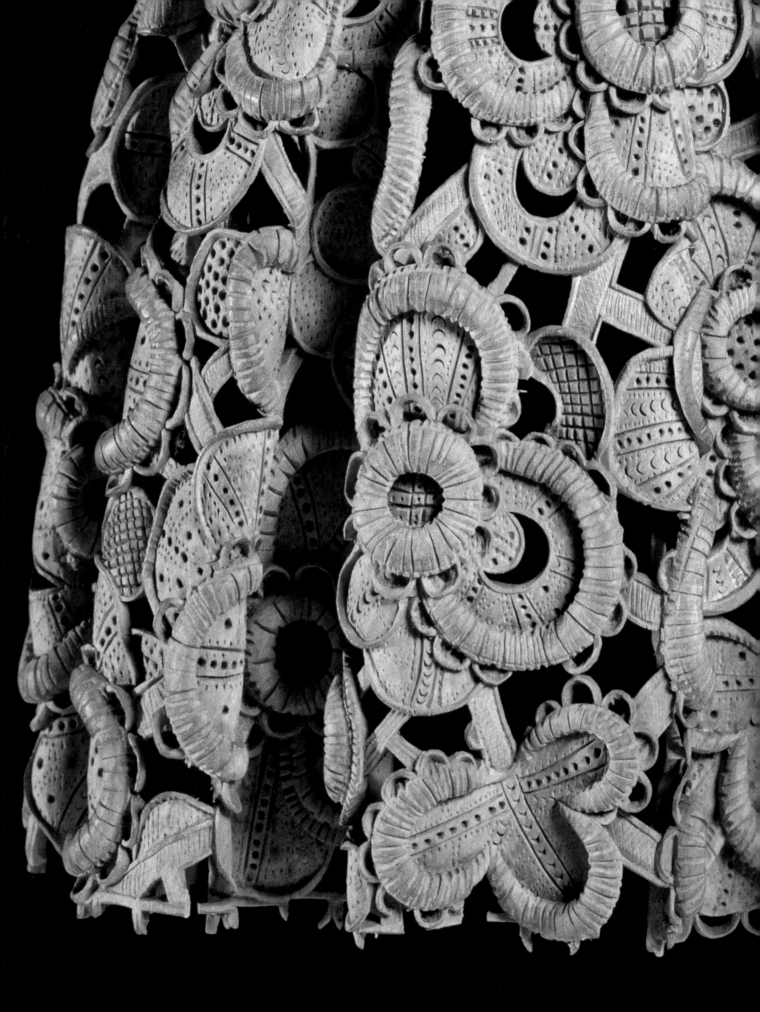

wood

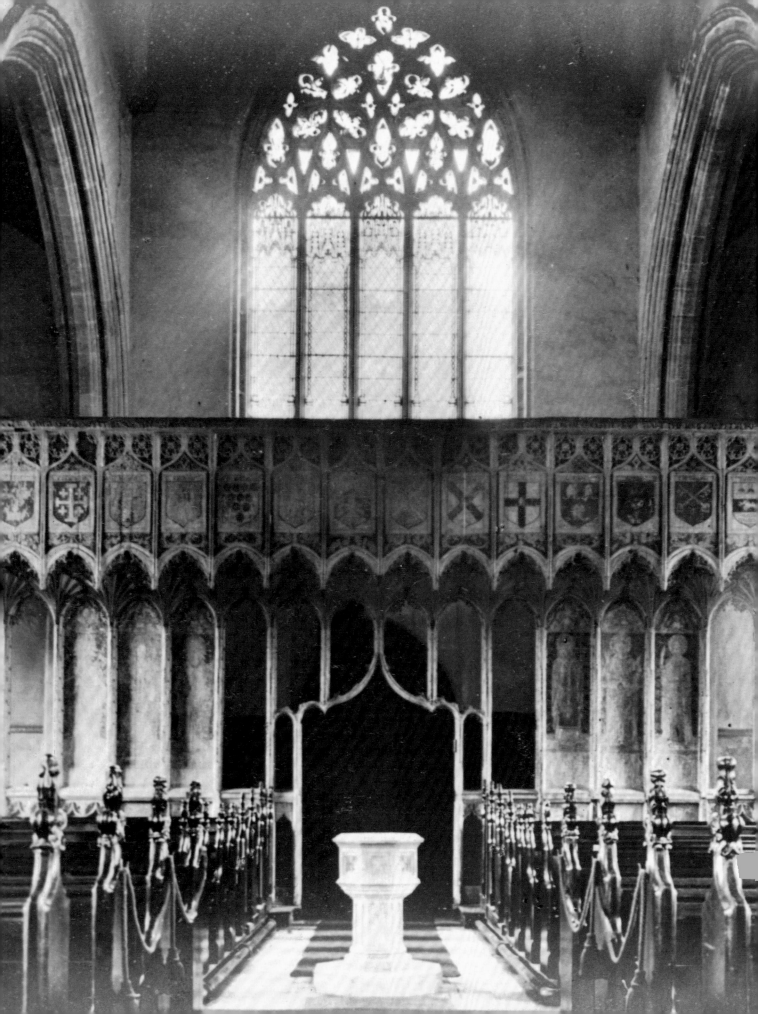

Wood has been used for centuries to house us and supply the objects that furnish our lives – above all, those that we use for sitting, sleeping and eating. It forms part of our natural habitat, gradually marking the passing of the seasons. It serves as fuel, to heat our homes. Perhaps even more than other materials, wood is a material that is intricately linked to changes in fashionable living and in the ways that people have furnished their homes to serve particular purposes. In addition, the story of wood is one that is bound up in Britain's rise and fall as a trading nation, both within Europe and internationally.

The susceptibility of wood to fire, worm and rot means that – as with many materials – what we now see, looking back over hundreds of years, is only a partial representation of what was once made and used. This is true particularly for objects made during the medieval period. Very little domestic woodwork survives at all, and although Britain is fortunate to retain significantly more church woodwork than many European countries, the iconoclastic destruction begun with the Reformation and continued in later periods means that only a fraction of what originally adorned the medieval cathedrals and churches of Britain survives today. Despite such losses, we are able to piece together a picture of the place of wood in the pre-Reformation Church, from what is still conserved in churches and museums across Britain.

Wood plays an integral role in the Christian story, from the Creation to the Passion. In Genesis, the act of eating the fruit from the Tree of the Knowledge of Good and Evil causes the Fall of Man and the expulsion of Adam and Eve from the Garden of Eden. In the New Testament, Christ is crucified on a wooden cross to make the supreme sacrifice to save mankind. For a medieval population whose prime concern was religion, the significance of the wooden cross was absolute, and it was reflected in the popularity of the story of the True Cross. According to this story, St Helena (the mother of Constantine, the first Christian emperor) discovered the relics of the True Cross (the cross on which Christ was crucified) when travelling in the Holy Land. By the Middle Ages this story was well established. It was included, in several different versions, in *The Golden Legend* (*Legenda Aurea*) by Jacopo da Voragine, Archbishop of Genoa – an account of saints' lives compiled around 1260, which became one of the most popular medieval books and an important textual source for artists. Devotion to the True Cross was widespread throughout the Middle Ages, with fragments of it being venerated as holy relics across Europe.

While relics of the True Cross were at the heart of Christian devotion, the cross as a visual symbol was ubiquitous within the medieval church. It was most prominent of all in the form of the rood screen: the screen present in almost all medieval churches that divided the nave (occupied by the laity) from the choir (reserved for the clergy). The rood screen served several functions. Like metal grilles, although it physically separated the laity from the clergy, it still allowed a certain amount of visual access through the screen. It could act as a back-drop to one or more nave altars used for daily Masses, which might be funded by the individuals or organiza-tions who had paid for the screen. And it served as the primary focus of devotion for the laity, whose eyes could not fail to be drawn to it. Usually constructed from oak, the lower level of the rood screen was generally divided into panels painted with devotional figures, sometimes conceived as reredos (altarpieces or decorative screens) to the altars placed in front. The upper level was also usually carved with single figures – such as representations of the saints – or with biblical scenes.

However, the main component of the rood screen was actually above it: surmounting the screen, and giving it its name, was a large-scale carved and painted wooden cross, known as a rood, bearing a figure of the crucified

152
Virgin and Child
Polychromed oak
England, c.1220–30
V&A: A.79–1925

Christ, often flanked by standing figures of the Virgin and St John. As the main visual focus of the church, rood screens were often the most popular subject of patronage, with different elements being funded by different bodies or individuals.[1] The majority of medieval rood screens were destroyed during the Reformation, but some do survive, particularly in Devon and East Anglia, such as that of St Mary's Church in Attleborough, Norfolk, constructed in c.1470–78 and now restored and reinstated in its original position in the church (pl.151).

The rood may have been the principal visual focus in the medieval church, but it was far from being the only one. Unlike the open spaces to which contemporary worshippers are accustomed, the medieval church would have been a convoluted space, shared by many different institutions and individuals, who expressed their faith and their desire for commemoration through their patronage of church fittings, including altars, devotional figures, vestments and stained glass (see Chapter 1). Each altar would have been topped by an image, usually of Christ – often as the Man of Sorrows – the Virgin or a saint. Although they were the most common form of church sculpture in the Middle Ages, these relatively small carved figures were eminently portable, so they rarely escaped the devastation of the Reformation. One rare example survives in the V&A: a figure of the Virgin and Child from c.1220–30, probably from Langham in Essex, which even bears traces of its original polychromy (pl.152).

The importance to the Catholic faith of carved wooden figures such as roods and altar sculpture made them particular targets for destruction during the Reformation. Medieval religion conceived of images as an aid to devotion: by fixing their eyes on an image of the crucified Christ or the sorrowing Virgin, worshippers were supposed to strengthen their faith by empathizing with the pain of Christ or the sufferings of the Virgin.

As such, images served a real purpose as a conduit for devotion, which was particularly important during the Middle Ages for a largely illiterate population. For many, however, there was a fine line between images facilitating devotion and images themselves becoming the focus of devotion – which veered dangerously close to idolatry. When an object was thought to have miraculous powers, then the image itself (rather than the saint it represented) was often attributed with the power to perform miracles. Such unease surrounding images – which can be found in written sources from as early as 1400 – and their perceived power made them a prime target for iconoclasts during the Reformation and later, particularly during the rule of Edward VI, whose accession caused an especially zealous period of devastation that included the pulling down of the Great Rood in St Paul's Cathedral in November 1547.[2] Carved wooden figures such as the Langham Virgin were burned in huge numbers, or mutilated – their arms and heads being cut off in the same way that the faces of painted images were scratched out – to demonstrate that the images were just that, and were not embodied with superhuman powers (pl.153).

Although this kind of figurative woodwork has largely been lost (and, with it, much of the colour that would have adorned the church interior), what remains – whether *in situ* or in museums – is a wide range of church fittings, including choir stalls, misericords, stall ends, font covers, bishops' thrones and bosses. In some cases their survival was due to their location: woodwork situated high on the roof of the church could not easily be removed, for example. In other instances their survival resulted from a continued practical function, or a lack of figurative decoration that made them seem less threatening than devotional images of the saints.

These more architectural fittings provide us with some idea of how rich the medieval church interior would have been, and of the quality and nature of ecclesiastical

153
The Annunciation
Oil on oak panel
England (Bury St Edmunds),
1470–90
V&A: W.50–1921

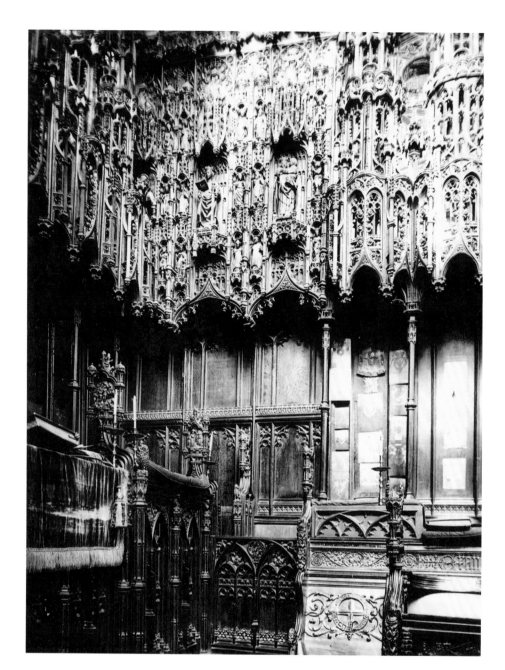

154
Choir stalls in St George's Chapel, Windsor Castle, photographed by Sir Benjamin Stone, 1899
V&A: E.812–2001

woodcarving in the Middle Ages. Some of this was purely decorative, such as the canopy arches over choir stalls, whose tracery echoed that of the Gothic architecture of the churches in which they were housed. Some of the finest surviving choir stalls are those in St George's Chapel, Windsor, made from 1477 to 1483 and decorated with towering two-tiered canopies with elaborate traceried decoration (pl.154). Other types of fittings were designed to suit their location: bosses, placed at the intersection of ribs on church vaults, were intended to be seen from a distance and so were often brightly painted and gilded, but were also carved to suit; rather than displaying the intricacy and delicacy of something that would be seen

close-up, they can seem rather crude in comparison. One from a group of bosses now in the V&A from St Albans Cathedral in Hertfordshire (pl.155), removed during restoration of the church in 1890, was probably originally located on the vault of the Lady Chapel, which was roofed during the rule of Abbot Hugh of Eversden in the first quarter of the fourteenth century. Probably a keystone boss, it is made in the form of the head of a snarling lion, its mane forming the circumference and its face at the centre, gnawing on a bone. It was created from a single block of oak, hollowed out and carved using a variety of gouges and chisels on the exterior, to create the stylized waves of the lion's mane. The strong carved contours of

155
Boss from St Albans Cathedral
Carved oak with traces of
gold and colour
England (Hertfordshire), 1300–25
V&A: W.51–1914

156
**Bench end from the Chapel
of St Nicholas, King's Lynn**
Carved oak
England (probably King's Lynn),
c.1419
V&A: W.16–1921

the boss would have made it easier to see from a distance, particularly – as traces of red pigment and gilding reveal – in its original decorated state.

Other forms of ecclesiastical woodwork were intended for locations where they would be more easily visible, necessitating far more intricate kinds of carving. In the early part of the Middle Ages congregations simply stood or knelt for services, partly because churches were used for secular as well as religious purposes, requiring a nave free of furniture. Permanent congregational seating, usually in the form of benches, was introduced only in the early fifteenth century, possibly linked to an increase in the preaching of sermons. The ends of these benches (vertical panels set at right-angles to the bench seats) provided carvers with a rectangular surface for decoration that would be placed alongside the nave aisle – visible to all who passed through the body of the church. Surviving bench ends, mostly from the West Country or East Anglia, display different approaches to their decoration. On some, the rectangular surface was left plain, with the only carved elements being a finial (known as a poppy head) and an animal (often kneeling and fantastical or grotesque) carved on the elbow rest. Others exploited the possibilities of this face of solid oak – usually a single board – and produced low-relief carvings that ranged from the purely decorative, such as blind traceries, to the narrative. One unusual bench end comes from the Chapel of St Nicholas in King's Lynn (pl.156), the largest chapel of ease (an additional church building built within parish boundaries for those who could not easily access the parish church) in Britain. Dating from *c.*1419, it is carved

157
Misericord from the Chapel of St Nicholas, King's Lynn
Carved oak
England (King's Lynn), c.1419
V&A: W.54–1921

158
Section of the façade of Sir Paul Pindar's house
Joined and carved oak
England, 1600
V&A: 846–1890

with an accurate depiction of a contemporary two-masted ship moored at anchor, with waves beneath and the sun, moon and stars above. At this time King's Lynn was one of the most important ports in England, and the spire of the chapel served as a sea-mark for ships approaching the port. This maritime imagery may well have been chosen by members of the local community who paid for the rebuilding of the chapel in the first years of the fifteenth century, in reference to the significance of their town and the chapel itself.

Clergy and monks also stood during religious services in the Middle Ages, and continued to do so after the introduction of congregational seating. According to the sixth-century rule of St Benedict, monks had to sing the eight daily offices standing up, and were only allowed to sit during the Epistle and Gradual of the Mass, and during the Response at Vespers. For older and weaker monks this was an arduous task, and in the eleventh century misericords were devised as a means of easing their load, the earliest surviving British versions appearing a century later. Misericords – whose name comes from the Latin for 'pity' – were ledges, each supported by a corbel, that were revealed when hinged choir seats were tipped upright; elderly and infirm monks could lean against them, but continue to fulfil their duty of standing up. Since the misericords were on the underside of the choir seats, they would not be visible when the seats were in use. Their decoration was concentrated on the central corbel, and often extended to secondary carvings, known as 'supporters', on each side. Their subject matter was rarely overtly religious, which may explain why they survive in significant numbers. Many examples are decorated with foliage; others present imaginative carvings of monstrous creatures inspired by medieval bestiaries, moralizing fables and well-known cycles such as the Labours of the Months.

Some misericords, such as one at All Hallows, Wellingborough (Northamptonshire) and another in the V&A, part of the St Nicholas Chapel fittings, depict a master-carver at work (pl.157). The central corbel of the King's Lynn misericord shows the master-carver seated at his bench, a pair of compasses in his hand, a square and rule in front of him. His dog sits at his feet, while a piece of tracery behind his bench indicates the work he has been producing. Two journeymen work at a separate bench to the left, while an apprentice brings a mug of beer or ale to quench his thirst. In this case, and that of other misericords from St Nicholas Chapel, the supporters are composed of letters: a W on the left pierced with a saw, and a V to the right, pierced with a gouge.

It is unclear whether these letters refer to particular patrons, or whether the letters of all the misericords in the set combine to produce a particular saying or motto, but it is unlikely that they refer to the makers of the misericords. As with most medieval crafts, the names of the craftsmen who produced these works are generally unknown. Although it is likely that many of the finest craftsmen worked for the Crown, most craftsmen were probably based near ecclesiastical centres where there was work. Architectural woodwork, in particular, was executed on site, as the carver needed to work with the mason to ensure a happy marriage of architecture and woodwork.

Little early woodwork for secular use survives, but it is evident that wood was as ubiquitous in the home – throughout all social circles – as it was in the church, as much in architecture as in furnishings. Wood is most apparent now as part of architectural frameworks: in timber-framed buildings such as the Guildhall in Lavenham, Suffolk, or Sir Paul Pindar's house in Bishopsgate, part of whose front is now in the V&A (pl.158); and in roof carpentry, such as the astonishing

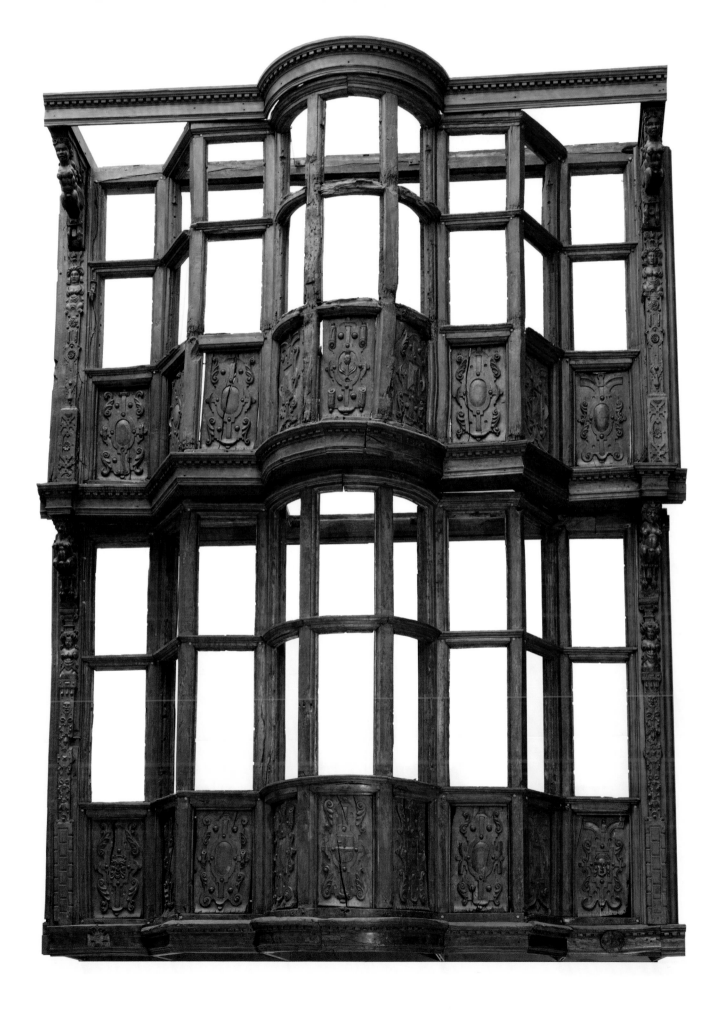

159
View of the interior of
Westminster Hall, London
Oak hammerbeam roof, 1393–9
Published in R. Ackermann,
The Microcosm of London, London
(1835), vol.III, pl.94
RIBA Library Photographs Collection

161
Section of linenfold panelling
in the Long Gallery at
The Vyne, Hampshire
Oak
England, 1526–8

160
Corner-post
Carved oak
England, c.1500
V&A: W.6–1928

hammerbeam roof of Westminster Hall, made by Hugh
Herland, with its 20.3-metre (66½-foot) span, one of the
greatest achievements of medieval timber architecture
(pl.159).[3] We also sometimes find detached sculptural
elements that adorned these buildings. A corner-post in
the V&A (pl.160) would originally have been situated on
the outside corner of a two-storey timber-framed house.
The upper storey of such houses usually jutted out into
the street, allowing more room on the walkways below.
Corner-posts acted as supporters to the upper storey,
but also provided an opportunity for carved decoration.
The figure depicted on this particular post is a wildman,
also called a 'woodwose'. A common subject in medieval
woodwork, he is represented with hair covering his
entire body, holding a club and with a grotesque mask
at his feet, and probably served as a protective presence
for the household.

Examples of surviving woodwork from inside the
house are relatively rare until the seventeenth century.
Wooden panelling was one of the principal forms of
wall covering, used to exclude draughts in stone houses.
It often imitated linen curtains and so was known as
'linenfold', and could be combined with overmantels
carved with heraldry, as in the Long Gallery of The Vyne
in Hampshire (pl.161). Wood was also used for the screens
that separated the great hall of country houses from the

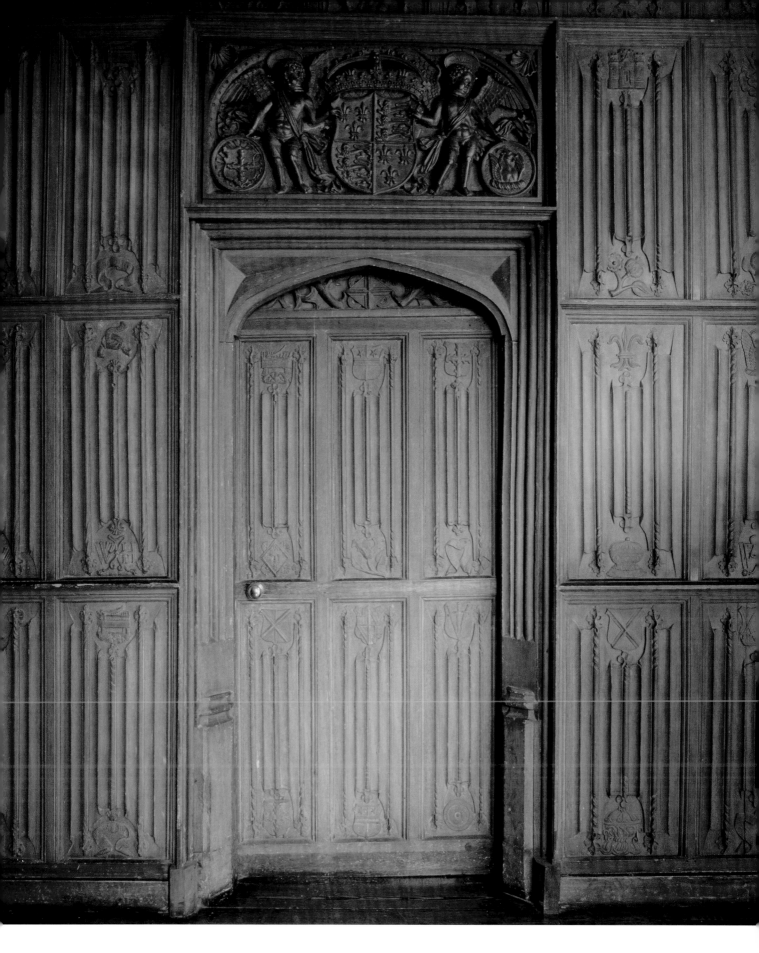

service areas that served them, as at Penshurst Place in Kent, one of the best surviving fourteenth-century great halls, which retains a screen (though dating from the mid-sixteenth century, so probably not its original one) in the correct position.

In terms of furnishings, wood provided everything from beds to chests and chairs, and even small-scale objects such as trenchers (the forerunners of plates) and spoons. Houses were sparsely furnished, however: a 1542 inventory of The Vyne lists just 19 chairs in the house, which contained 52 rooms. Of these sparse furnishings even less survives, but what does demonstrates that until the seventeenth century most furniture was made from oak, decorated with carving.

Despite the scarcity of domestic furniture surviving from before the seventeenth century, there are single pieces that give us an indication of what it would have looked like. A rare desk cupboard (its origin unknown) was probably originally used in a monastic building such as a chapter house, scriptorium or refectory, where it would have been used as a lectern (V&A: 143–1898). It is made from two types of oak: English oak for the structure, and imported eastern-Baltic oak for the carved panels. This is not unusual. English oak grew quickly, and thus produced timber with an irregular grain, whereas eastern-Baltic oak grew much more slowly, and produced a straight-grained wood that was preferable for decorative work.

Chests were the most ubiquitous pieces of furniture, both in the home and in the church, and a number of medieval chests survive, often fitted with iron strap-hinges to protect them, and with multiple locks, security and protection being their primary function. One example, now thought to have been made in the North of England, possibly on the Scottish borders, is typical of this form (pl.162). It is constructed from six boards, all sawn from the same tree, with iron strap-hinges and two locks (the key to each lock would be held by a different key-holder, ensuring that the chest could only be opened when both were present). The front of the chest is decorated with carving. At each end is a panel of rather sophisticated Gothic tracery. In contrast, the two panels at the centre, depicting the Temptation of Adam and Eve and two figures in contemporary dress gesturing towards the

162
Chest
Carved and joined oak
with iron fittings
Probably England, 1450–1550
V&A: W.32–1948

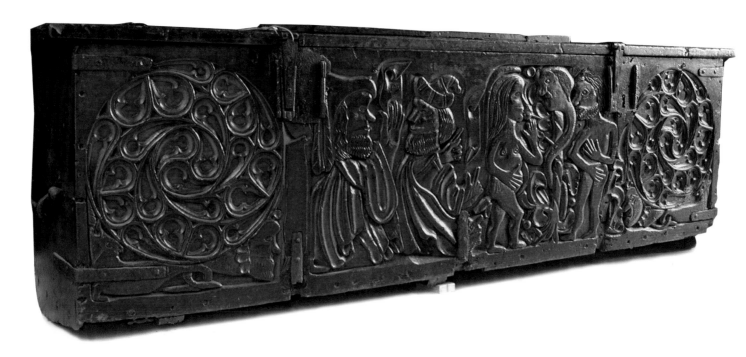

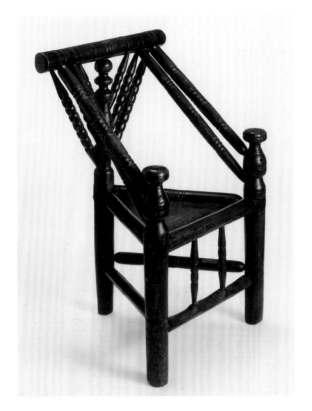
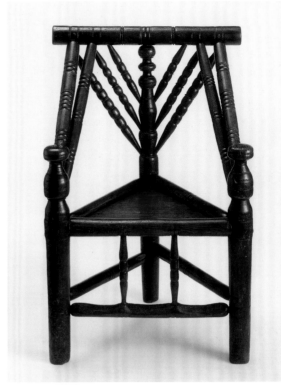

163
Armchair
Unseasoned ('green') oak,
turned
England, 1580–1620
V&A: W.32–1931

Temptation scene, are rather crudely carved. We do not know the significance of the two figures, but they may perhaps represent the Old and New Testaments.

Chests (and to a lesser extent, cupboards) remained the most common form of storage furniture from the Middle Ages until the seventeenth century, with so-called 'Nonsuch' chests (a nineteenth-century term referring to Henry VIII's palace at Nonsuch in Surrey) becoming popular in the late sixteenth century, decorated with an early form of inlay and probably made by Dutch or German craftsmen working in Southwark. The most common form of seating was the joined stool, while armchairs might be of the 'box chair' type with linenfold panelling in place of legs, or turned on a lathe, with three legs for stability (pl.163). Beds – the most important piece of furniture in a house – were also carved from oak, in a box form, and mounted with a tester from which to hang curtains for warmth. Typical of the form and decoration of beds in the late sixteenth century (although not of their scale) is the Great Bed of Ware (pl.164). Twice the size of a normal bed, it was probably made as a curiosity to attract customers to one of the inns in Ware,

Hertfordshire, and was already famous soon after it was made, being cited in Shakespeare's *Twelfth Night*. It is carved with ornament on the foreposts, which rise up like columns to support the tester, and with human and satyr figures on the headboard, flanking marquetry panels with perspective scenes of fantasy Mannerist architecture in the style of the Netherlandish printmaker Vredeman de Vries, whose engravings were circulating around Europe at this time. Originally the bed would not only have been adorned with these carvings and marquetry, but would also have been brightly coloured, as traces of paint on the headboard figures and underside of the tester reveal.

After the Restoration in 1660 British wooden furniture was completely transformed, largely due to the influence of Charles II, who acquired considerable knowledge of continental court fashion during his exile. Charles, whose mother was French, was already well disposed to France, but his experience on the continent proved highly significant. He saw Louis XIV as the prime exemplar of a modern monarch and, although Charles lacked the same kind of absolutist power as the French ruler, he could

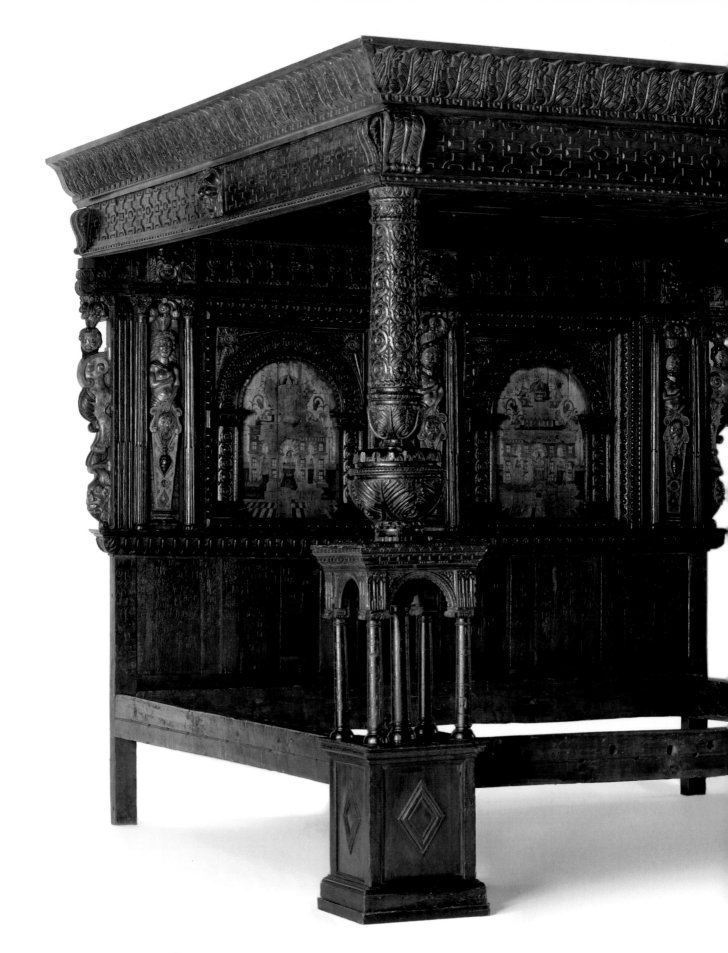

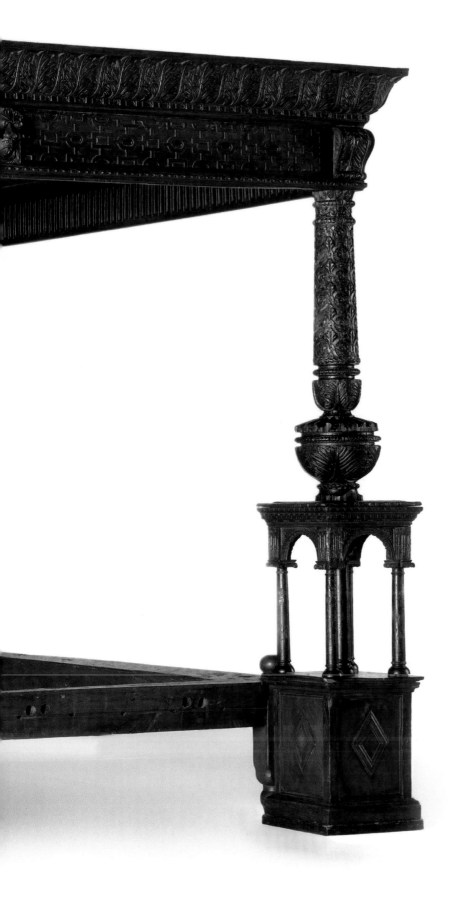

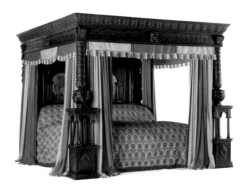

164
The Great Bed of Ware
(with detail showing
modern upholstery)
Oak, carved and originally
painted, with marquetry panels;
modern upholstery
England (probably Ware,
Hertfordshire), 1590–1600
V&A: W.47–1931

nonetheless attempt to emulate his patronage of the arts and his patterns of consumption and fashionable behaviour. As such, the Restoration saw a new approach in British furniture: an opening-up to European influences that had not been present previously. This in turn led to a number of innovations in furniture types and techniques, which would prove revolutionary for woodwork in Britain.

The interior of the 'typical' baroque palace – which originated in Italy, but found its most elaborate expression at Louis XIV's Versailles – was arranged in the form of a sequence of state rooms, which essentially functioned like stage sets for the ritualized behaviours that were performed there. Visitors would progress up a grand ceremonial staircase and through the sequence of rooms, whose furnishings increased in richness as they moved closer to the heart of the palace: the state bedchamber, where the bed stood as a symbol of the ruler, even when he was not present. The sequence of rooms, often referred to as an 'apartment', was usually arranged along one side or wing of a palace (often with a mirror-image apartment for the consort on the opposite side), with each room leading straight into the next along the same axis, an arrangement known as *en enfilade* (pl.165). This meant there were only windows along one side of the apartment, so in order to maximize whatever light there was, a new form of furniture was invented: the matching set of table, mirror and pair of candlestands, sometimes now referred to as a 'triad'. When placed against the wall, on the piers between the windows, with the mirror canted over the table, triads served the practical function of maximizing natural light during the daytime, and providing candle-light – from the candelabra placed on the candlestands – at night. In addition to the triad, and replacing the earlier chests and cupboards prevalent in British interiors, the cabinet-on-stand rapidly became the most desirable form of case furniture, performing a dual function as a

container for small objects and a piece of permanent display furniture for these new 'parade' rooms. For more intimate spaces, upholstered furniture gradually became more prevalent, with a new emphasis on comfort and luxury. The visual importance of the state bed was no longer in its carving, but in the textile hangings that constituted the greater part of its expense, and with which chairs and stools would be arranged around the walls of the room *en suite* (see pl.134).

These new kinds of furniture were not the sole preserve of the monarchy, as the nobility began to follow the shifts in architectural and interior fashions in newly built or rebuilt homes. After the Great Fire of London of 1666 the market expanded, as the city's importance as a commercial centre necessitated its rapid rebuilding. In order to prevent the possibility of such a disaster recurring, the Rebuilding Act of 1667 dictated how London should be rebuilt and what materials should be used. By 1671 nearly 7,000 houses had been built in line with these regulations, which included more standardized interior spaces than had previously existed. Once the houses were built, these interior spaces had to be furnished, and their owners chose to furnish them in the latest fashions. The boom in the furniture trade was extraordinary, with restrictions on foreign workers being lifted to ensure there were enough joiners, carpenters, carvers and turners to meet demand.[4]

These new types of furniture were important not only as stylistic innovations, but because their manufacture led to novel materials and techniques for woodworking in Britain. Before the Restoration most furniture was made from oak, and in most cases the decoration was created by carving, painting or both. There were instances of other, more exotic woods being used for objects destined for very important patrons: a portable writing box dating from 1580–1620 with similar decoration to the 'Nonsuch' chests is inlaid with boxwood and bog oak,

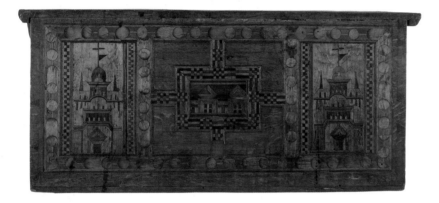

166
Table desk (with detail below)
Oak, inlaid with boxwood
and bog oak; interior drawers
in poplar; tinned iron hinges
England (probably Southwark,
London), 1580–1620
V&A: W.4–1911

167
Table (with detail below)
Marquetry of walnut, sycamore,
ebony and other woods on
a carcase of oak and pine; legs in
solid elm, possibly once ebonized
England, c.1674
V&A: W.53–1948

to create a decorative panel from contrasting colours of wood (pl.166). But such examples were rare. With the Restoration, this type of surface decoration became much more widespread and the range of woods used to create it expanded. Usually the body of a piece of furniture, known as the carcase, would continue to be made of oak, but a thin sheet of a more expensive, attractive or exotic wood, known as a veneer, would be used to cover all the visible surfaces.

A table made for Wingerworth Old Hall, Derbyshire, in about 1674 exemplifies the possibilities of this technique and of new kinds of inlay, known as marquetry (pl.167). The carcase of the table is made from oak and pine, but its surface bears a background of walnut 'oyster' veneer, created by cutting across small branches of walnut and setting thin slices of branch wood into a decorative pattern. The other technique used on the tabletop is that of floral marquetry. Popular on the

continent – in France and in Antwerp – as a means of imitating the naturalism of real flowers, the decoration was made using a number of veneers chosen for their colours. To make a marquetry panel, a design would first be created on paper and then transferred (probably by pouncing: pricking holes in the outlines of the paper design and dabbing chalk or charcoal dust through the holes) to the various pieces of veneer for the ground and for the individual elements of the marquetry. These would be cut out with a marqueteur's jigsaw or donkey, probably in packets, to avoid the thin pieces of wood tearing. The panel would be constructed by laying the ground veneer onto a sheet of paper for stability, then gluing each individual piece onto the paper until a whole panel was created.[5] The choice of woods varied according to what was available and the desired effect: in this case, probably a combination of sycamore, pearwood, planewood and ebony (one of the most highly prized of all woods),

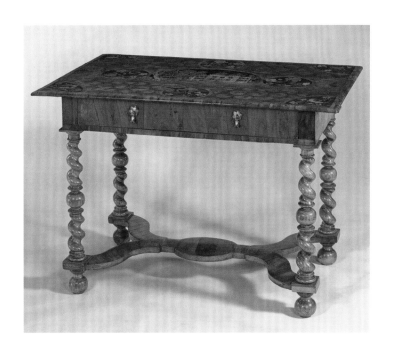

together with bone, stained green. Some woods were chosen for their natural colours, while others were used because they were neutral enough to be stained. In his second edition of *Sylva, or a Discourse of Forest Trees*, published in 1670, John Evelyn bemoaned the lack of naturally occurring materials that could be used for the purpose: 'beside the *Berbery* for *Yellow*, and *Holly* for *White*, we have very few; Our *Inlayers* use *Fustic, Locust*, or *Acacia*; *Brasile, Prince* and *Rosewood* for Yellow and Reds, with severall others brought from both the Indies . . .'[6]

As Evelyn suggests, craftsmen working in wood such as furniture-makers benefited from the expansion of trade and the position of Britain as an emerging global power from the late seventeenth century onwards. Some materials, such as French walnut (the most commonly used wood for fashionable furniture at this time), Mediterranean olivewood and Baltic oak (known as wainscot), were already imported from Europe, but others only became available as a result of trade with the Indies – for

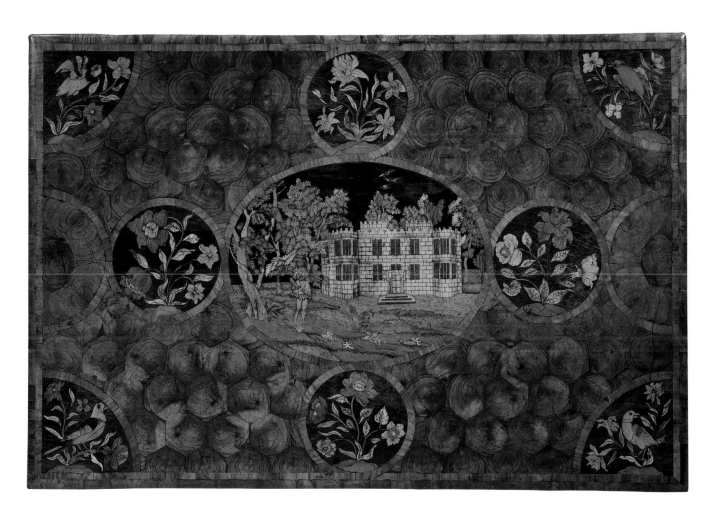

instance, princeswood (its name commensurate with its expense), cocus wood (often used for oyster veneers), *lignum vitae* (a black, oily wood used to make wassail sets) (pl.168) and red-coloured Brazil wood. Each of these had different properties, not only in terms of aesthetics and cost, but also in their ease or difficulty of working and their strength. Olivewood, for example, was often used for triads of relatively modest expense, although the legs were usually made from ash. Olive was not strong or straight-grained enough to be used for structural elements, but ash was straight, cheap and could be stained and washed with lampblack, to resemble olive-wood and make the whole piece look as if it was made from the same kind of wood.[7]

In addition to new woods, other materials made a significant impact. Cane was imported from Asia in vast quantities, leading to the invention of the caned chair, which was far cheaper and more portable than its upholstered equivalent, and advantageous for its 'Durableness, Lightness, and Cleanness from Dust, Worms and Moths, which inseparably attend Turkey-work, Serge and other stuff chairs and couches, to the spoiling of them and all Furniture near them' (pl.169). The caned chair – its seat and back panels of caning set into a turned and carved walnut frame – became so popular within and outside Britain that it was exported in vast numbers 'to almost all the Hot Parts of the World, where Heat renders Turkey-work, Serge, Kidderminster and other stuffed Chairs and Couches useless', becoming known as the 'English' chair.[8]

Imports also provided new objects in exotic materials, which were instantly sought after by consumers. Oriental

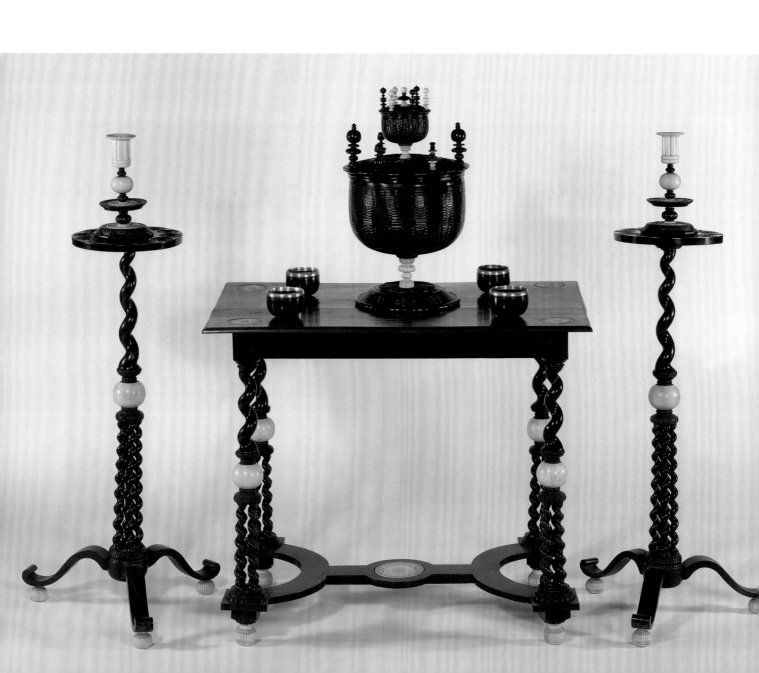

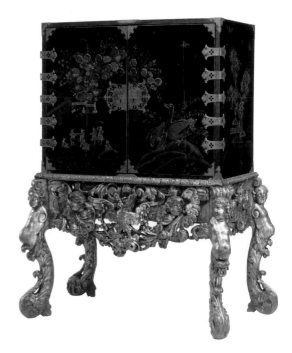

lacquer was one of these, imported by the East India Company. Like porcelain, lacquer was a mystery substance for Europeans. It was exotic, extremely expensive and produced by an unknown process. Two-door lacquer cabinets became prized possessions in Britain and Europe, often being placed on specially made, elaborate carved and gilded stands that heightened their richness and set off their severe form. As with porcelain, the demand for lacquer was so high that it could not be met by imports alone, giving furniture-makers the opportunity to develop an imitation that could satisfy the market. Lacking knowledge of the rhus tree, whose sap provided real lacquer, British makers developed different formulas of shellac combined with resins and gums, coloured with lampblack or ivory black, to create a convincing imitation known as 'japanning' that proved surprisingly difficult to distinguish from genuine oriental lacquer (pl.170).[9] Such was its popularity that in 1688 John Stalker and George Parker published their *Treatise of Japanning and Varnishing*, a comprehensive guide to japanning that was used by both professionals and amateurs such as noble-women, who engaged in japanning as a leisure activity.

By the end of the seventeenth century the British furniture trade had advanced to an unprecedented extent. Although, as in many other trades, there were foreigners operating at the level of the court, having been brought to this country for their superior skills and knowledge of the most fashionable European design, these foreigners were obliged by the rules of their guilds to train British apprentices to ensure the continued expansion and quality of the native trade. By this time the trade was divided into separate specialists in particular kinds of work.

171
Cravat by Grinling Gibbons
Limewood, with raised
and openwork carving
England (London), c.1690
V&A: W.181–1928

172
**The Carved Room at
Petworth House, West Sussex,**
with limewood carved surrounds
by Grinling Gibbons
Limewood carvings on
oak panelling
England, c.1692
© National Trust Images /
Bill Batten

Joiners, carpenters, carvers, turners and upholsterers each had their own tools, techniques and guilds, which regulated their production to ensure consistent levels of quality. In the seventeenth century new offshoots of joinery emerged as a result of the new types of furniture – cabinet-making, japanning and caned chair-making – all of which expanded trade further.

The proliferation of commissioning, marketing and woodworking following the Restoration and the Great Fire applied not just to furniture-makers, but to other craftsmen working in wood, who introduced new ideas and techniques into Britain – most notably Grinling Gibbons. Born and raised in the Netherlands, but of British parents, Grinling Gibbons was first documented in Britain in 1671, when John Evelyn claimed to have discovered him in a workshop in Deptford carving a relief after a *Crucifixion* by Tintoretto, while working as a ship-carver. Although the details of Gibbons's early life are unclear, it seems that he learned to draw and carve (in stone and wood) in Amsterdam with Artus Quellin I, the great Flemish baroque sculptor responsible for the carved decoration of Amsterdam Town Hall. In moving to Britain and working – once he had established his reputation, a lengthy process – Gibbons was responsible for introducing an entirely new form of woodcarving that he had learned in the Netherlands: decorative limewood-carving. Limewood (from the linden tree) had never previously been used in Britain, but Gibbons showed how this soft wood could be manipulated to create

sculptural carvings of astonishing virtuosity. Although he also used limewood to produce occasional figurative reliefs, such as the early *Crucifixion* and a *Stoning of St Stephen* (now in the V&A), it is for his decorative carved surrounds and trophies (individual virtuoso carvings composed of an assemblage of objects) that Gibbons is best known.

A kind of small-scale trophy is his limewood cravat, carved out of a single block of wood excavated from underneath, extensively pierced and carved to imitate the most intricate details of late seventeenth-century Venetian needle lace (pl.171). The imitation is so astonishing that its erstwhile owner, Horace Walpole, declared that the artifice 'arrives even to deception'.[10] Gibbons's carved surrounds, composed of swags and drops of fruit and foliage (often with the addition of other elements such as dead game birds or musical instruments), are equally astonishing in their naturalism, being not unlike that of the Dutch still-life botanical painting with which he would have been familiar from his years in the Netherlands. Although his reputation was not established immediately – indeed, Evelyn bemoans the fact that his introduction of Gibbons to the king was not successful – by the end of his career Gibbons had produced carvings for such illustrious buildings as St Paul's Cathedral and Hampton Court, as well as country houses such as Petworth in Sussex, perhaps the finest expression of his carved foliage surrounds (pl.172). These surrounds were conceived as three-dimensional surface ornament to the

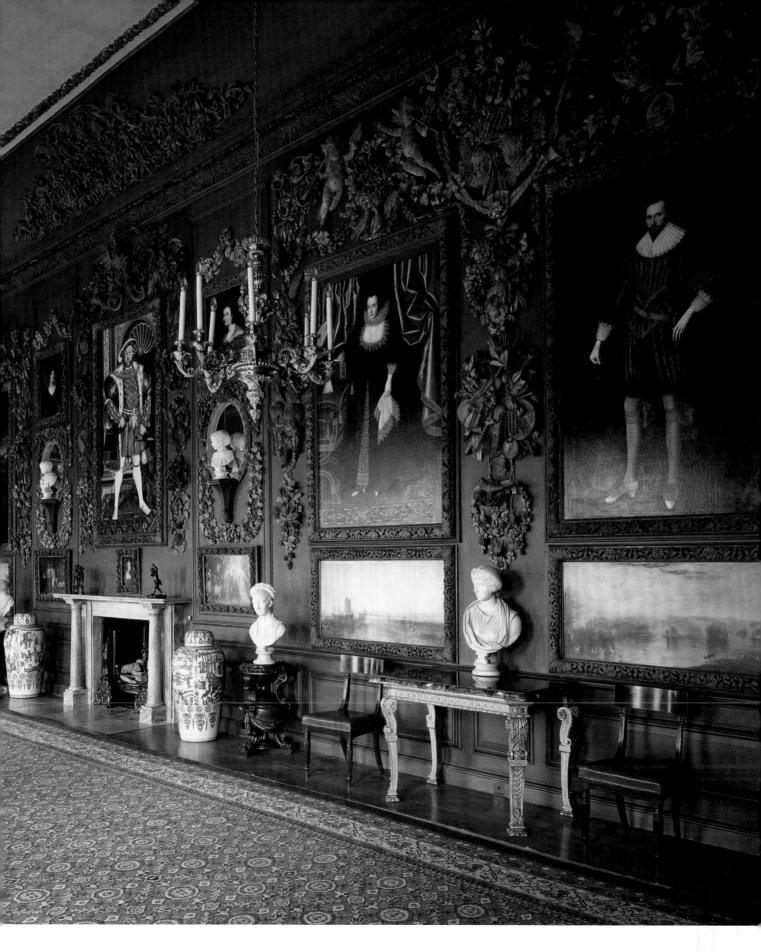

wainscot panelling, which continued to be used to line the interiors of rooms. The paleness of limewood, which has darkened in most of his works through centuries of dust and dirt (and, in some cases, paint or varnish), would have been extremely pronounced when freshly carved, creating a strong tonal contrast between the limewood and the oak ground to which it was attached, and would have emphasized Gibbons's extreme under-cutting through the interplay of light and shadows.

Seventeenth-century woodwork in Britain showed great advances, but woodwork reached its high point in the eighteenth century, with designers, makers and entrepreneurs able to build on the progress that had been made previously, assisted by the expansion of British power overseas. The best known of these is Thomas Chippendale the Elder, who succeeded in capitalizing on shifts in fashion and an expanding market to create a name with impact the world over.

Like his equally successful contemporaries in other media, such as Josiah Wedgwood, Chippendale did not emerge from a vacuum to revolutionize British furniture single-handedly. The first half of the eighteenth century had seen some significant changes and stylistic developments. Marquetry, lacquered and japanned furniture continued to be popular, but changed their form with the introduction of the cabriole leg, in line with a taste for more curvilinear shapes. New pieces of small-scale furniture, such as card tables and tea tables, were introduced to cater for new fashionable activities. Style movements developed and changed: the early eighteenth century saw a vogue of neo-Palladianism, inspired by the publication by the Scottish architect Colen Campbell of *Vitruvius Britannicus, or the British Architect*, in three volumes from 1715 to 1725. This presented a reaction against the popular baroque style, and instead proposed a 'British' style based on a mix of influences from classical antiquity combined with influences from Inigo Jones.[11]

Neo-Palladianism offered a peculiarly British form of classicism, seen above all in the architecture and interior furnishings designed by William Kent for locations such as Lord Burlington's Chiswick House. Kent and his peers created a style that did not entirely turn its back on the exuberance of the baroque, but chose from it selectively, creating grand but contained and classically correct mirrors, candlestands and console tables, the last being notable for their carved giltwood stands and marble-slab tops (pl.173).

Perhaps the most significant change in British woodwork in the early eighteenth century was in the materials used by craftsmen. In 1709 the Great Frost had destroyed the majority of walnut trees in continental Europe, leading to a ban on French exports in 1720. Although imports of North American walnut went some way towards compensating for this, walnut's decline in popularity was hastened by a new, exotic wood from the colonies: mahogany. Native to the West Indies (including Jamaica, a British colony from 1655), mahogany was imported to Britain from the 1720s, being prized for the width of its planks, its deep colour that took varnish well, its stability and resistance to warping and worm, and its exotic allure. It was also economically advantageous, as the Naval Stores Act of 1721 allowed West Indian timber to be imported without any duties.[12]

As a woodworker's material, mahogany is extraordinarily versatile. The large proportions of the trees meant that mahogany could be cut in much wider and longer timber planks than other woods. This made it eminently suitable for big structures such as library bookcases and dining tables. And its strength and ease of carving lent itself to the rococo style, which was introduced into Britain from France in around 1740. The complex asymmetrical curved designs of rococo furniture required woods that were strong enough to sustain extensive carving, and so – although other woods were used – proved well suited to

173
Console table from Chiswick House,
designed by William Kent,
carved by John Boson
Carved and gilded soft wood
with Siena marble top
England (London), 1727–32
V&A: W.14–1971

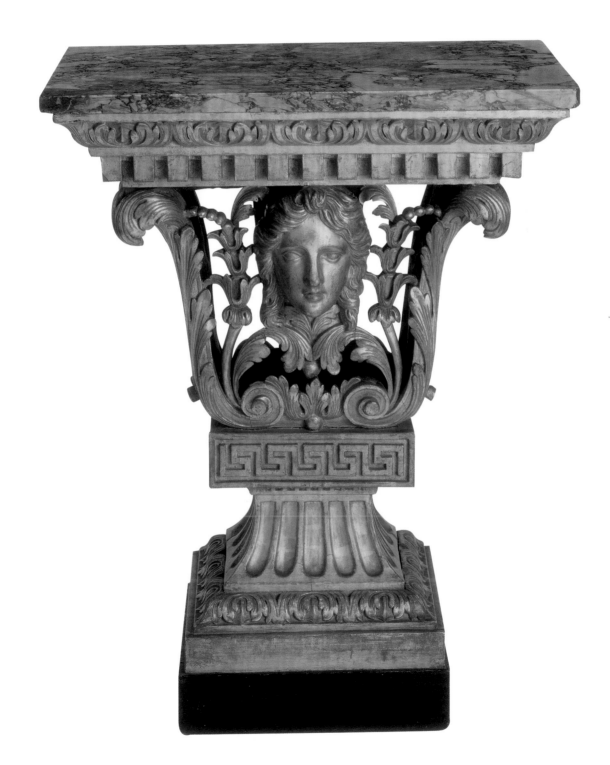

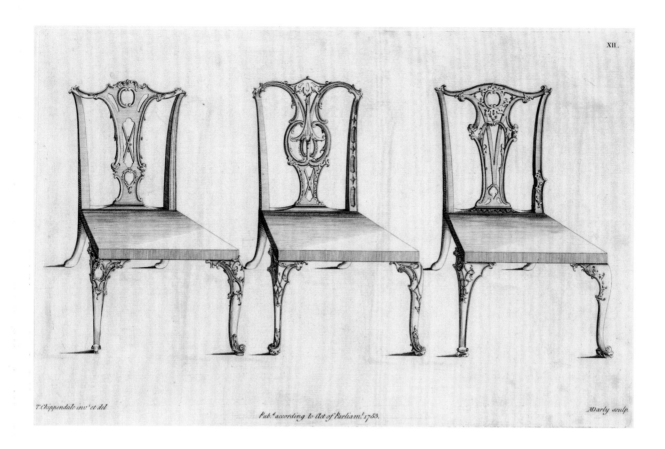

T. Chippendale inv.t et del. Pub.d according to Act of Parliam.t 1753. MDarly sculp.

mahogany, as did the fanciful chinoiserie and neo-Gothic forms of decoration that were also popular at this time. Each of these styles appears in Chippendale's *Gentleman and Cabinet Maker's Director* (pl.174), the publication that made his name, and for which it continues to be known today.

Little is known of Chippendale's early life, other than that he was born in Otley, Yorkshire, in 1718, the son of a joiner. We do not know where he trained in design or cabinet-making, although it may have been in York, but by 1753 he was established in St Martin's Lane, the centre of the London cabinet-making trade. A year later he was in partnership with a Scottish merchant, James Rannie, and building up a sizable workshop of craftsmen. Also in 1754 he published the first edition of the *Gentleman and Cabinet Maker's Director*, a catalogue of designs intended to promote his reputation and attract clients.[13] The intention of the *Director* (as it would become known) can be seen in a notice announcing its forthcoming publication, placed in the *London Daily Advertiser* in March 1753, which called it a 'New Book of Designs of Household Furniture in the GOTHIC, CHINESE and MODERN TASTE ... a Work long wished for, of universal Utility, and accommodated to the Circumstances of

Persons in every Degree of Life'.[14] When published in May 1754, it had 160 engraved illustrations and a list of its 308 subscribers. Although some members of the aristocracy featured in the list (most notably the Duke of Northumberland, who accepted its dedication to him), the majority of the names were those of other furniture practitioners, above all cabinet-makers. These did not generally include Chippendale's direct competitors – such as Vile & Cobb, suppliers of refined case furniture to the royal family; or William and John Linnell; or carvers such as Matthias Lock, famed for his rococo designs – but predominantly comprised provincial firms, such as Gillow's of Lancaster, which could use the *Director* as a sourcebook of designs that they could adapt for their own purposes.[15]

Unsurprisingly, the pattern book inspired competitors to produce their own rival publications, such as that of the carver Thomas Johnson, and of the cabinet-makers and upholsterers William Ince and John Mayhew, who published *The Universal System of Household Furniture* in weekly numbers from 1759. Chippendale's response was to issue a revised and expanded edition of the *Director* in 1762, reasserting his own style as the dominant one. His success in establishing this style can be seen clearly

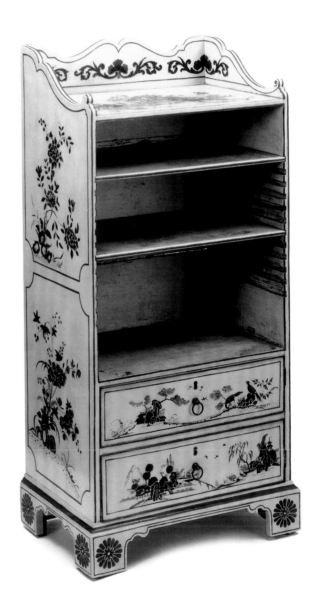

in the take-up of his designs by other cabinet-makers and their practical use of his designs as a pattern book. In 1765 Richard Gillow wrote to a client regarding a commission for a bookcase that he was to execute: 'if any of Chippindales designs be more agreeable, I have his Book and can execute 'em & adapt them to the places they are for'.[16] It can also be seen in the widespread take-up of particular designs, such as the 'ribband-back' chair, so much so that it is often impossible to date and attribute these accurately, owing to their popularity.

Chippendale's success was enshrined in the variety of designs offered in the *Director*, the varied and prolific output of his workshop, and in his ability to adapt to changes in style to secure significant commissions from patrons. Documented commissions reveal the wide range of styles in which he worked. A set of furniture for the actor David Garrick and his wife was japanned in the chinoiserie style appropriate for the Garricks' new Chinese bedroom (pl.175) at their Thames-side villa in Hampton, Middlesex. The Earl of Dumfries commissioned a quantity of furniture from Chippendale, some with chinoiserie decoration and some in the rococo style. Chippendale's later commissions, such as those for Nostell Priory and especially Harewood House, both in West Yorkshire, show his

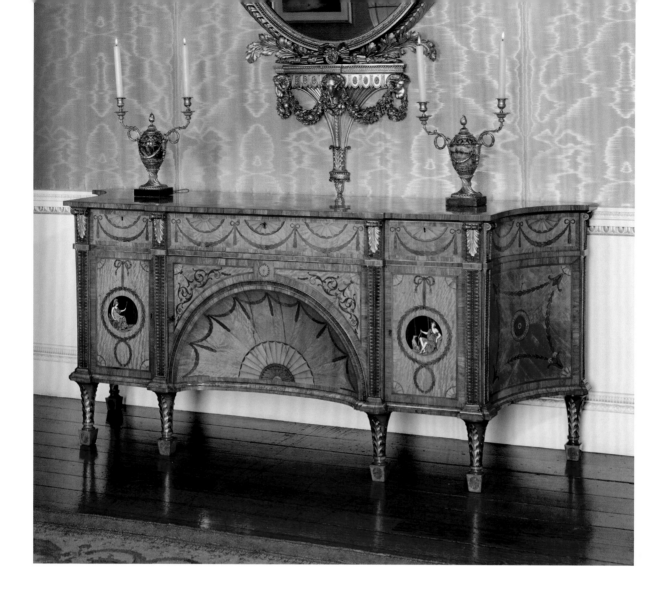

willingness to adapt to the growing popularity of neo-classicism and his association with its leading architect, Robert Adam. The Harewood commission was the most significant of Chippendale's whole career. Home to the Lascelles family, who had made their money from sugar plantations in Barbados, Harewood had only recently been built by the first Baron Harewood, Edwin Lascelles, and had neoclassical interiors designed by Robert Adam. Furniture supplied by Chippendale, such as the spectacular Diana and Minerva Commode, was designed specifically to accord with Adam's interiors, using the same classically inspired motifs and the same elegant forms to create a harmonized effect (pl.176).

It is significant that, when talking about British furniture today, it is still Chippendale's name that is most widely known throughout the world. His ability to capture his market, and the high regard in which 'Chippendale' furniture is still held, indicate the success of his brand more than two centuries on. Subsequent developments in British furniture and woodwork inevitably moved stylistically away from Chippendale. The nineteenth century saw a proliferation of historicist styles, including the Gothic Revival pieces designed by A.W.N. Pugin and made by J.G. Crace, which adorned the new Palace of Westminster, as well as country houses with their medieval-inspired decoration (pl.177). With changes in living habits, the design of furniture altered to suit its new requirements – furniture no longer being arranged around the walls of rooms as 'parade' items, but moving into the centre of rooms, in more informal

176
Diana and Minerva Commode,
supplied by Chippendale
Marquetry on satinwood ground
with ivory medallions and
brass mounts
England, 1773
Harewood House, Yorkshire /
The Bridgeman Art Library

177
Armoire or bookcase, designed
by A.W.N. Pugin and made by
J.G. Crace for the Great Exhibition
Carved oak, with painted shields
and brass panels and handles
England, 1850
V&A: 25–1852

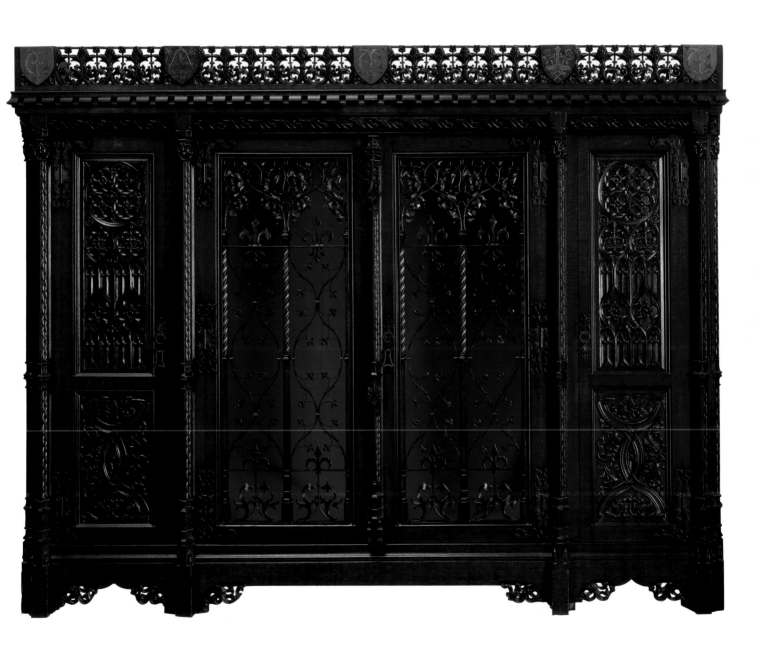

178
Chair designed by
Charles Rennie Mackintosh
Stained oak with upholstery
Scotland (Glasgow), 1897–1900
V & A: Circ.130–1958

dispositions. The heaviness and solidity of Victorian pieces gave way towards the end of the nineteenth century to simpler Arts and Crafts forms, which emphasized the natural qualities of the woods they employed, and to the elegant lines of Art Nouveau pieces designed by Charles Rennie Mackintosh (pl.178).

In the twentieth and twenty-first centuries modern living has made changing demands on furniture crafted from wood. The simplicity of Arts and Crafts furniture found its twentieth-century equivalent in modernism's clean lines and clear functionality. The influence, in particular, of Scandinavian bent-plywood furniture has proved lasting, in line with a continued taste for minimalist interiors and furnishings. At the same time wooden furniture has faced competition from other materials, including steel and plastic, while handmaking processes have been called into question by increasingly rapid advances in the possibilities for manufacture offered by digital technology. Nonetheless, wood continues to be made into objects by hand, with makers and designers such as John Makepeace exploiting traditional and newer materials such as plywood – easily worked and highly flexible – to create sculptural pieces of unusual form (pl.179), which combine a commitment to functionality with an understanding of the organic nature of the material from which they are crafted. The conjunction of highly skilled craftmanship and the variety of finish that different timbers offer to designers ensure that there is still a place for handmaking in wood in the twenty-first century.

179
Coloumn of drawers
by John Makepeace
Birch plywood, acrylic
and stainless steel
England (Dorset), 1977–8
V & A: W.56–1978

John Makepeace

Born 1955. Lives and works in Dorset.

Can you tell us how your making begins?
Making things is about ideas, and realizing them in an appropriate material. For me, ideas arise from how we can make things that fulfil their function better, possibly by improving the form, the structural concept and the way an object expresses its time, its intention, its material, its method of manufacture and sometimes a relevant allegory or fantasy.

In making furniture, the process may spring either from a specific commission from a client or from the independent welling-up of a concept that excites my attention. Fundamental to the design process is challenging every convention: why? why? why? This radical approach is prone to reveal that many objects take their form not from what is best for their purpose, but because of some expedience, whether of material, manufacture or distribution.

Equally valuable, when clarifying a brief, is to avoid nouns and adjectives – to express it in verbs. Objects, and furniture in particular, support activities; identifying them and studying them in depth begins to reveal forms that are inherently more effective in supporting the intended activity. For example, the noun 'desk' is likely to conjure up a preconceived image. Once the activity is analysed with verbs – typing, looking at a screen, reading, meeting – a very different set of possibilities emerges.

Whether working on a commission or a speculative design, the next stage is an intense imagining of all the various aspects through drawing, model-making and playing with different notions to find ones that resonate together. Out of this, several possible directions are likely to result. In assessing them against the criteria set out in the brief, some – or none – may emerge as suitable for development through to more detailed drawings, the mocking-up of particular features or even a full-size prototype.

Throughout the design stage it is likely that a specific range of materials will be foremost in the designer's mind. Every material has very distinctive properties and understanding these is vital, as is an awareness of how that material can either be manipulated to enhance it or combined with a complementary material whose properties are better in certain situations.

Material scientists specialize in this area, and technical developments mean advances in performance over traditional methods of construction. These advances are another valuable catalyst for innovation in design.

Similarly, each material has distinctive methods by which it is processed, and a grasp of manufacturing methods – whether by hand or by machine – will be in the designer's mind as a design progresses.

What are your preferred raw materials?
My own inclination is to use timber as my preferred material for making furniture. Initially that was because I had some facility for working it; metal did not have the same attraction. Over time, my choice of wood has been reinforced by numerous factors: its strength in relation to its weight; its diversity (no two pieces of wood are the same); its range of colour (from pale holly to black

bog oak); its growing as part of our own landscape, and its sustainability if properly managed; its scope for rigidity, and its flexibility in thin slices; and its efficient conversion of sunlight into an endlessly beautiful and engaging resource.

Against these attractions, there are disadvantages. The world's forests are still being cleared at an alarming rate, largely for the uncertain prospect of generating regular cash crops on the cleared land. Harvesting, hauling, sawing and seasoning timber are energy-intensive, even before the start of any manufacturing process. Working wood is relatively labour-intensive, and especially so at a high level of craftsmanship – those skills require special training and take years to master. However, wood remains one of our most ecological materials.

So where does the future lie? There remains a modest supply of the more unusual indigenous timbers, which are ideally suited in volume and quality to the needs of the artist furniture-maker. The larger-volume and global markets will be met from more widely available woods and more processed materials – paper and wood-veneered panels, steel and synthetics, cleverly presented to appeal to rich and poor consumers alike.

What are your main technical challenges?
It seems to me that most woodworking techniques have altered little since the seventeenth century. Although now mechanized so that there is less physical effort, the methods of construction in solid timber have remained very similar, with the result that design has not changed significantly. For example,

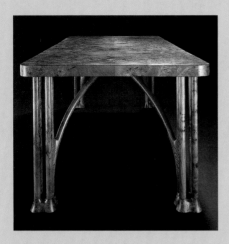

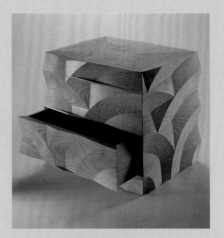

far left
'Cluster' table designed
by John Makepeace and
made in his workshops
at Parnham House
Burr elm, laminated,
turned and joined
England (Dorset), c.1986

left
'Arcade' chest designed
by John Makepeace and
made in his workshops
at Parnham House
English cherrywood and
Lebanon ceder linings
England (Dorset), c.1990

frames and panels are still the norm. Whereas science and technology have focused substantially on developments in metals and plastics, wood has been relatively neglected, despite its environmental credentials. The supply chain from the forest to the consumer is so dispersed that there has not been the commercial muscle to envisage and drive research into the improved processes that will keep timber at the forefront of scientific, technological, aesthetic and commercial developments.

As a consequence, the finest furniture in wood remains dependent on relatively low-capital, skill-intensive methods. These require extensive training, and because of the scale of operation and the fact that they are time-consuming, the products are costly, although they do remain a valuable source of distinguished furniture. Where research has effectively bridged the gulf between forest and consumer is in the production of reliable panel products. While much despised and maligned, medium-density fibreboard (mdf) has radically improved the stability and durability of the core material that is widely used in the industry for veneered cabinets and tabletops.

For the designer furniture-maker, sourcing indigenous timber has become more challenging as the number of sawmills has diminished. But I believe that it is really important for the future of our landscape to value and use indigenous trees towards the end of their lifecycle. By providing a market for timber from beautifully managed woodlands, we enable them to continue.

Do you think of your work as being part of a heritage?
There are three main forms of furniture: the chair, the table and the chest or cupboard. Each has a distinct role and quite different structural requirements.

Chairs generally need to be light enough to move, strong enough to withstand the stresses we impose on them and to provide support that encourages good posture and levels of comfort. Although research has established how to achieve this in different situations, millions of chairs still fail to apply it. I think of **tables** as a way of supporting a surface so that the means of support is expressive, and the shape of that surface influences the relationship between those around it. **Chests and cupboards** protect things that we value, while making them more easily accessible.

Each of these 'activities' has a distinct heritage; its functional, ergonomic and psychological requirements demand different forms and structures. For example, a chair echoes the human form, but the body needs particular support in specific areas – the base of the spine (the coccyx) and the lumbar region. The seat of a chair helps us wriggle our way into position. The psychological role of the chair is to make us feel secure and at ease. These objectives are best served by relatively firm surfaces at the right heights, angles and curvatures to enable freedom of movement while retaining good posture.

Achieving these goals presents challenges beyond those met by earlier generations. The 'joinery' approach to chair-making falls short of the potential, and a more sculptural approach can best embrace the body's needs. On a small scale, this is possible by carving or bending timber three-dimensionally. For example the 'Knot' chair (previous page) combines laminated oak legs and arms (thin layers of oak bent and glued to the required curvatures) with 'cushions' knotted to the legs. New high-performance steel and resin junctions eliminate the constraints of conventional joinery. The 'Millennium' and 'Trine' chairs apply the same principles in different ways.

These advances in technology, use, materials and aesthetics have always excited me in relation to the continuing history of furniture that we call 'heritage', part of a dynamic tradition that clearly expresses our evolving culture. This can be seen as a series of landmarks. My role as designer and maker is to apply and express these advances in an orchestrated 'essay'.

How does your work relate to art, craft and design?
Whether the results are art, craft or design may not be a meaningful debate. One could argue that they are all three. If art is 'a human creative skill', craft 'a practical skill' and design 'a plan for making', then all are integral to the realization of a cogent concept.

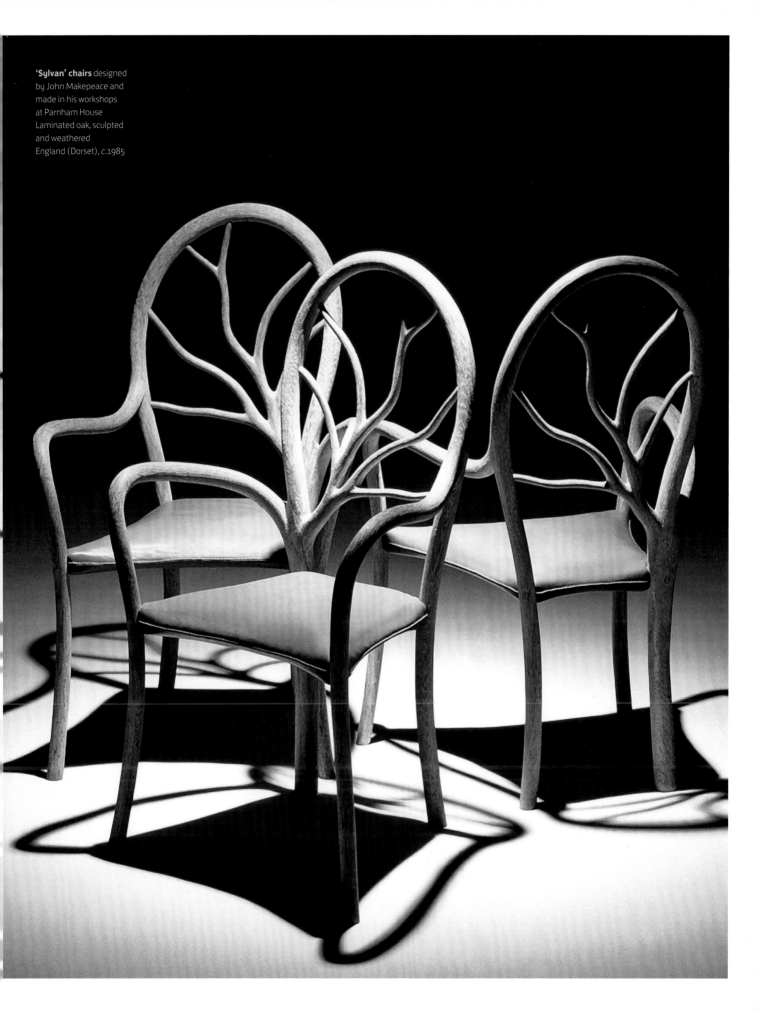

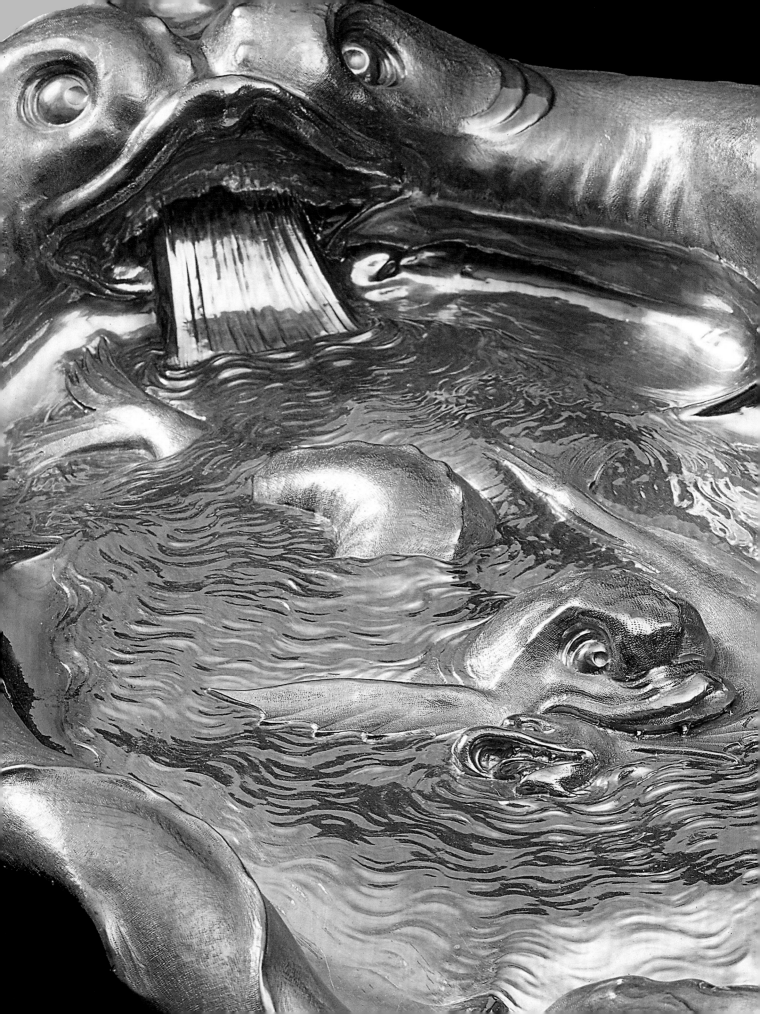

Conclusion

At the beginning of the twenty-first century the practice of making by hand manages paradoxically to be both the preserve of the few and yet open to many. With the transfer overseas of many of the great industrial successes of nineteenth-century Britain – most obviously textile and ceramic manufacture – and the decline in the teaching of manual skills, in favour of an ever-increasing focus on digital media, it might seem that Britain no longer has a role as a manufacturing nation in contemporary society. However, this seems to be too simplistic a view of what is in reality a more complex picture. It is undoubtedly true that Britain is unlikely to reach ever again the heady heights of Victorian production, when British-made objects dominated the global market, but at the same time it is also true that certain industries have not only continued to exist, but have even seen something of a revival since the manufacturing collapse of the 1970s and '80s – often being relatively small-scale operations that have succeeded in finding a particular niche in which they can make a name for themselves.

At the same time, the worlds of craft and art have merged and intermingled, so that the traditionally perceived distinctions and hierarchies between them no longer seem to apply. Long liberated from the traditional fine arts, contemporary artists now look not only to digital, time-based media, but also to traditional crafts for their work. Tracey Emin and Grayson Perry are just two examples of artists who have made a deliberate decision to work in media that have particular resonances to be exploited and subverted in the work itself, but which also require a certain manual skill as well as a talent for design. At the opposite end of the scale, making by hand is flourishing at an amateur level, particularly in crafts that offer either individual satisfaction or participation in a communal activity, the latter perhaps increasingly important in a world of virtual interaction and social media. Above all, the fascination with the handmade object – on the part of the maker and of the consumer – remains alive and well. Materials continue to inspire creativity, and the constant tug of form and function that applies to the decorative arts is one that often still seems compelling to contemporary makers.

The 2011 V&A exhibition *Power of Making* demonstrated not only the diversified areas in which handmaking plays a crucial role, but also the ways in which traditional processes and materials can work with new technologies or media to produce innovative works that capture the eye, the hand and the imagination. If there were ever any doubt, the overwhelming success of that exhibition proved unquestionably that making by hand is still an activity that remains absolutely relevant in Britain today.

Notes

INTRODUCTION

1 M. Snodin and J. Styles (eds), *Design and the Decorative Arts: Britain 1500–1900* (London, 2001), p.178
2 Snodin and Styles (2001), p.175
3 Snodin and Styles (2001), p.284
4 Snodin and Styles (2001), p.185
5 T. Harrod, *The Crafts in Britain in the 20th Century* (New Haven and London, 1999), p.27
6 Harrod (1999), p.194
7 D. Charny (ed.), *Power of Making: The Importance of Being Skilled* (London, 2011), p.33
8 Snodin and Styles (2001), p.312
9 L.E. Miller and S. Medlam (eds), *Princely Treasures: European Masterpieces 1600–1800 from the Victoria and Albert Museum* (London, 2011), p.10

STAINED GLASS

1 S. Brown, *'Our Magnificent Fabrick': York Minster, an architectural history c.1220–1500* (Swindon, 2003), pp.218–19
2 R. Marks, *Stained Glass in England in the Middle Ages* (London, 1993), p.59
3 Marks (1993), p.105
4 Quoted in Marks (1993), p.30
5 R. Marks and P. Williamson (eds), *Gothic: Art for England* (London, 2003), p.226
6 Marks (1993), p.181
7 *'Ut nichil tale possit in Anglia videri in vitrearum fenestrarum luce'*, quoted in Marks (1993), p.110
8 P. Williamson, *Medieval and Stained Glass in the Victoria and Albert Museum* (London, 2003), p.132, cat.4
9 Marks (1993), p.165
10 Williamson (2003), p.138, cat.31
11 Marks (1993), pp.38–9
12 Marks (1993), p.6
13 Marks and Williamson (2003), p.49
14 S. Brown, *Stained Glass at York Minster* (London, 1999), p.42

15 *Gothic* (2003), p.226, cat.89
16 Brown (1999), pp.74–5
17 Brown (1999), p.43
18 Marks (1993), p.55
19 Marks (1993), p.30
20 Marks (1993), p.206
21 Marks (1993), pp.190–91
22 Marks (1993), pp.209–11, 217–19
23 Marks (1993), p.235
24 Snodin and Styles (2001), p.336
25 Harrod (1999), p.452
26 Quoted in F. Spalding, 'John Piper and Coventry, in war and peace', in *The Burlington Magazine*, vol.145, no.1204 (2003), pp.488–500
27 Quoted in Spalding (2003), p.498

METALWORK

1 J. Alexander and P. Binski (eds), *Age of Chivalry: Art in Plantagenet England, 1200–1400* (London, 1987), p.162
2 Alexander and Binski (1987), pp.240–41
3 P. Glanville (ed.), *Silver* (London, 1996), pp.88–90
4 Alexander and Binski (1987), pp.164–5
5 M. Campbell, *An Introduction to Ironwork* (London, 1985), p.9
6 Glanville (1996), p.162
7 S. Thurley, *Hampton Court: A social and architectural history* (New Haven and London, 2003), p.229; R. MacCubbin and M. Hamilton-Phillips (eds), *The Age of William III and Mary II: Power, Politics, and Patronage 1688–1702* (Williamsburg, 1989), p.229. Half of this sum was spent on the gardens of Hampton Court.
8 M. Snodin and N. Llewellyn (eds), *Baroque 1620–1800: Style in the age of magnificence* (London, 2009), cat.132, p.348
9 R. Lister, *Decorative Cast Ironwork in Great Britain* (London, 1960), p.74

10 J. Gay (photographs) and G. Stamp (introduction), *Cast Iron: Architecture and ornament, function and fantasy* (London, 1985), p.10
11 A. Eatwell, 'Capital lying dead: attitudes to silver in the nineteenth century', in *The Silver Society Journal*, no.12 (Autumn 2000), pp.59–64
12 Eatwell (2000), p.60
13 Eatwell (2000), p.62
14 *The Illustrated London News*, 30 August 1862, p.246
15 Eatwell (2000), p.63
16 M. Campbell, *Decorative Ironwork* (London, 1997), p.26

CERAMICS

1 Quoted in R. Faulkner (ed.), *Tea East and West* (London, 2003), p.40
2 H. Young, *English Porcelain 1745–95: Its makers, design, marketing and consumption* (London, 1999), pp.21–2
3 Young (1999), pp.25, 27
4 Young (1999), p.17
5 H. Young (ed.), *The Genius of Wedgwood* (London, 1995), p.44
6 Young (1995), p.147
7 Quoted in Young (1995), p.102
8 Young (1995), p.53
9 Quoted in Young (1995), p.57
10 Quoted in Young (1999), pp.81–2
11 B. Leach, *A Potter's Book* (London, 1940), p.1
12 G. Adamson, A. Graves and E. de Waal, *Signs & Wonders: Edmund de Waal and the V&A ceramics galleries* (London, 2009), p.24

FABRIC

1 Alexander and Binski (1987), p.157
2 Alexander and Binski (1987), p.159
3 G. Davies and K. Kennedy (eds), *Medieval and Renaissance Art: People and Possessions* (London, 2009), p.92

4 T. Campbell, *Tapestry in the Renaissance: Art and Magnificence* (New York, 2002), p.24
5 Davies and Kennedy (2009), p.137
6 Campbell (2002), pp.5–6
7 T. Campbell, *Tapestry in the Baroque: Threads of Splendour* (New York, 2007), pp.171–2
8 Campbell (2007), p.188
9 Campbell (2007), p.497
10 D. King and S. Levey, *The Victoria and Albert Museum's Textile Collection: Embroidery in Britain from 1200–1750* (London, 1993), p.17
11 Snodin and Styles (2001), pp.268–9
12 Snodin and Styles (2001), pp.300–1
13 Snodin and Styles (2001), pp.138, 174
14 L. Parry, *The Victoria and Albert Museum's Collection of Textiles: British textiles from 1850–1900* (London, 1993), p.13

WOOD

1 Marks and Williamson (2003), p.66
2 Marks and Williamson (2003), p.68
3 Alexander and Binski (1987), p.507
4 A. Bowett, *English Furniture: 1660–1714, from Charles II to Queen Anne* (Woodbridge, 2002), p.29
5 Bowett (2002), pp.60–61
6 Quoted in Bowett (2002), p.62
7 Bowett (2002), p.119
8 Bowett (2002), p.84
9 Bowett (2002), pp.152–4
10 M. Snodin (ed.), *Horace Walpole's Strawberry Hill* (New Haven and London, 2009), p.94
11 Snodin and Styles (2001), p.190
12 Snodin and Styles (2001), p.293
13 C. Gilbert, *The Life and Work of Thomas Chippendale* (London, 1978), 2 vols, vol.I, p.65
14 Gilbert (1978), vol.I, p.66
15 Gilbert (1978), vol.I, p.71
16 Quoted in Snodin and Styles (2001), p.226

Further reading

GENERAL

Alexander, J. and Binski, P. (eds), *Age of Chivalry: Art in Plantagenet England, 1200–1400* (London, 1987)

Baker, M. and Richardson, B. (eds), *A Grand Design: The art of the Victoria and Albert Museum* (London, 1997)

Charny, D. (ed.), *Power of Making: The Importance of Being Skilled* (London, 2011)

Davies, G. and Kennedy, K. (eds), *Medieval and Renaissance Art: People and Possessions* (London, 2009)

Faulkner, R. (ed.), *Tea East and West* (London, 2003)

Glanville, P. and Young, H. (eds), *Elegant Eating: Four hundred years of dining in style* (London, 2002)

Harrod, T., *The Crafts in Britain in the 20th Century* (New Haven and London, 1999)

MacCubbin, R. and Hamilton-Phillips, M. (eds), *The Age of William III and Mary II: Power, Politics, and Patronage 1688–1702* (Williamsburg, 1989)

Marks, R. and Williamson, P. (eds), *Gothic: Art for England* (London, 2003)

Miller, L.E. and Medlam, S. (eds), *Princely Treasures: European Masterpieces 1600–1800 from the Victoria and Albert Museum* (London, 2011)

Snodin, M. (ed.), *Horace Walpole's Strawberry Hill* (New Haven and London, 2009)

Snodin, M. and Llewellyn, N. (eds), *Baroque 1620–1800: Style in the age of magnificence* (London, 2009)

Snodin, M. and Styles, J. (eds), *Design and the Decorative Arts: Britain 1500–1900* (London, 2001)

Thurley, S., *Hampton Court: A social and architectural history* (New Haven and London, 2003)

Trench, L., *V&A: The Victoria and Albert Museum* (London, 2010)

Wood, G. and Breward, C. (eds), *British Design from 1948: Innovation in the modern age* (London, 2012)

STAINED GLASS

Brown, S., *Stained Glass at York Minster* (London, 1999)

Brown, S., *'Our Magnificent Fabrick': York Minster, an architectural history c.1220–1500* (Swindon, 2003)

Marks, R., *Stained Glass in England in the Middle Ages* (London, 1993)

Williamson, P., *Medieval and Stained Glass in the Victoria and Albert Museum* (London, 2003)

METALWORK

Campbell, M., *An Introduction to Ironwork* (London, 1985)

Campbell, M., *Decorative Ironwork* (London, 1997)

Gay, J. (photographs) and Stamp, G. (introduction), *Cast Iron: Architecture and ornament, function and fantasy* (London, 1985)

Glanville, P. (ed.), *Silver* (London, 1996)

Lister, R., *Decorative Cast Ironwork in Great Britain* (London, 1960)

Lomax, J. and Rothwell, J., *Country House Silver from Dunham Massey* (London, 2006)

CERAMICS

Adamson, G., Graves, A. and de Waal, E., *Signs & Wonders: Edmund de Waal and the V&A ceramics galleries* (London, 2009)

Archer, M., *Delftware: The tin-glazed earthenware of the British Isles* (London, 1997)

Hildyard, R., *Ceramics* (London, 1999)

Hildyard, R., *English Pottery, 1620–1840* (London, 2005)

Leach, B., *A Potter's Book* (London, 1940)

Young, H. (ed.), *The Genius of Wedgwood* (London, 1995)

Young, H., *English Porcelain 1745–95: Its makers, design, marketing and consumption* (London, 1999)

FABRIC

Campbell, T., *Tapestry in the Renaissance: Art and Magnificence* (New York, 2002)

Campbell, T., *Tapestry in the Baroque: Threads of Splendour* (New York, 2007)

King, D. and Levey, S., *The Victoria and Albert Museum's Textile Collection: Embroidery in Britain from 1200–1750* (London, 1993)

Opus Anglicanum: English medieval embroidery (London, 1963)

Parry, L., *The Victoria and Albert Museum's Textile Collection: British textiles from 1850–1900* (London, 1993)

Rothstein, N., *The Victoria and Albert Museum's Textile Collection: Woven Textile Design in Britain to 1750* (London, 1994)

Rothstein, N., *The Victoria and Albert Museum's Textile Collection: Woven Textile Design in Britain from 1750 to 1850* (London, 1994)

WOOD

Beard, G. and Goodison, J., *English Furniture, 1500–1840* (Oxford, 1987)

Bowett, A., *English Furniture: 1660–1714, from Charles II to Queen Anne* (Woodbridge, 2002)

Bowett, A., *Early Georgian Furniture 1715–1740* (Woodbridge, 2009)

Esterly, D., *Grinling Gibbons and the Art of Carving* (London, 1998)

Gilbert, C., *The Life and Work of Thomas Chippendale* (London, 1978)

Tracy, C., *English Medieval Furniture and Woodwork* (London, 1988)

Wilk, C. (ed.), *Western Furniture, 1350 to the Present Day* (London, 1996)

Acknowledgements

Handmade in Britain has only been possible thanks to the contribution of many colleagues, both inside and outside the Museum, to whom I owe the most sincere thanks.

At the BBC the project has been led by Jonty Claypole and Judith Nichol, with programmes made by Janice Hopper, Ben McPherson, Franny Moyle, John Mullen, Kath Pick, Suniti Somaiya, Paul Tilzey and David Vincent. They and their colleagues have succeeded in making a series of films that have revealed the richness and variety of the V&A collections.

I am extremely grateful to all colleagues in the Museum who have contributed their time, expertise and assistance to the project. The Research Department, under the directorship of Christopher Breward and Glenn Adamson, and with the particular support of Liz Miller and Ghislaine Wood, offered the ideal environment in which the project could develop. Current and former colleagues in curatorial and conservation departments provided the expertise that was fundamental to creating the content for the television programmes and for this book, and for making objects available for filming. In particular I would like to thank Terry Bloxham, Clare Browne, Marian Campbell, Matthew Clarke, Judith Crouch, Jemma Davey, Ann Eatwell, Richard Edgcumbe, Philippa Glanville, Alun Graves, Kate Hay, Diana Heath, Nick Humphrey, Reino Liefkes, Leela Meinertas, Luisa Mengoni, Lesley Miller, Rosie Mills, Tessa Murdoch, Angus Patterson, Sue Prichard, Alicia Robinson, Marjorie Trusted, Eric Turner, Christopher Wilk, Paul Williamson, Ghislaine Wood, Anna Wu, Hilary Young and Heike Zech.

In V&A Publishing, I am particularly grateful for the support of Clare Davis, Mark Eastment and Tom Windross, as well as the copy-editor Mandy Greenfield and the designer Philip Lewis.

I am also grateful to the contributors who have added an important and different practical perspective: Caroline Benyon, Jo Budd, Chris Knight, John Makepeace and Edmund de Waal.

Index of makers

Photographic credits